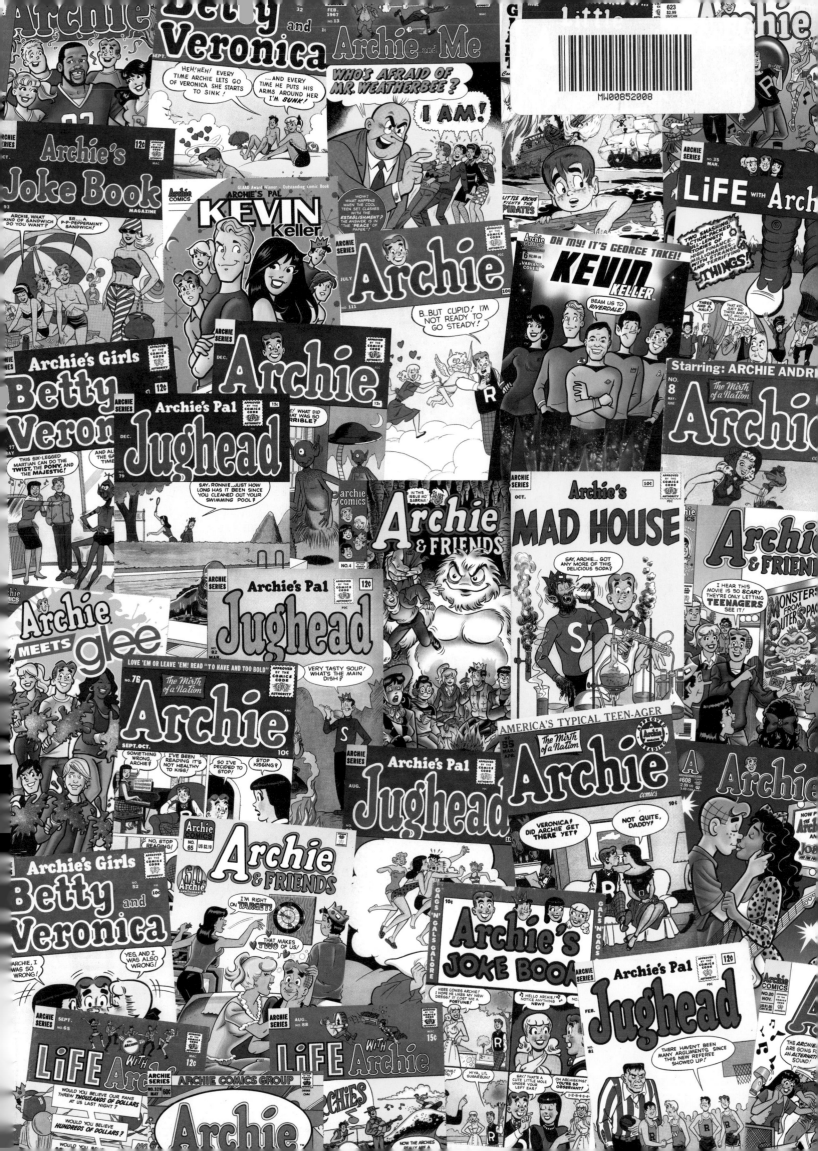

DEDICATION

To My Wife, Kathie.
My favorite cover girl.
I Love You.
—Victor

To My Wife, Clizia.
My favorite cover girl.
I Love You.
—Craig

Book design by Craig Yoe

This book could not have happened without the help and knowledge of
Steve Barghusen.

We are deeply grateful for the generous help from
Jack and Nancy Copley.

Front cover illustration by Harry Lucey from the cover of *Life with Archie* #1, September 1958.
Back cover illustration by Fernando Ruiz, done especially for this book. Back cover colored by Tito Peña.
Title page: *Dan Parent,* Veronica #*187, February 2008.*

Our deepest gratitude to the comic book, art, and ephemera collectors who generously shared their priceless treasures:
Steve Barghusen, Arthur Chertowsky, Shaun Clancy, Jack and Nancy Copley, Nick Katradis, R. Gary Land, Karl-Erik Lindkvist,
James Meeley, Richard Morgan, Steven Ng, Rod Ollerenshaw, Jesse Rubenfeld, and Rick Shurgin.

Many thanks to our diligent and skilled proofreaders: Carly Inglis, Mark Lerer, Peter Sanderson, and Steven Thompson.

Thanks to: Mark Arnold, Brendon Fraim, and Brian Fraim.

OFFICERS/VIPs ARCHIE COMICS: OFFICERS/VIPs ARCHIE COMICS: Publisher/CEO: Jonathan Goldwater; Co-CEO: Nancy Silberkleit;
President: Mike Pellerito; Co-President/Editor-in-Chief: Victor Gorelick; Senior Vice President Sales and Business Development:
Jim Sokolowski; Senior Vice President Publish and Operations: Harold Buchholz; Vice President Publicity and Marketing: Steven Scott;
Executive Director of Editorial: Paul Kaminski; Production Manager: Stephen Oswald.

ISBN: 978-1-936975-79-2

Printed in China

THE ART OF Archie

THE COVERS

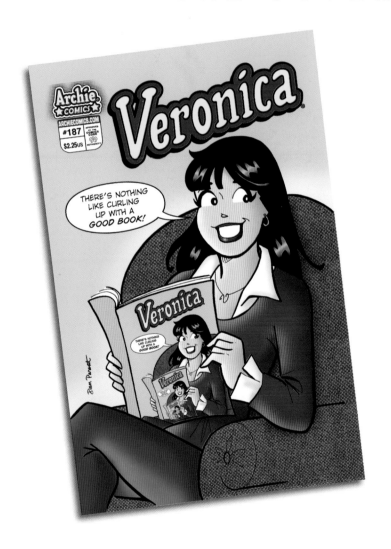

EDITED BY VICTOR GORELICK & CRAIG YOE
PRODUCED BY CLIZIA GUSSONI

CONTENTS

IT'S A GIFT!

THE COVERS ON A COMIC BOOK are like the gift wrapping on a present. They give you a hint as to what may be inside, but you need to unwrap it to find out for certain.

The covers on Archie Comics combine all the elements that make Archie a unique comic book hero beloved by generations. First and foremost, Archie comic book covers are "eye candy." The vibrant and rich colors immediately capture your attention. The images pop off the page in marvelous reds, blues, greens, and, most importantly, orange. The colors accentuate the fashions, and both Betty and Veronica always look sharp. Next up is the art itself. The way the characters are drawn is absolutely perfect. One look at the cover and you know exactly what you are looking at. There is no mistaking an Archie cover for anything else. The images of Archie and the gang are as original and iconic as any comic book image ever created. The backgrounds and the settings are all so familiar—the Chocklit Shoppe, Riverdale High, and the Lodge mansion have been with us for decades. It just feels good.

Finally, the all important gag. It ties everything together and is the last piece of the puzzle that brings a smile to the face of the reader. It is meant to be funny or sweet or just fill you with cheer. The cornerstone of Archie's stories, the "love triangle," has appeared on too many comic books to count. Since Archie first appeared more than 70 years ago, there have been more than two billion Archie comics sold. That's a lot of covers!

If anyone knows how to pick the funniest, the most classic and important covers, it is Victor Gorelick. Victor and his partner on these books, the brilliant Craig Yoe, have picked the best of the best. They have literally pored over our thousands and thousands of covers to produce this book.

I hope you enjoy these Archie covers as much as we do.

—Jon Goldwater
 Publisher/Co-CEO

YOU CAN JUDGE A BOOK BY ITS COVER!

I WOULD GUESS THAT WHEN *Archie Comics* #1 appeared on the newsstand in the winter of 1942, most people had never seen or heard of him. Archie's first appearance was in *Pep Comics* #22 dated December, 1941. Featured on this cover were superhero characters The Shield and The Hangman. Archie's image was not on the cover. Archie stories also appeared in *Jackpot Comics* without any indication (with the exception of issue #4, Winter, 1941) that an Archie story was in that comic. Considering the fact that there was very little promotion about Archie, it's amazing that the comic practically sold out month after month.

Looking at the first cover of *Archie Comics,* you see Archie, a goofy teenager, showing off, while two beautiful girls, a blonde and a brunette, Betty and Veronica respectively, look on as he attempts to jump over two large barrels. The blonde girl is obviously thrilled at Archie's skating ability. The brunette is not as optimistic about the outcome. In the background, Archie's best pal, Jughead, is having trouble staying upright.

What was it about the first Archie cover that attracted so many readers? In 1942, the United States was at war with Germany and Japan. People needed something to make them laugh. This cover was funny. You knew Archie was going to end up in very cold water. The two girls, most likely rivals for Archie's affections, represent two thirds of a love triangle that has been the underlying theme of Archie stories for more than 70 years. As for Jughead, he may have fallen, but at least he, unlike Archie, stayed away from the thin ice.

The saying, "You can't tell a book by its cover" is associated more with judging people than knowing the content of a book. The content of *Archie Comics* #1 had nothing to do with the cover, but the cover—and every cover since—had everything to say about what you could look forward to in every Archie comic book.

—Victor Gorelick
 Co-President/Editor-in-Chief of Archie Comics

ON THE COVERS

"I'VE GOT YOU COVERED!" shouted the glossy outer-wrap to the newsprint innards of the Archie comic book.

WELL covered.

Comic book covers featuring muscle bound guys wearing capes and spandex (a.k.a. superheroes) have action. Comic book covers featuring funny animals like Donald Duck were usually clever. Archie covers could have both those qualities, but leave it to the folks at Archie to thankfully put the COMIC in comic books. Not only in but ON. As Victor Gorelick said earlier, you CAN judge an Archie book by its cover. The cover starts with a good laugh and you know you are going to be laughing all the way to the back.

One of Archie's first magazines was even called *Laugh Comics*. The word "Laugh" was boldly emblazoned across the top of this title in Archie's trademark blue against a red background, or, alternately, red against a blue background. The logo on *Laugh* and the other Archie comics was a variation on the typeface Cooper Black with its inviting, comforting serifs with their round maternal goodness.

Laugh and put laughter in and on your comic books and the world will laugh with you. And buy millions of copies across multiple chuckling generations.

Along with a good laugh, the Archie covers delivered good looks. Freckle-faced, buck-toothed, carrot-topped hair with waffle-iron-on-the-sides Archie was Everyman—at best! But somewhat looks-challenged Archikins was flanked in Pop's Choklit Shoppe, or under the mistletoe, or at the beach, by the two hottest, sexiest, most beautiful girls in comicdom: Betty and Veronica.

This threesome has a distinct advantage over real-life cover girls and gents. Their looks don't fade. These paper dolls and dude are eternally wrinkle-free.

Unlike Hollywood celebs, Archie and his pals and gals aren't dependent on a skilled make-up crew, miracle-working plastic surgeons, or talented photoshoppers. Tinseltown has nothing on the "teenagetown" of Riverdale. Richard B. Stolley, a managing editor of *People* magazine, once said about covers and their resulting sales, "We know young is better than old; pretty is better than ugly." Some of the greatest artists in the world are responsible for making comics' ultimate pals and gals look amazingly young and pretty for their cover appearances.

The first Archie artist was Bob Montana. He could have been a great pinup artist of the 1940s like the famed Alberto Vargas, renowned for the "Vargas Girl," or George Petty, renowned for the "Petty Girl." After being drafted by Archie creator John L. Goldwater to visually realize the Archie characters, Montana drew sizzling covers with Archie's girlfriends equal to the work of those pinup masters' creations. The "Montana Girls" and their Guy Friend had something the other pinup masters didn't: the benefit of Bob's pitch perfect humor. His comedic skill may have been garnered when Montana toured vaudeville stages as a youngster with his entertainer parents.

Influenced by Montana, but an artist who developed his own style and an army of fans, was Dan DeCarlo. DeCarlo fused the beauty of the Girls of Riverdale with a cuteness that created an irresistibly strong appeal. Though some of his inkers were better than others, DeCarlo's freshness and an uncanny sense of fashion always showed through.

Harry Lucey has been getting his due only recently for his sense of design in the characters and composition, his hilarious pratfall action scenes and, most of all, for the expressive body language in his work. If Montana came from the stage, Lucey made the Archie characters Tony Award worthy actors on the comedy stage of Archie Comics Cover Theater.

Among Archie devotees, Montana, DeCarlo, and Lucey are the holy trinity of the old-skool. But, as this book will amply show, there were many other talented cartoonists at the time who could deliver fun covers nearly as hot and hilarious. Bill Vigoda, Samm Schwartz, Al Fagaly, Harry Sahle, Bob White, and more, all delineated fabulous funny book covers.

Standing on the shoulders of past giants are immensely talented artists like today's Dan Parent and Fernando Ruiz. This pair of cartoonists are fans of their funny founding fathers. Parent favors DeCarlo. Ruiz loves Lucey. But this dynamic duo have made their own mark continuing the grand guffaws in the Archie cover tradition.

Thanks to the generosity of collectors, we are thrilled to present the original art to a number of the covers herein. The subtleties of the artists' craft can be examined and enjoyed. Every #2 sable Winsor-Newton brush stroke of the Higgins Black India Ink can be seen put there by master hands. Even most of the contemporary Archie artists do it old style rather than relying on digital approaches. Ain't nuthin' like the real thing, baby!

Fortunately, printer's proofs are extant for a number of primo 1960s covers so this book has some color reproductions of incredible vibrancy and fidelity as close to perfection as any book could ever hope for. In some instances, the black plate from these proofs has been scanned for special examination and enjoyment of the smooth "clear line" art at which the Archie artists are masters.

Comics fans will see the whole visual history of the Riverdale pack. There will be a number of surprises, there's some unusual subject matter, many of the covers are super sexy, and, maybe the biggest surprise of all, Archie's first cover appearance was a mere small bit on a superhero cover. Archie soon took over, though. The company even took the name of the Andrews boy himself. Archie didn't need to wear superhero long johns to win the battle for truthful titters, just jokes, and the American Way of Levity. (Though, as part of this important mission to generate chortles, Archie DID, in the 1960s, become Pureheart the Powerful in response to the *Batman* TV show frenzy that swept the country).

Students of fads, culture, and social movements will find much to consider in the offerings found in *The Art of Archie: The Covers*. Teenagers are the early adopters of cool fashion, music, electronics, and slang. Archie and crew have always reflected that throughout the decades. But it must be kept in mind that first and foremost this book is about art in the service of humor. Before the brainiacs fill their head bones with insightful intellectual revelations, they should let the comedic covers tickle their funny bones. You'll see that early covers hailed Archie as "The Mirth of A Nation." And our nation and the whole world could use some good healing laughter these days.

And on the laugh front... Archie's got you covered!

—Craig Yoe
 Cartoonist and Comics Historian

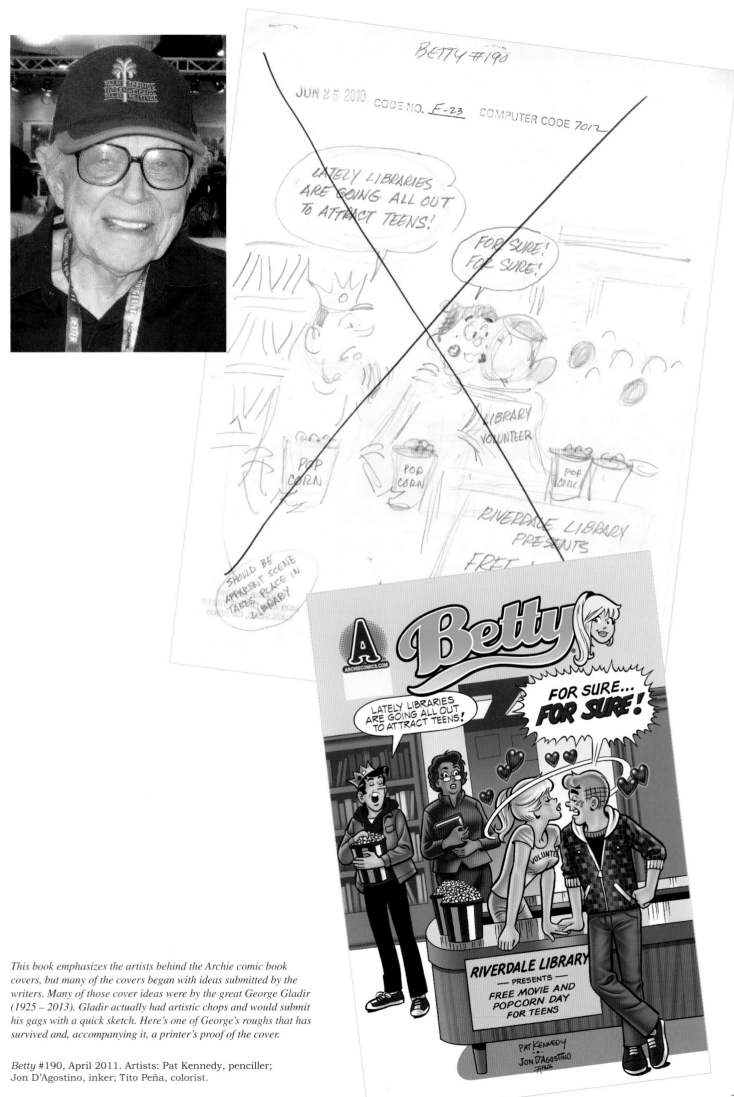

This book emphasizes the artists behind the Archie comic book covers, but many of the covers began with ideas submitted by the writers. Many of those cover ideas were by the great George Gladir (1925 – 2013). Gladir actually had artistic chops and would submit his gags with a quick sketch. Here's one of George's roughs that has survived and, accompanying it, a printer's proof of the cover.

Betty #190, April 2011. Artists: Pat Kennedy, penciller; Jon D'Agostino, inker; Tito Peña, colorist.

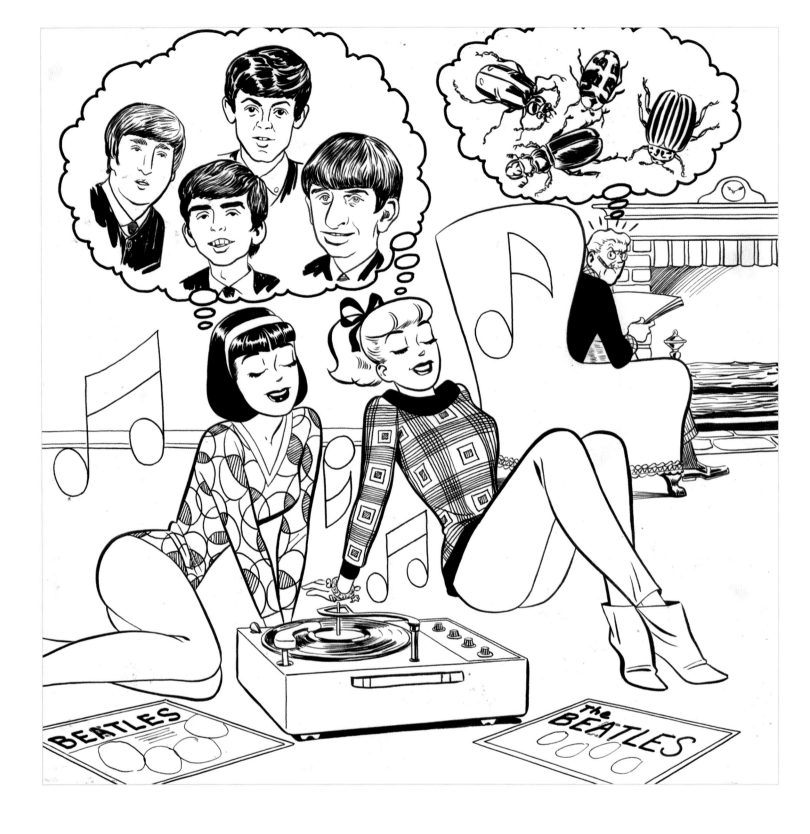

After a cover idea was accepted, it was turned over to the artist who began with pencils and finished the drawing off with India ink on a heavy Bristol board. Here Harry Lucey creates one of Archie's most famous covers: a wry comment on the generation gap of the 1960s, starring Betty, Veronica, and John, Paul, George, and Ringo... the Beatles!

Look carefully to see how the fab four's name was spelled "Beetles" on the art but was corrected before going to press.

On the right hand page are the progressive proofs produced by Chemical Color Plate Corp. for the Archie staff to check over. The proofs demonstrate how the final cover is composed of yellow, red, blue, and black to achieve the final "music for your eyes!" Yeah! Yeah! Yeah! The composite proof is on the overleaf. The final printed cover can be seen on page 43.

Laugh Comics #166, January 1965. Artist: Harry Lucey. Original art from the collection of Craig Yoe.

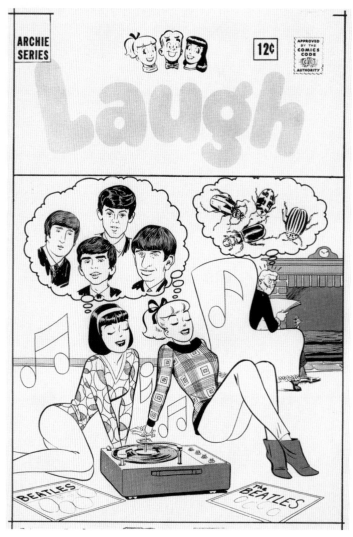

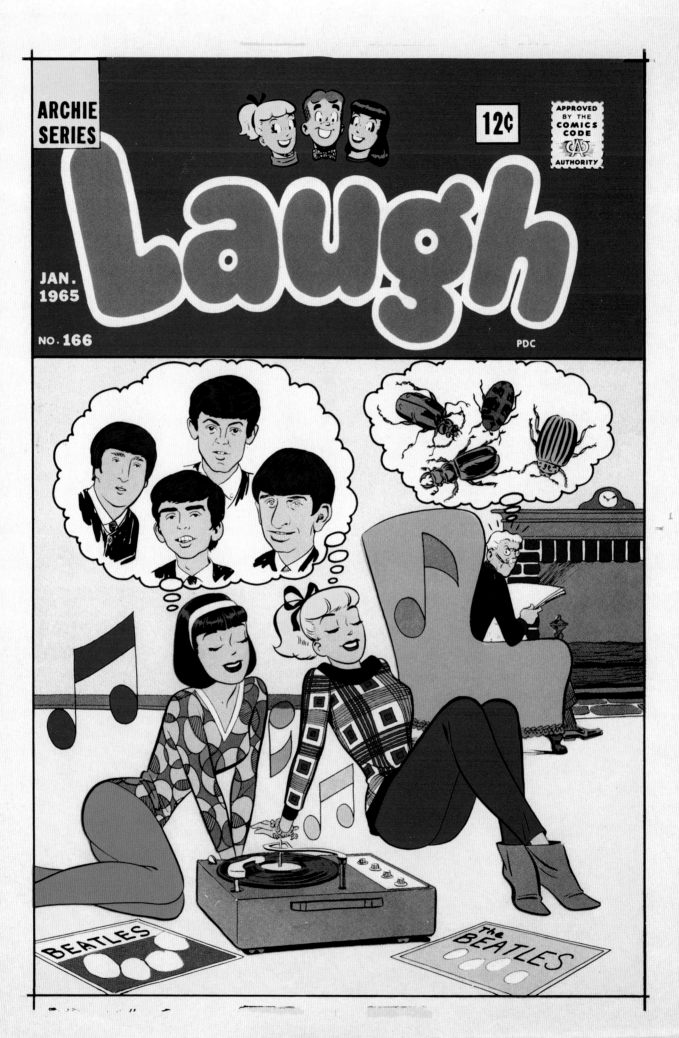

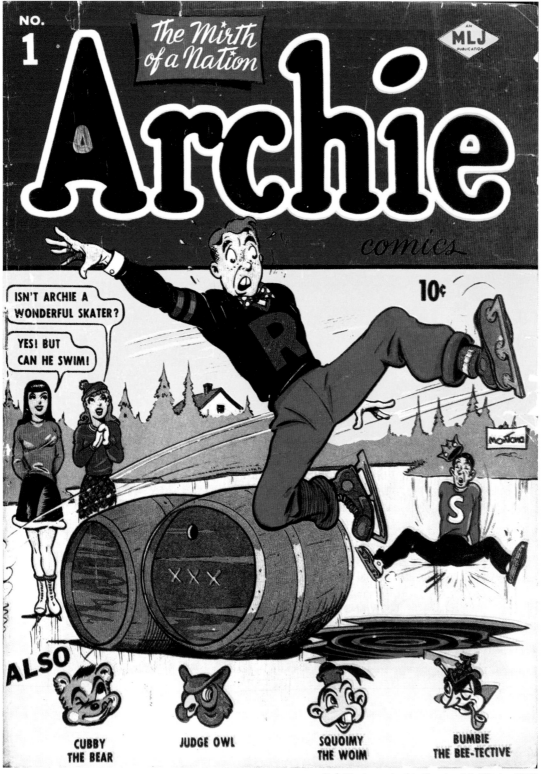

Bob Montana, Archie Comics #1, Winter 1942

IN THE BEGINNING...

One year after Archie made his first appearance in *Pep Comics* #22, *Archie Comics* #1 was published in 1942. The cover was drawn by Bob Montana, sending a clear message that Betty and Veronica have Archie jumping over a barrel in more ways than one. On the upper right hand corner, you'll notice a diamond shape with the letters "MLJ." MLJ Magazines was the name of the publishing company a the time. The letters represents the first name of each partner: Maurice Coyne, Louis H. Silberkleit, and John L. Goldwater. With the phenomenal success of Archie, four years later in 1946, the name of the company was changed to Archie Comic Publications, Inc.

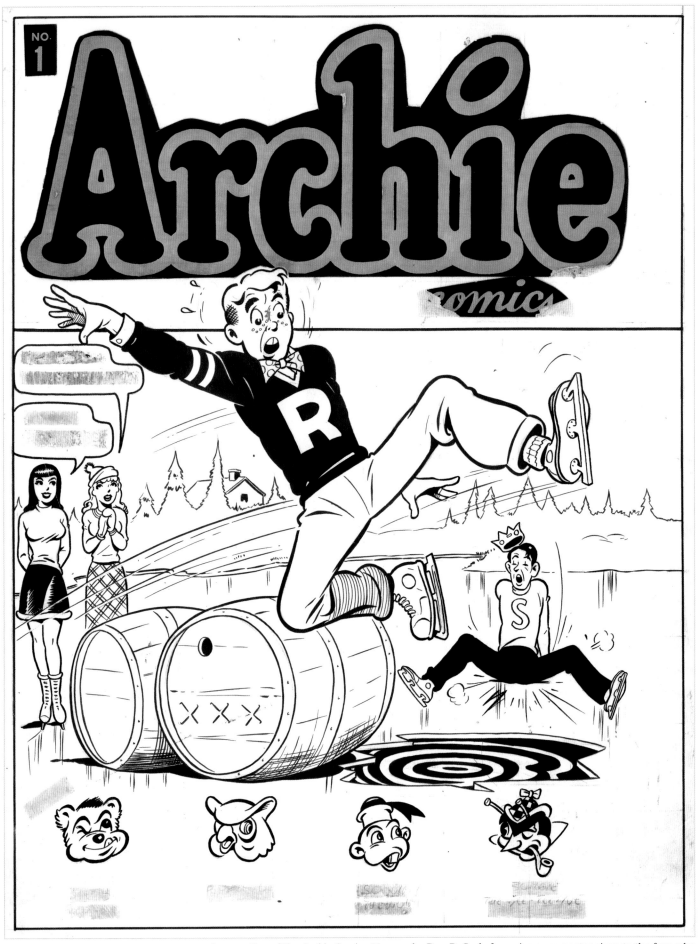

A recreation of the *Archie Comics* #1 cover by Dan DeCarlo for a give-away poster given to the fans who ordered by mail an *Archie Annual* #25 (1973-74).

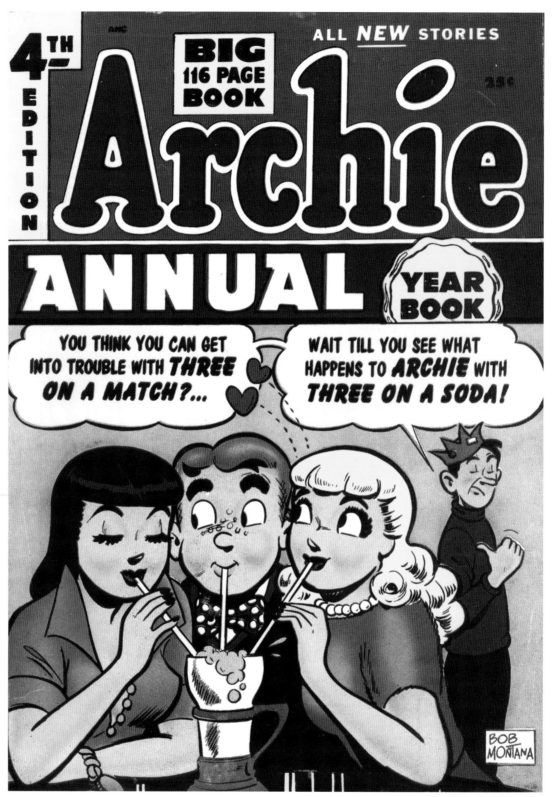

Bob Montana, Archie Annual #4, 1952

A MATCHLESS COVER!

A strong contender for the greatest and most beloved Archie cover of all time is the "three on a soda" image drawn by Bob Montana for *Archie Annual* #4. Jughead's comment about "three on a match" refers to an old expression going back to a pre-World War I superstition, that if three soldiers share a match to light up then the last one gets shot and dies. It's not the words or Jughead's cynicism that carries this iconic cover, but the delightful visual depiction of the love triangle of Archie, Betty, and Veronica, probably at Pop Tate's Soda Shop, happily pausing for refreshment. The endearing scene has been re-imagined by a number of Archie artists for subsequent covers and Dan DeCarlo even drew a version for a U.S. postage stamp!

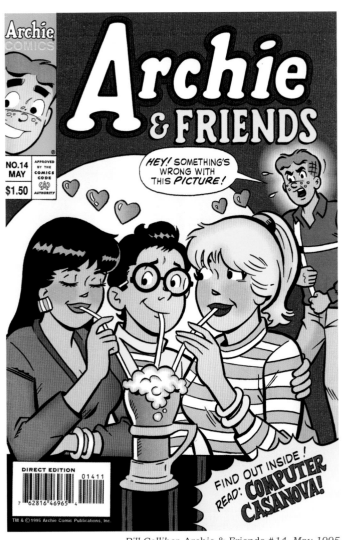

Bill Golliher, Archie & Friends #14, May 1995

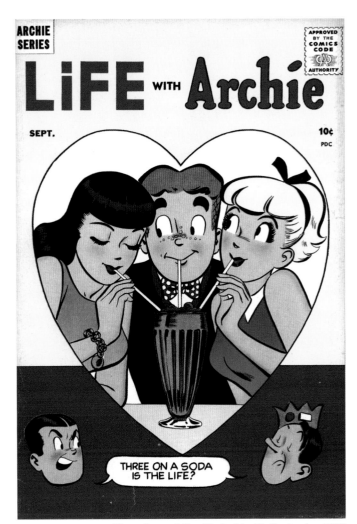

Harry Lucey, Life with Archie #2, September 1952

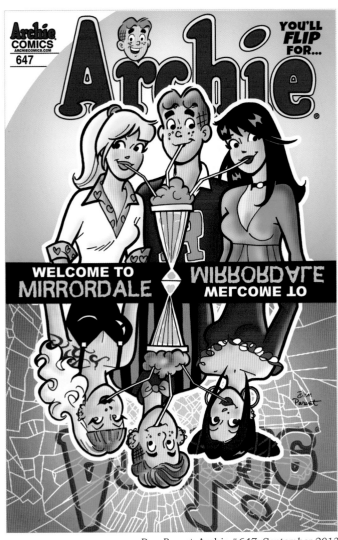

Dan Parent, Archie #647, September 2013

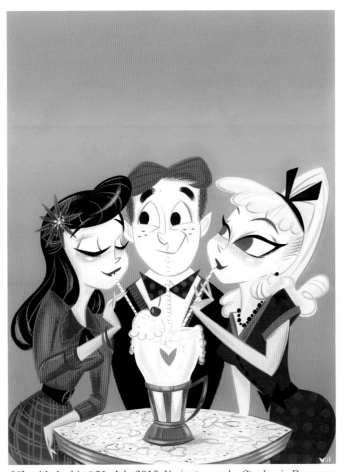

Life with Archie #31, July 2013. Variant cover by Stephanie Buscema.
Reproduced from the original art from the collection of Steve Barghusen.

ARCHIE COVER ARTIST
BOB MONTANA

Bob Montana (1920 – 1975)

Fate must have predetermined that Bob Montana was to be an entertainer when he was born in Stockton, California, to his dad, a banjo player in vaudeville, and his mom, a Ziegfeld Follies dancer. The family name Montana was a stage moniker. While performing and traveling with his parents and sister, Bob met cartoonists performing on stage—like Fay King—and baggy pants comedians who were all a big influence over the young boy. Bob attended Haverhill High School in Massachusetts, where he kept illustrated diaries which eventually served as a basis for his work on Archie. Before designing the Riverdale high schoolers, Montana cut his teeth at MLJ on the superheroes that preceded them. Montana was an incredible draftsman as well as a very funny writer as you'll see from his covers. This one-two creative punch served him well when he eventually focused on doing the *Archie* comic strip for King Features Syndicate.

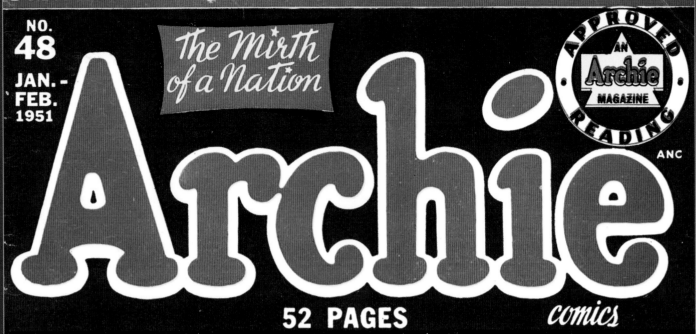

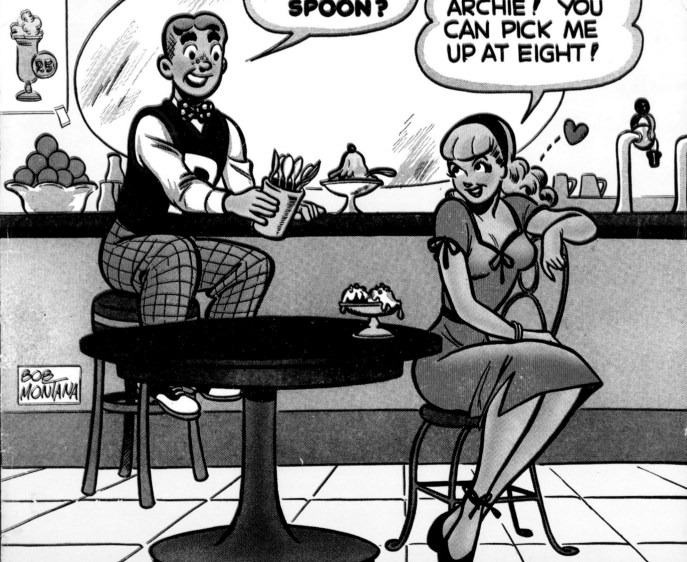

Bob Montana, Archie Comics #48, January-February 1951

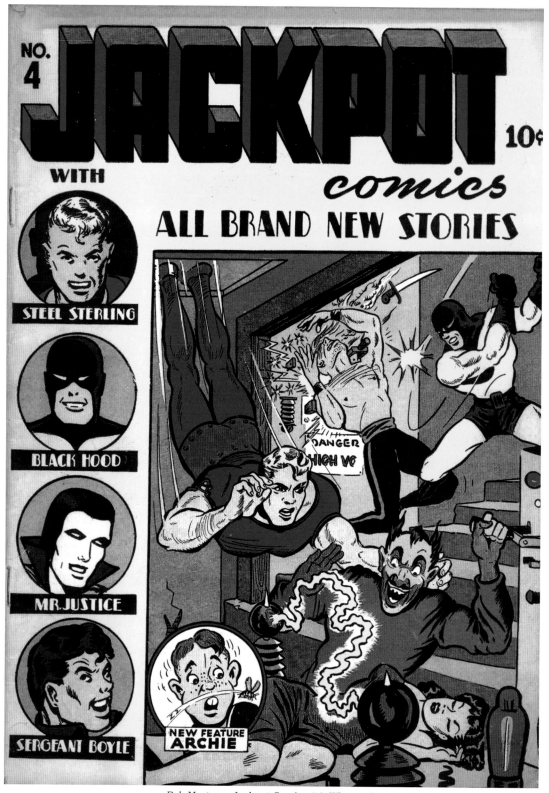

Bob Montana, Jackpot Comics *#4, Winter 1941. Archie's first cover appearance.*

WHO'S ON FIRST?!

Comic historians and collectors like to determine the first appearances of major and secondary characters in stories and on covers. At the original MLJ publishing company, Archie started amazingly just as a back-up feature in *Pep* #22 (December, 1941). Soon after, our auburn-haired hero's first cover shot was in a very small circle on *Jackpot* #4 (Winter, 1941), making room for the superheroes and their fisticuffs. In a short while, Archie became The Mirth of a Nation and dominated the covers. Following are the first fascinating cover appearances of Archie's pals and gals.

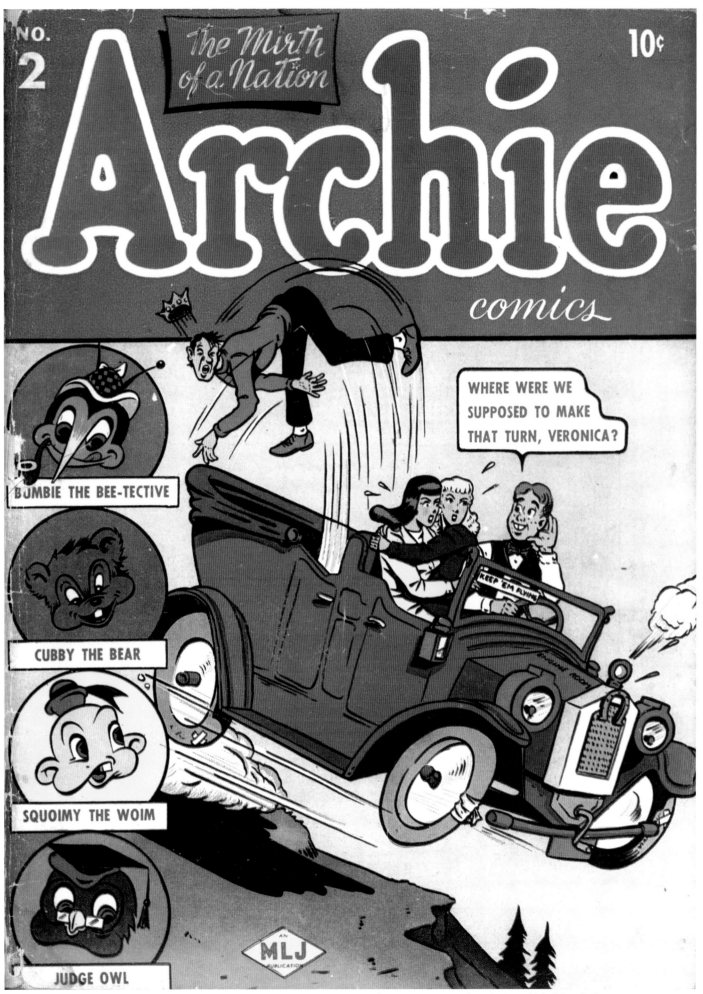

Bob Montana, Archie Comics #2, Spring 1943. Archie's jalopy's first cover appearance.

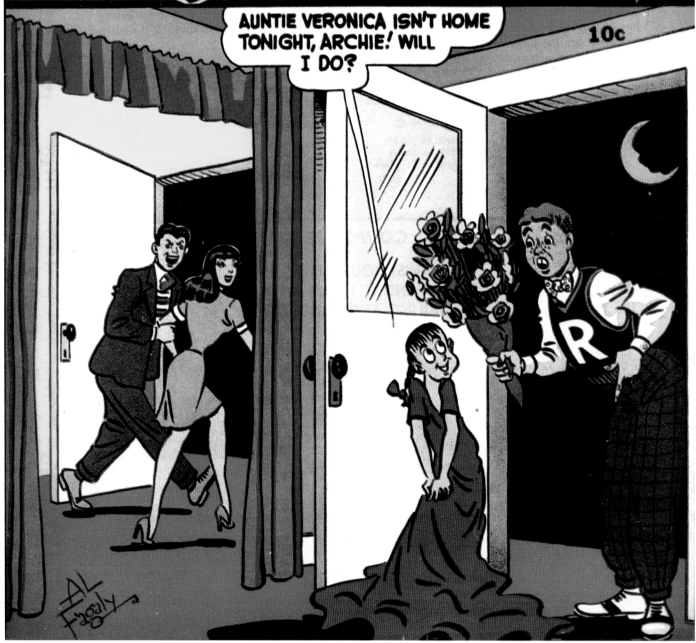

Al Fagaly, Pep Comics #57, *June 1946. Reggie's first cover appearance.*

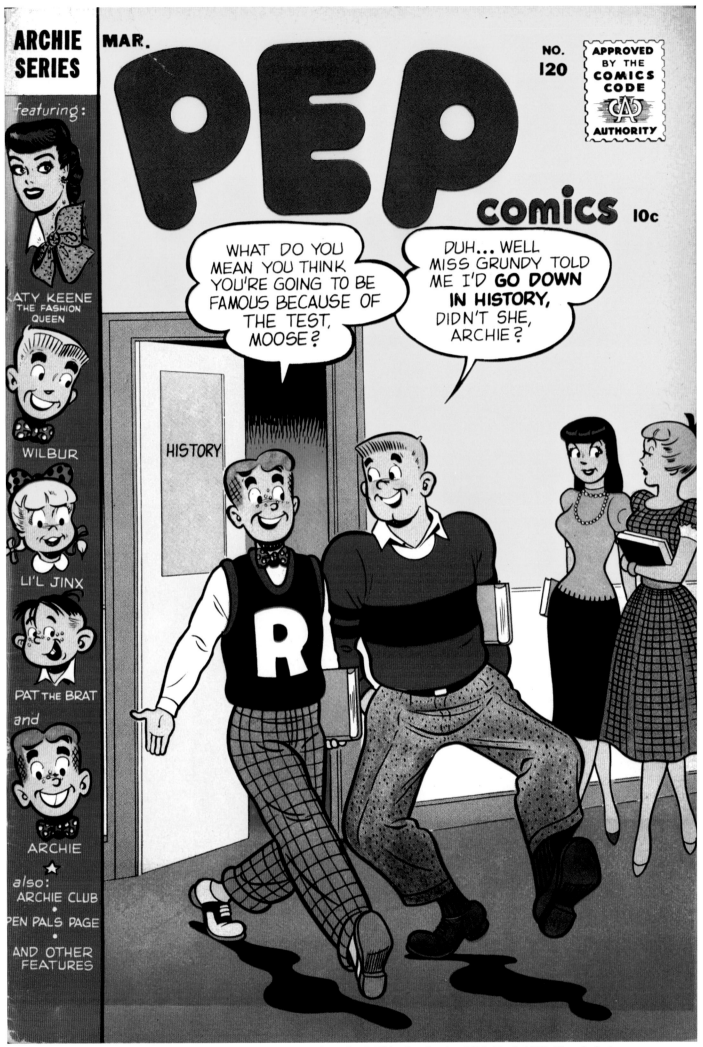

Joe Edwards and Bob White, Pep Comics *#120, March 1957. Moose's first cover appearance.*

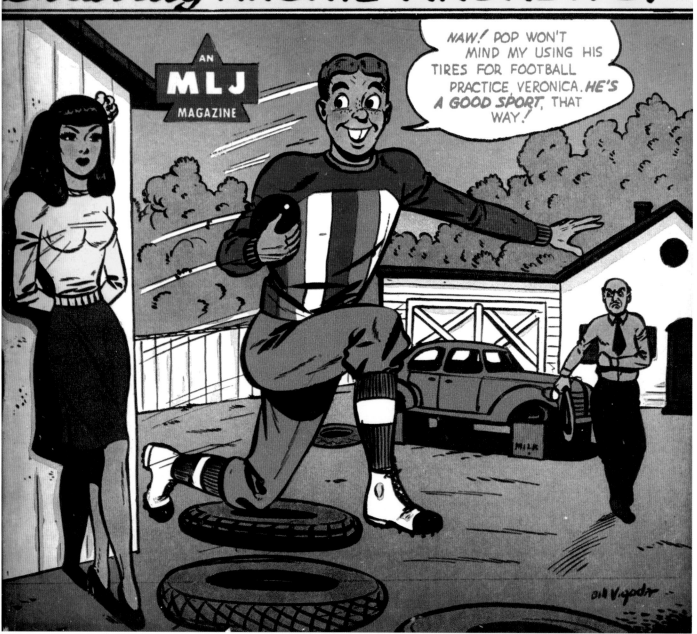

Bill Vigoda, Pep Comics #51, December 1944. Archie's dad, Fred Andrews' first cover appearance.

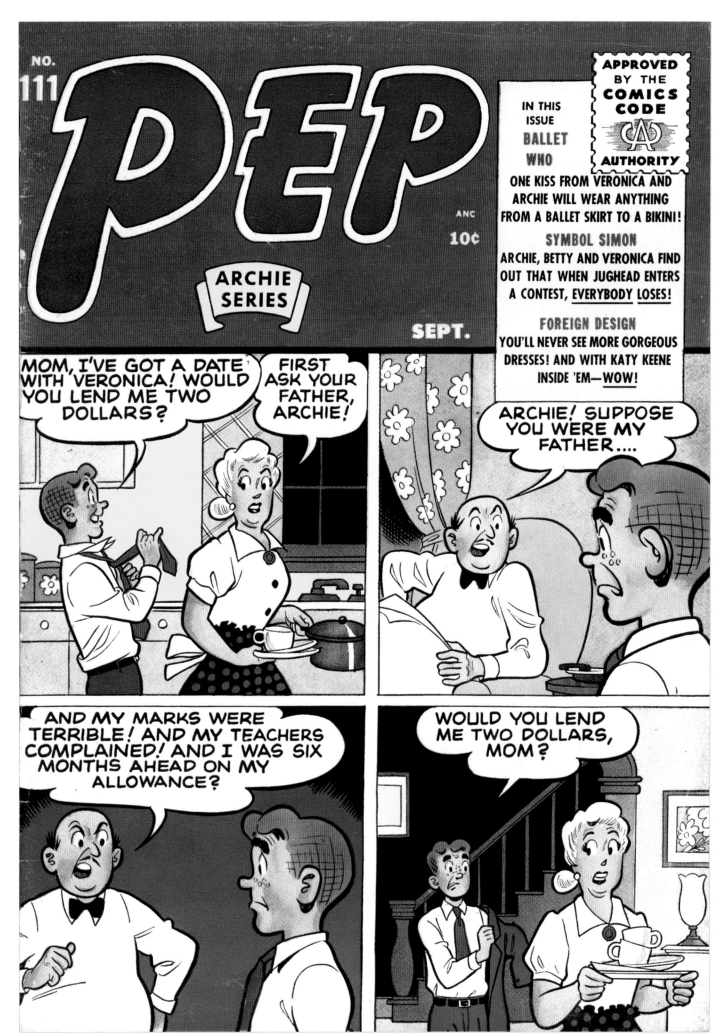

Samm Schwartz, Pep Comics #111, September 1955. Archie's mom, Mary Andrews' first cover appearance.

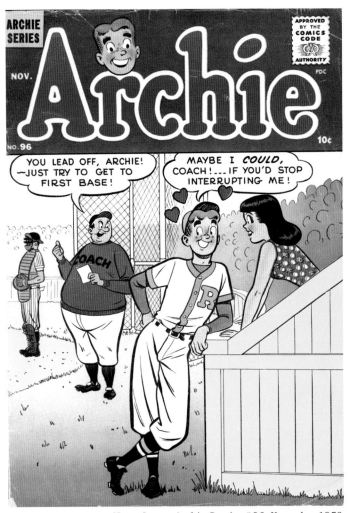

Harry Lucey, Archie Comics #96, November 1958.
Coach Kleats' first cover appearance.

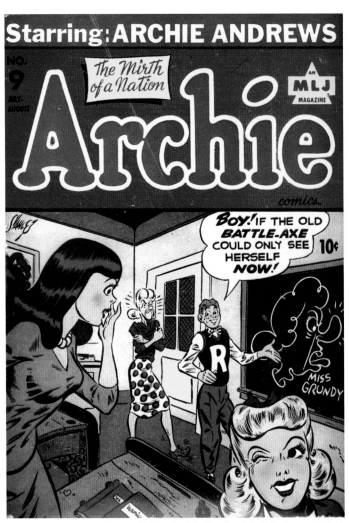

Harry Sahle, Archie Comics #9, July-August 1944.
Miss Grundy's first cover appearance.

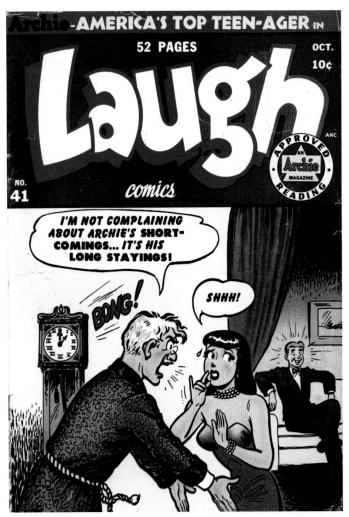

Bill Vigoda, Laugh Comics #41, October 1950.
Hiram Lodge's first cover appearance.

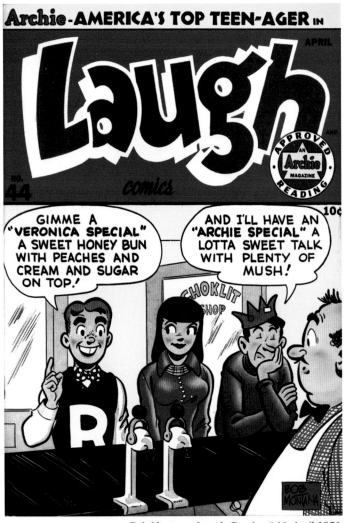

Bob Montana, Laugh Comics #44, April 1951.
Pop Tate's first cover appearance.

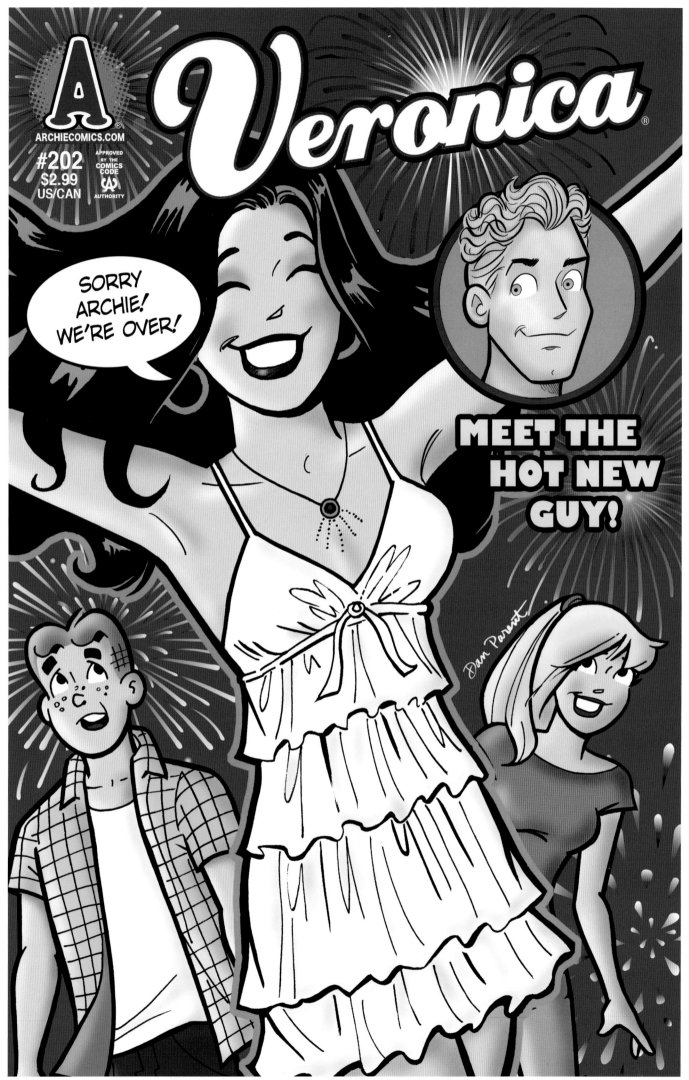

Dan Parent, Veronica #202, November 2010. Like Archie, Kevin Keller's first cover appearance was in a little circle.

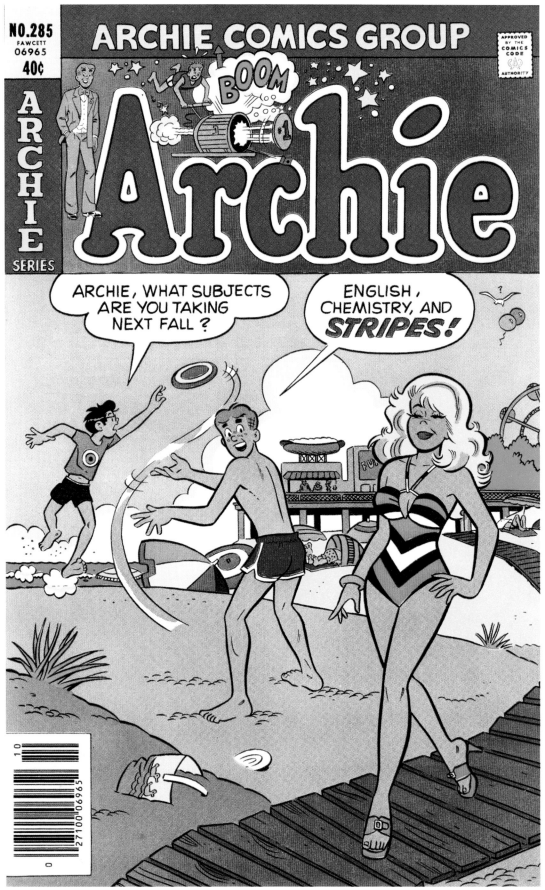

Dan DeCarlo, Archie #285, October 1979

IN THE SWIM

Long before *Sports Illustrated* started their swimsuit editions, the Archie gang was making waves with their hot beach fashions. Every summer fans eagerly buy up the many annual comics featuring scintillating covers of our bathing beauties and diving dudes of Riverdale. Do the Riverdale boys look hot in their swimsuits and do Betty and Veronica rock their bikinis? For the answer to this vital question of our times, one only has to feast his or her eyes on these funny book covers.

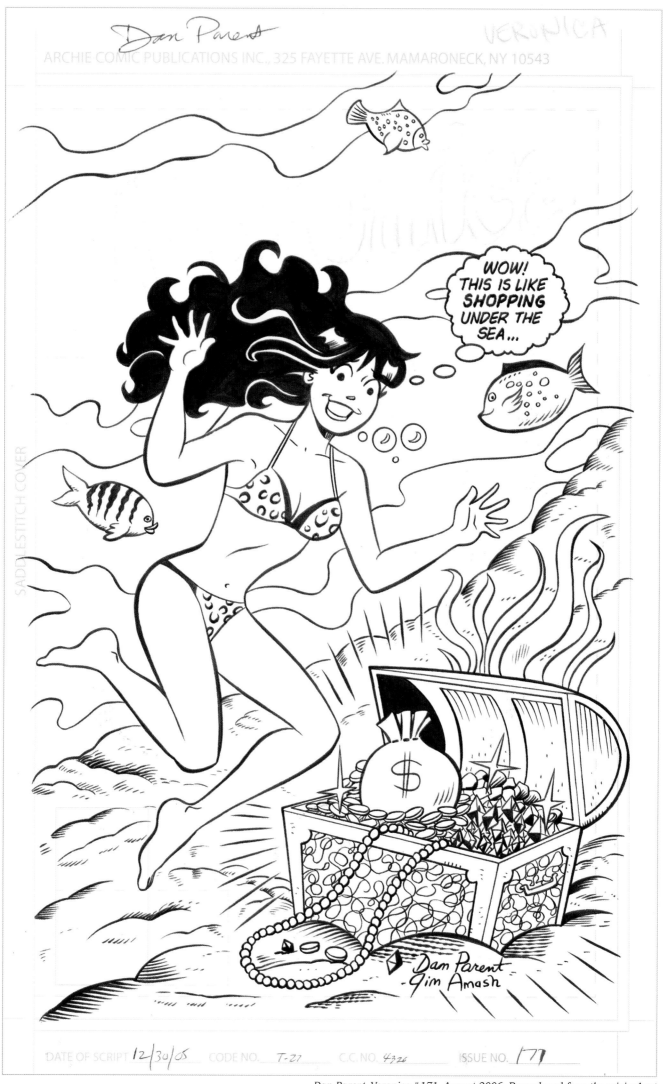

Dan Parent, Veronica #171, August 2006. Reproduced from the original art from the collection of Arthur Chertowsky.

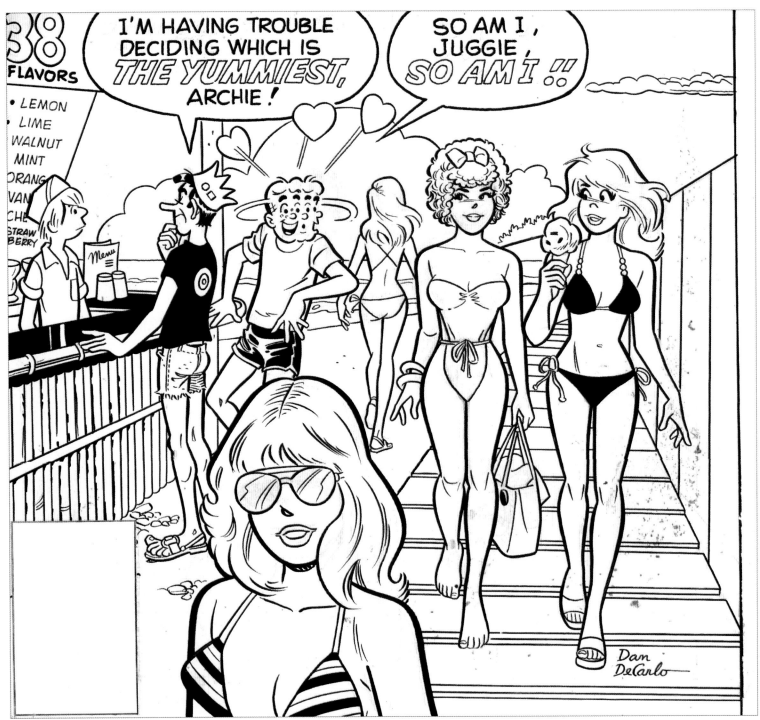

Dan DeCarlo, Everything's Archie *#95, August 1981. Reproduced from the original art from the collection of Nick Katradis.*

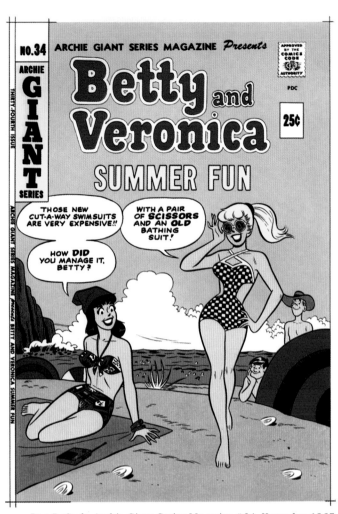

Dan DeCarlo, Archie Giant Series Magazine #34, November 1965.
Reproduced from the printer's proof.

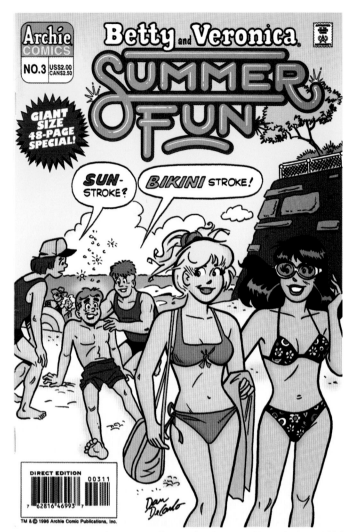

Dan DeCarlo, Betty and Veronica Summer Fun #3, June 1996

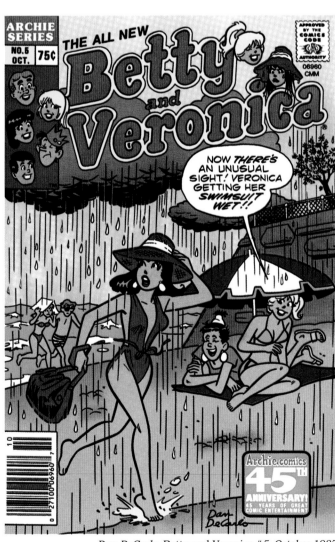

Dan DeCarlo, Betty and Veronica #5, October 1987

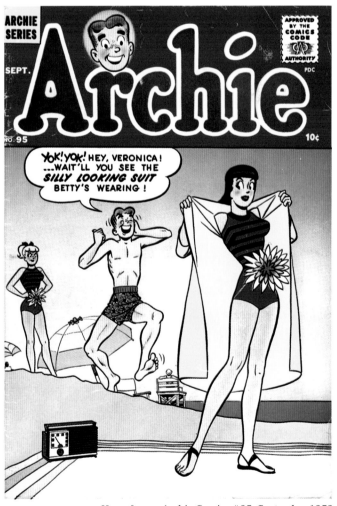

Harry Lucey, Archie Comics #95, September 1958

ARCHIE COVER ARTIST
BILL VIGODA

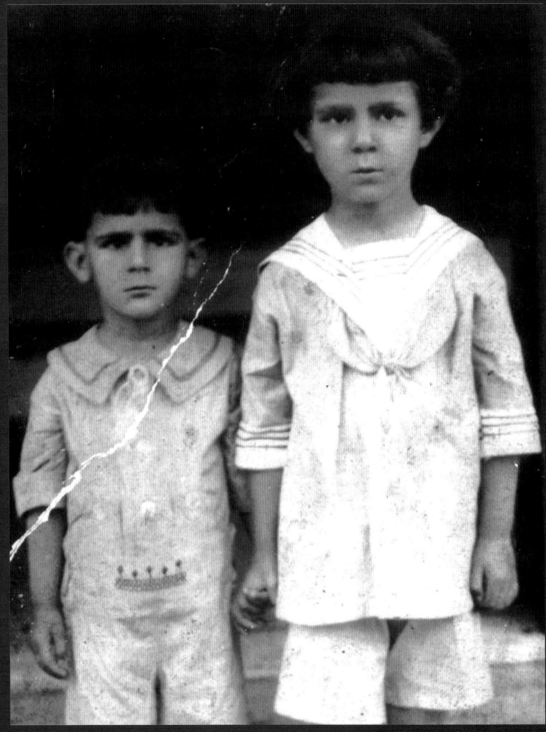

Bill Vigoda (1920 – 1973), right, with his brother Abe.
From the collection of Shaun Clancy.

Born in Brooklyn, Bill Vigoda studied at the Commercial Art Studios in New York City. In March 1943, he married his wife, Anita. Bill began his career in comics a few months later, when he started working at MLJ/Archie Comics in June 1943. Vigoda's work appeared in almost all of the Archie titles, especially in the 1940s, because many of his fellow artists were drafted. Vigoda wrote, penciled, inked, and lettered many of his covers. In the mid-'60s, Archie and his friends were often featured as superheroes. Bill was perfect for drawing adventure comics plus he was very fast, turning out 20 to 30 pages a week.

Bill's brother Hy was a writer for Archie Comics and his brother Abe is an actor beloved for his portrayal of Detective Fish on the TV series *Barney Miller*.

Bill Vigoda, Archie Comics #59, November December 1952

Al Fagaly, Pep Comics #56, March 1946

DÉJÀ VU ALL OVER AGAIN

Some covers are just so good that Archie has occasionally brought back the gags to be enjoyed by another generation of fans. In the new incarnations, the fashions are updated. In the composition, the artist recreating the cover might make slight changes. But the timeless humor remains intact. It's great fun to examine the similarities and differences on the covers that are created when the Archie artists hit the "re-do" button!

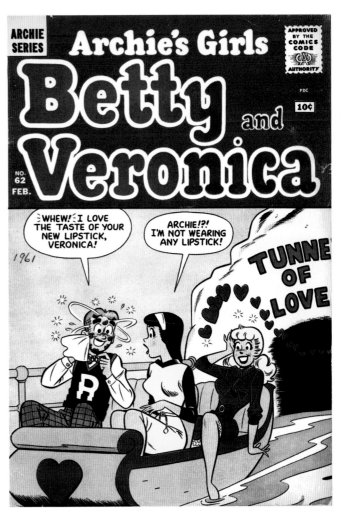

George Frese, Archie's Girls Betty and Veronica #3, September 1950

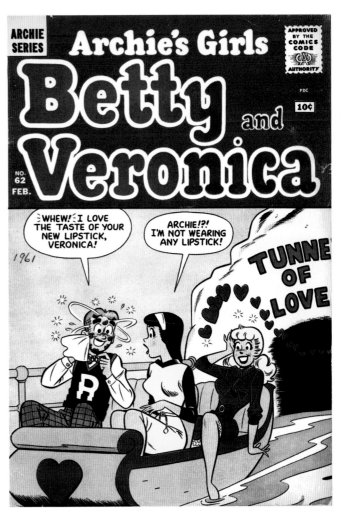

Dan DeCarlo, Archie's Girls Betty and Veronica #62, February 1961

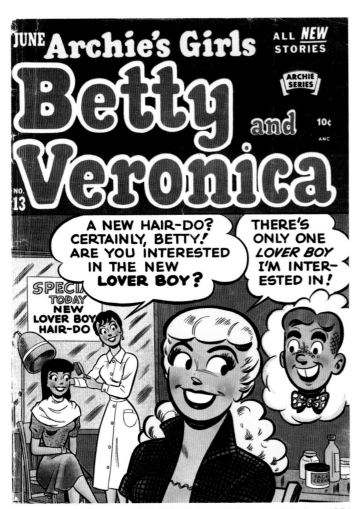

George Frese, Archie's Girls Betty and Veronica #13, June 1954

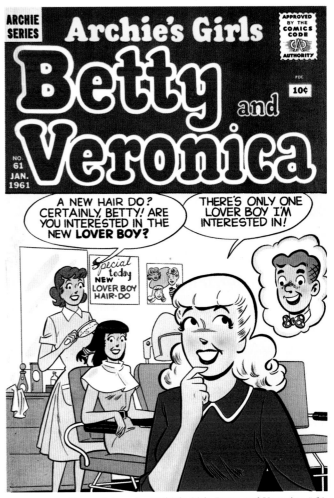

Samm Schwartz, Archie's Girls Betty and Veronica #61, *January 1961*

Attributed to George Frese, Archie's Girls Betty and Veronica #1, *March 1950*

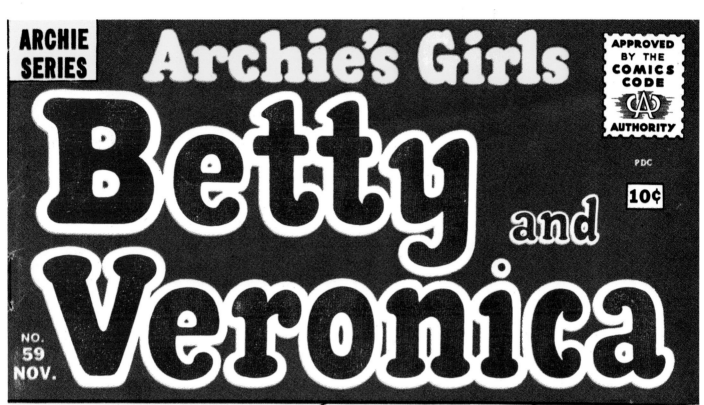

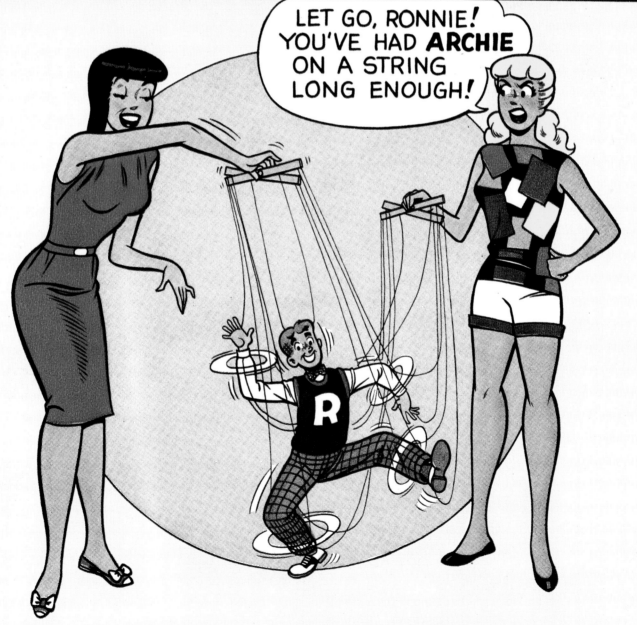

Bob White, Archie's Girls Betty and Veronica #59, November 1960

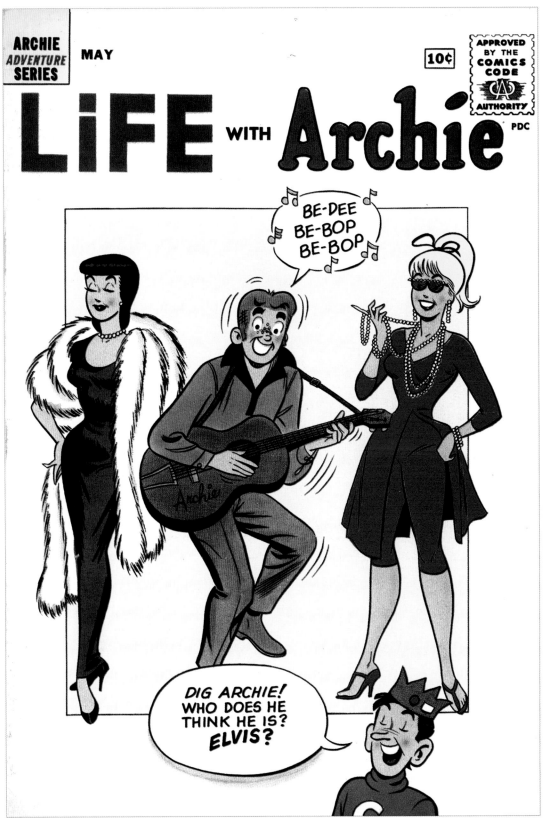

Bob White, Life with Archie #8, May 1961

ROCK 'N' ROLL!

The musical group The Archies was awarded a gold record for their bouncy song "Sugar Sugar" in 1969. Throughout the publishing history of Archie and his pals and gals there have been many nods to other hit acts from Elvis to the Beatles. Elvis was a fan of Archie comics and was photographed reading an issue of *Betty and Veronica* on his 1956 tour. The iconic cover on the right was drawn by Harry Lucey, who himself was more of a classical music fan, but still deftly captured the spirit of rock 'n' roll! Teenagers and rock music are forever entwined both in life and on the covers of Archie comics!

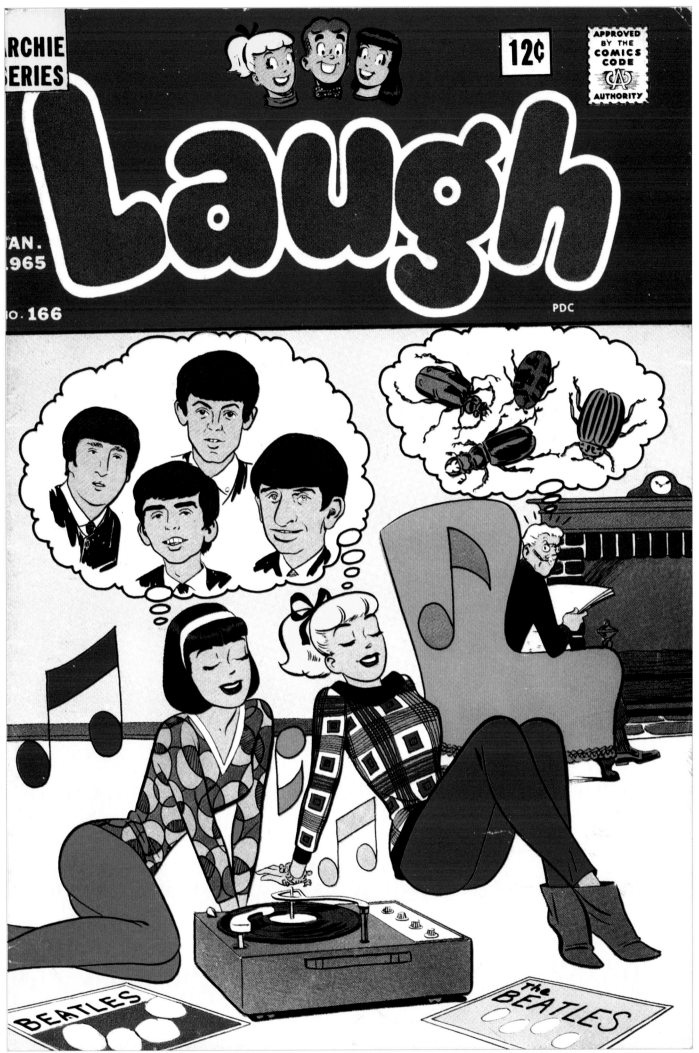

Harry Lucey, Laugh Comics #166, January 1965

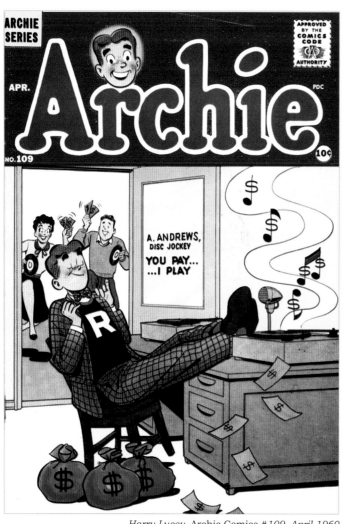

Harry Lucey, Archie Comics #109, April 1960

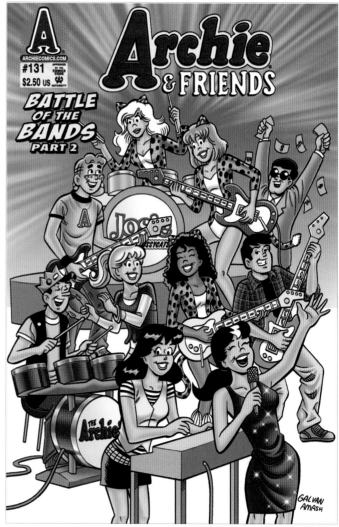

Bill Galvan, pencils, Jim Amash, inks; Archie & Friends #131, July 2009

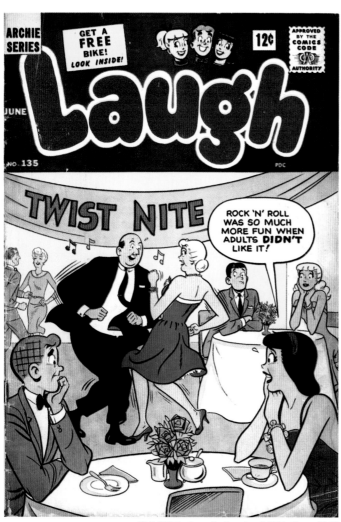

Bob White, Laugh Comics #135, June 1962

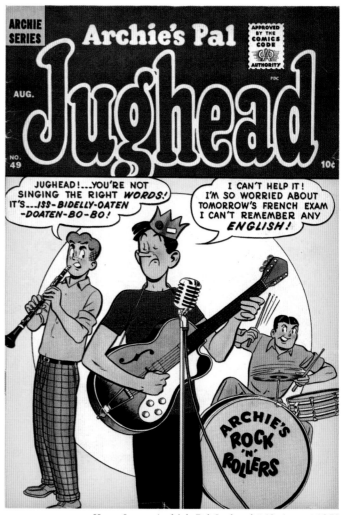

Harry Lucey, Archie's Pal Jughead #49, August 1958

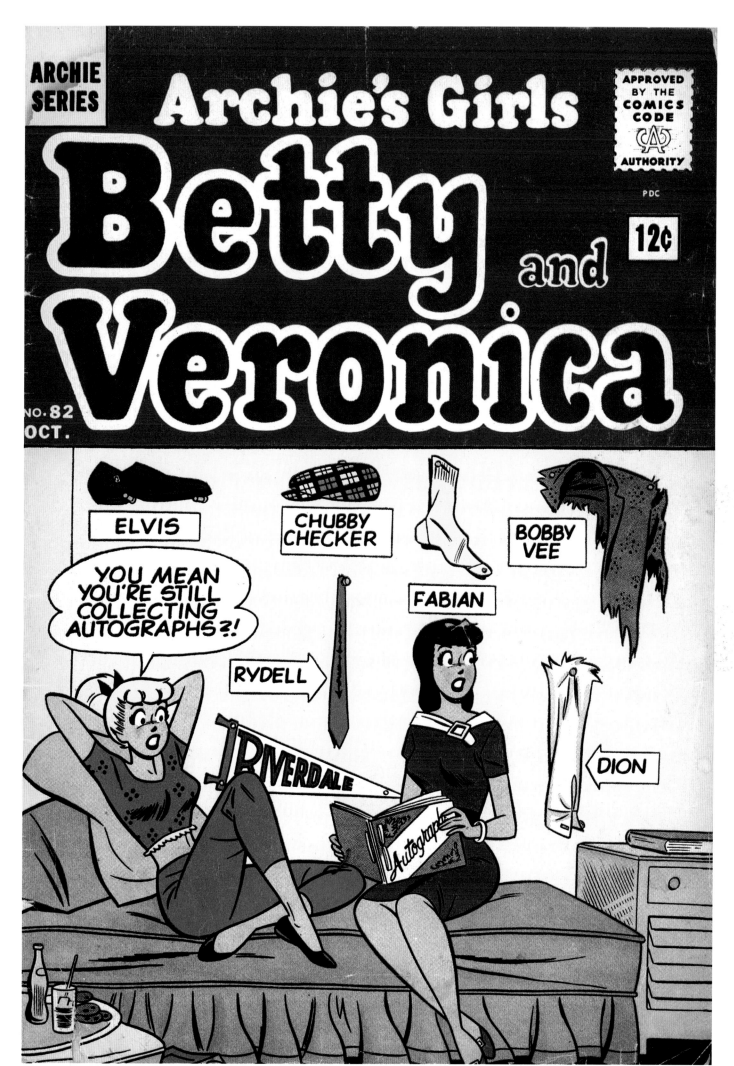

Dan DeCarlo, Archie's Girls Betty and Veronica #82, October 1962

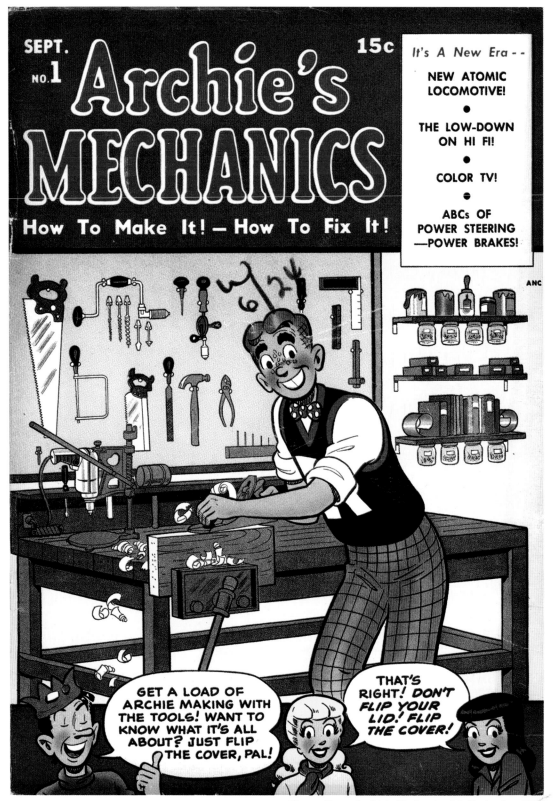

George Frese, Archie's Mechanics #1, September 1954

ARCHIE'S MECHANICALLY INCLINED

For many decades magazines like *Popular Science* and *Popular Mechanics* were extremely, well... popular! Archie Comics invented the idea of combining the Archie characters with a periodical in that genre—it wasn't rocket science! But the experiment unfortunately failed. The hybrid wasn't popular enough to last more than three issues. The *Archie's Mechanics* comic/magazine is now one of the rarest and most sought after collectibles by Archie fans.

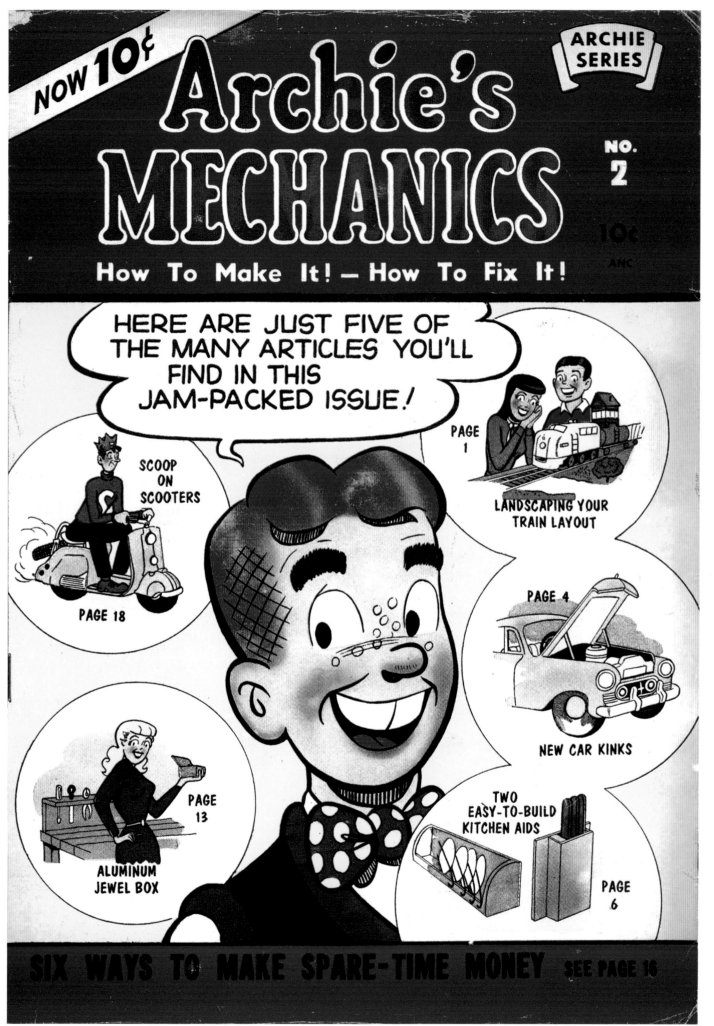

George Frese, Archie's Mechanics #2, 1954

ARCHIE COVER ARTIST
AL FAGALY

Al Fagaly (1909 – 1963). From the collection of Shaun Clancy.

Al Fagaly, with his four brothers and one sister, grew up in Vancouver, Washington. Al and his neighbor and boyhood pal Basil Wolverton both grew up to be cartoonists. After a brief move to California, Al returned to Vancouver where he did cartoons for the newspaper the *Vancouver Columbian*. Fagaly moved to the cartooning capital of the world, New York City, where he was roommates with comic book writer, soon to be famous pulp fiction detective writer, Mickey Spillane. Wolverton, Spillane, and Fagaly worked for Timely Comics, the precursor of Marvel, Al doing art on their signature characters Captain America and Human Torch. Later, Fagaly became involved with MLJ and drew well over 100 covers. On *Pep Comics* #67, Fagaly snuck in a self-caricature. He's the dapper gent on the left.

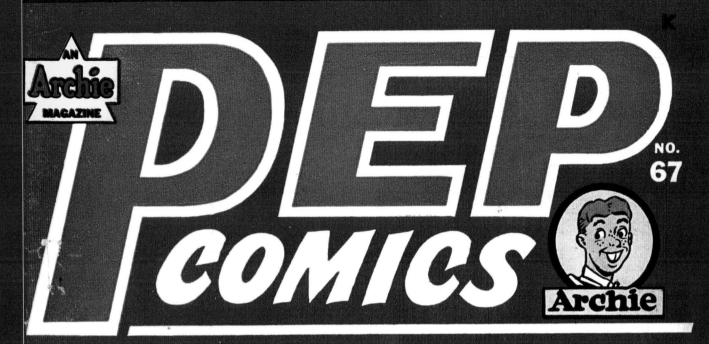
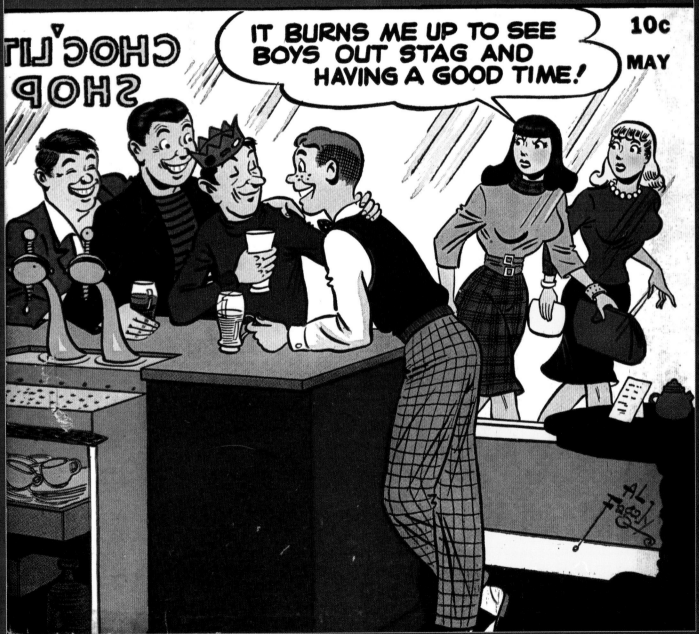

Al Fagaly, Pep Comics #67, May 1948

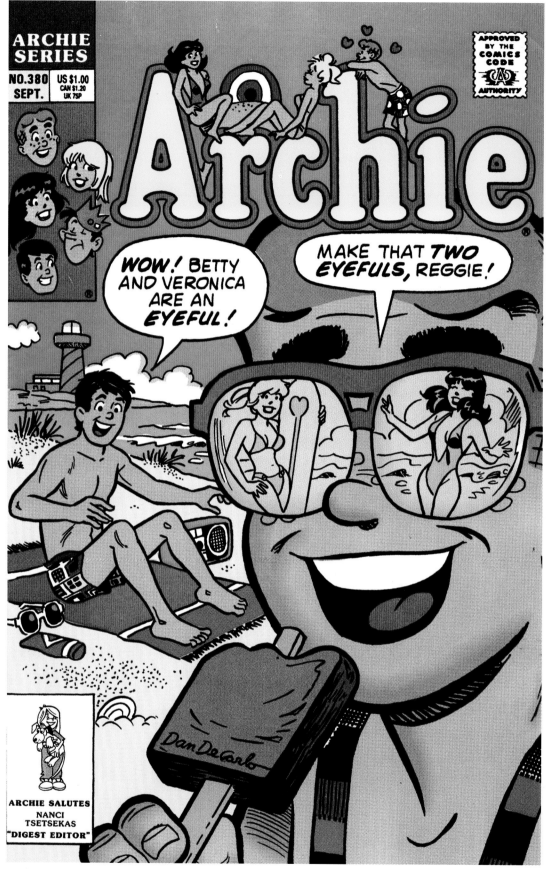

Dan DeCarlo, Archie #380, September 1990

FAN FAVES

Actors and musicians recognized at award shows always are quick to express their deep gratitude for the fans. Without the fans, what would celebrities do? That goes for the comic book celebs Archie, Betty, Veronica, Jughead, Reggie, and Kevin, too. When *The Art of Archie: The Covers* was conceived, the first order of business was to reach out to the fans to have them involved by suggesting their favorite covers. There was such a great response with most excellent choices which are presented here.

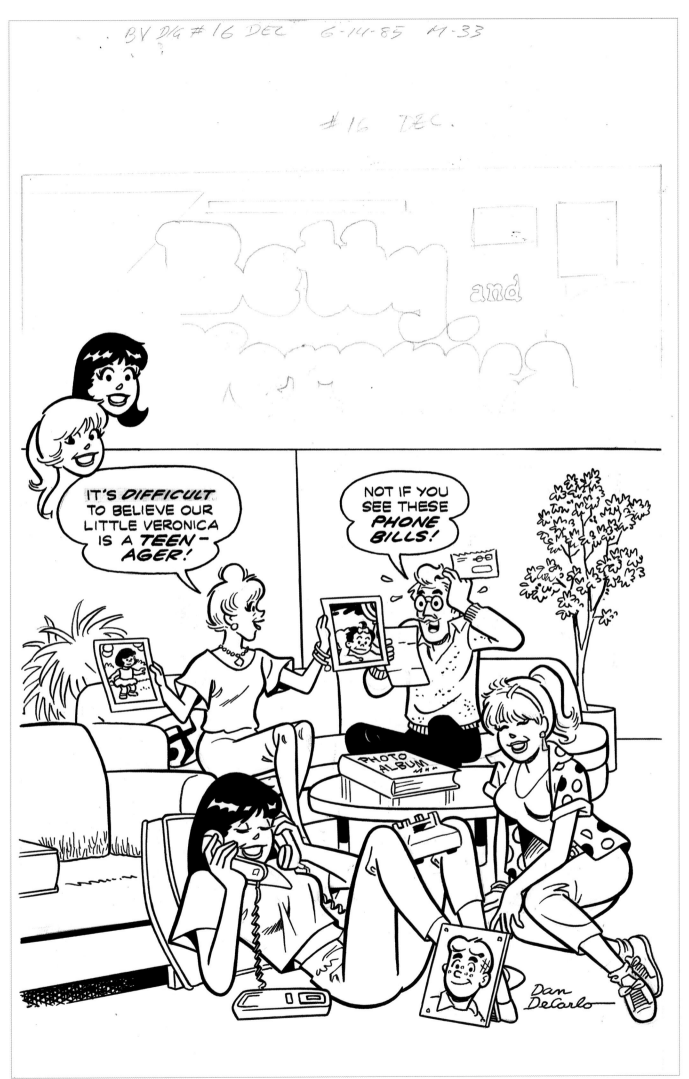

Dan DeCarlo, Betty and Veronica Comic Digest Magazine #16, *December 1985. Reproduced from the original art from the collection of Karl-Erik Lindkvist.*

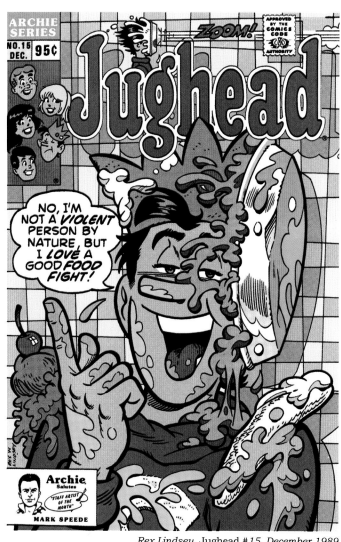

Rex Lindsey, Jughead #15, December 1989

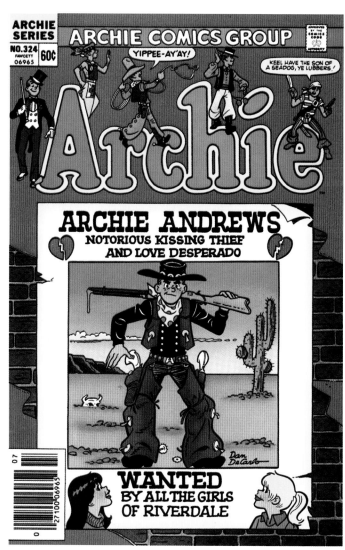

Dan DeCarlo, Archie #324, July 1983

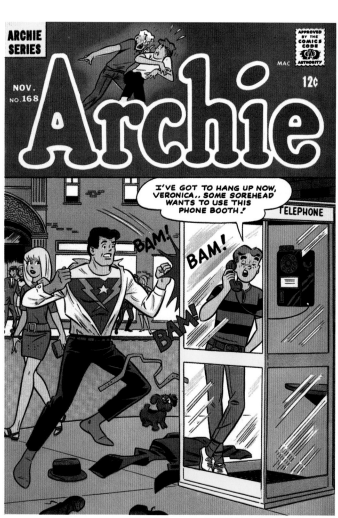

Dan DeCarlo, Archie #168, November 1966

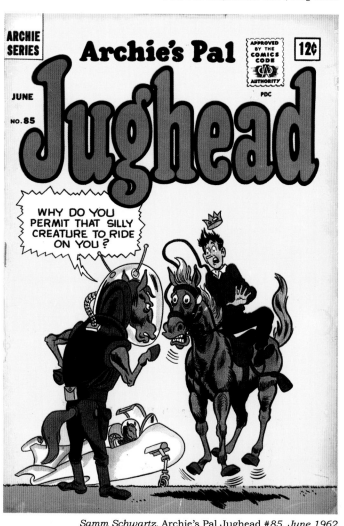

Samm Schwartz, Archie's Pal Jughead #85, June 1962

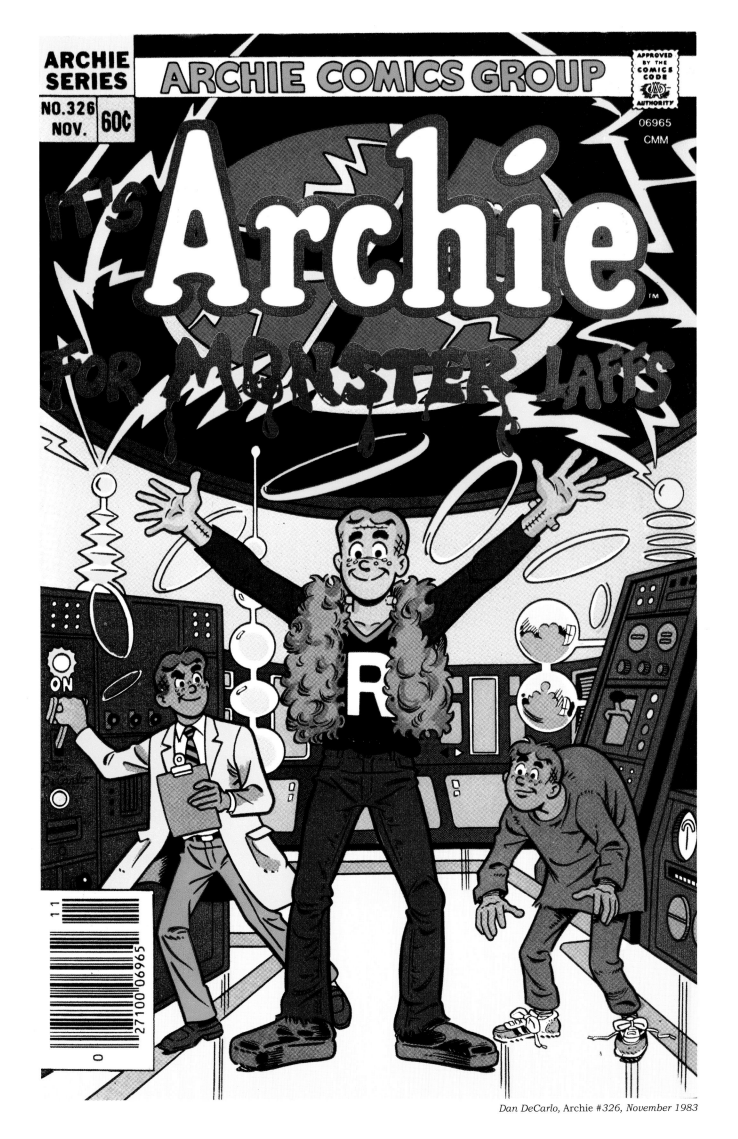

Dan DeCarlo, Archie #326, November 1983

Bill Vigoda Pep Comics #96, March 1951

Dan Parent, Jughead Double Digest #159, June 2010

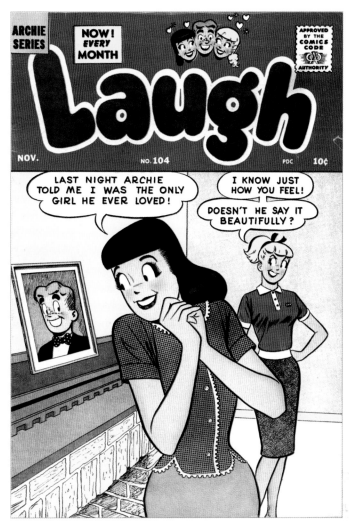

Harry Lucey, Laugh Comics #104, November 1959

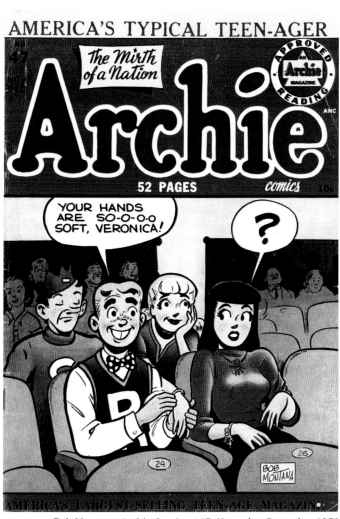

Bob Montana, Archie Comics #47, November-December 1950

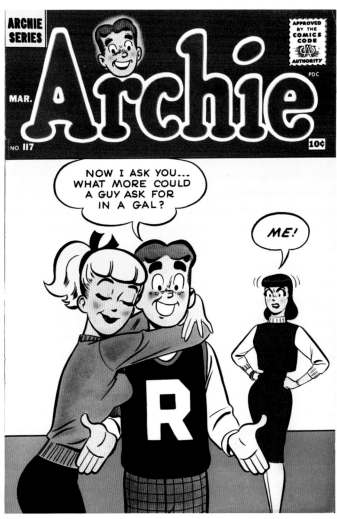

Harry Lucey, Archie #117, March 1961

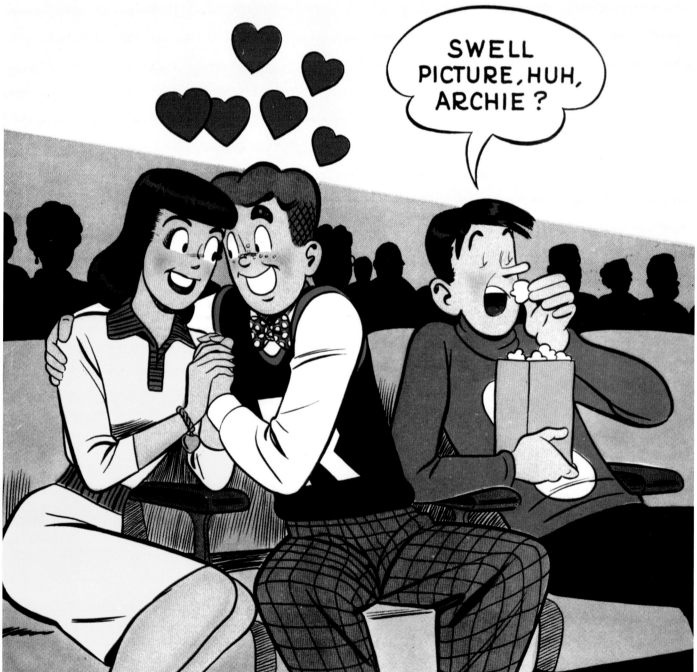

Harry Lucey, Archie #119, June 1961

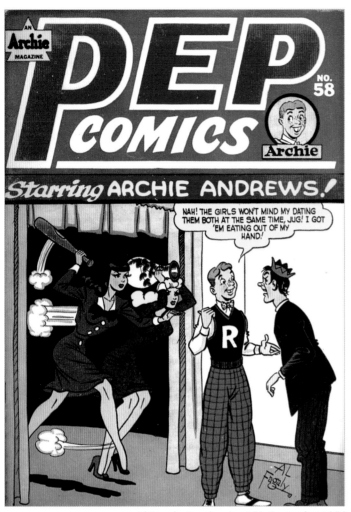

Al Fagaly, Pep Comics #58, September 1956

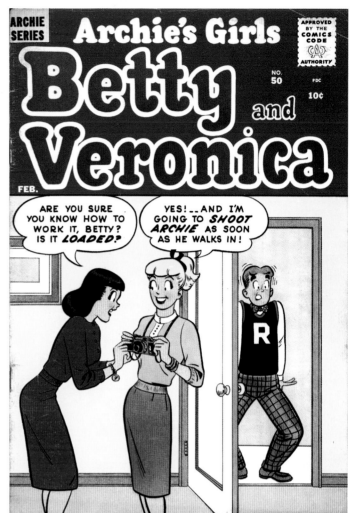

Harry Lucey, Archie's Girls Betty and Veronica #50, February 1960

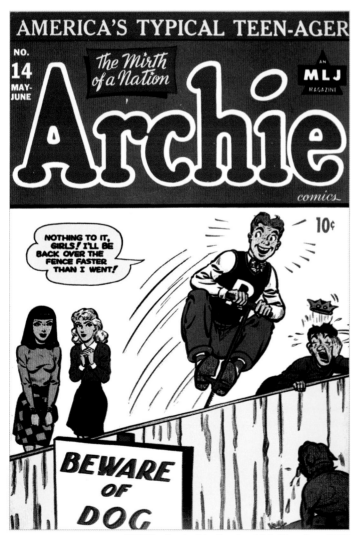

Bill Vigoda, Archie Comics #14, May-June 1945

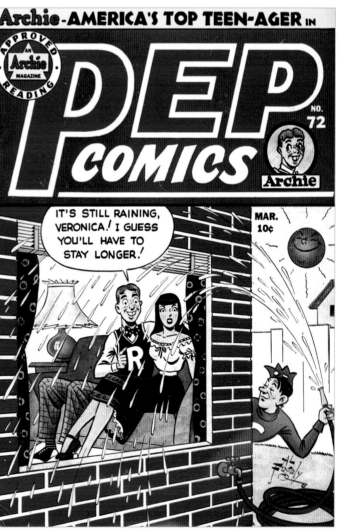

Al Fagaly, Pep Comics #72, March 1949

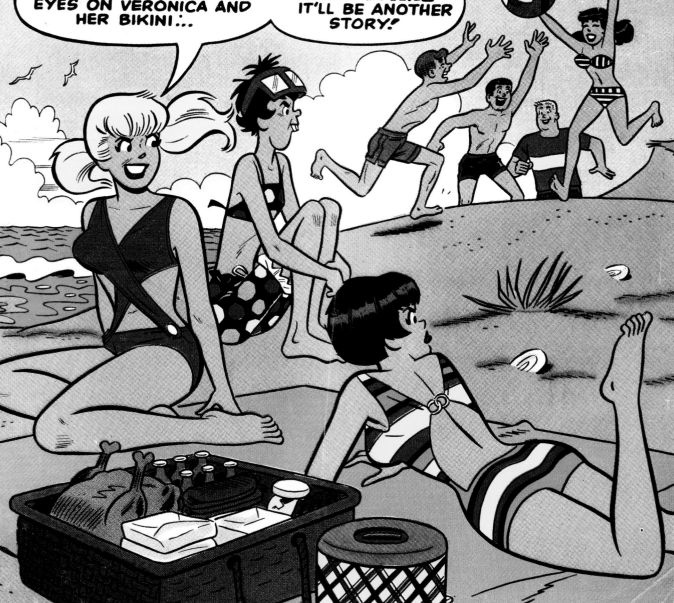

Dan DeCarlo, Archie Giant Series Magazine #147, August 1967

Harry Lucey, Laugh Comics #90, September 1958

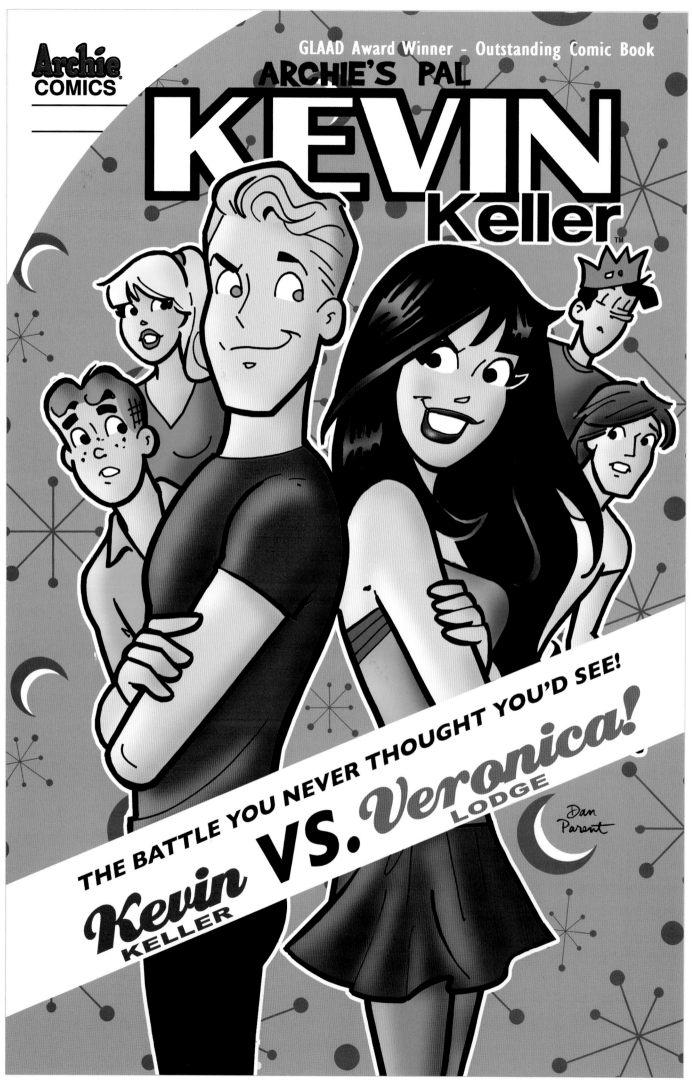

Dan Parent, Kevin Keller #11, December 2013

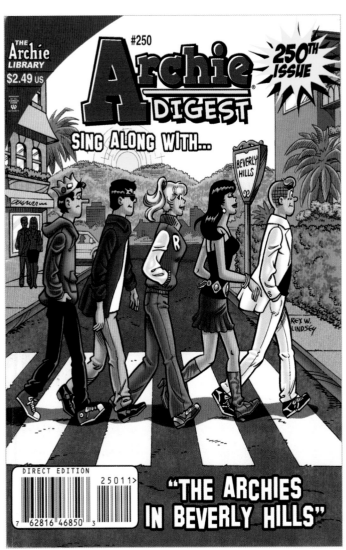

Rex Lindsey, Archie Digest Magazine #250, February 2009

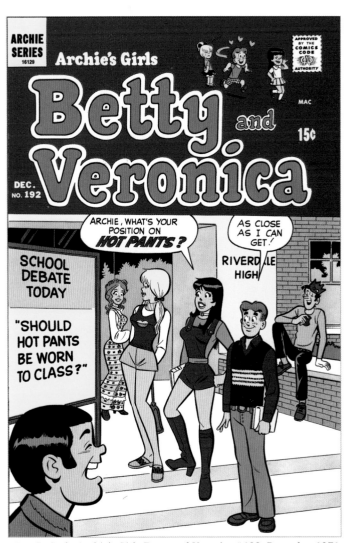

Dan DeCarlo, Archie's Girls Betty and Veronica #192, December 1971.
Reproduced from the printer's proof.

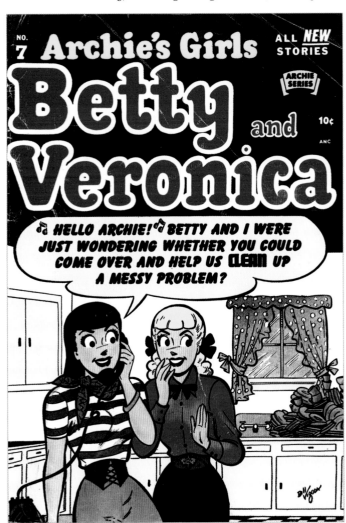

Bill Vigoda, Archie's Girls Betty and Veronica #7, December 1952

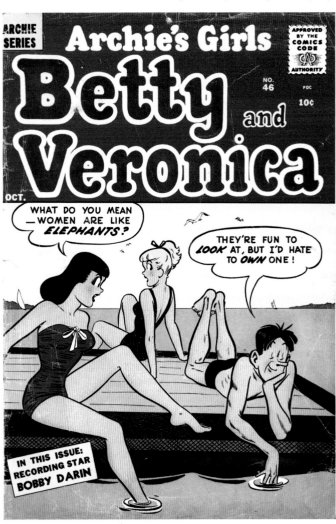

Harry Lucey, Archie's Girls Betty and Veronica #46, October 1959

ARCHIE COVER ARTIST
HARRY SAHLE

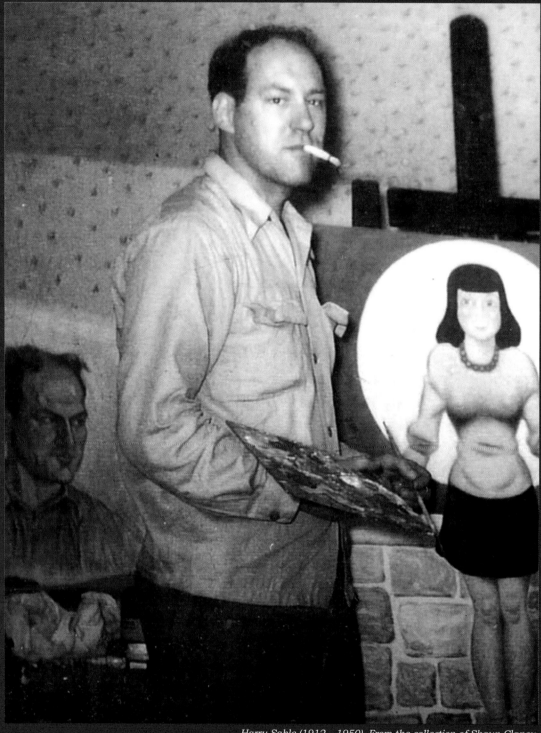

Harry Sahle (1912 – 1950). From the collection of Shaun Clancy.

Born in Cleveland, Ohio, Harry Sahle won a dollar at the age of seven in an art contest for kids sponsored by the *Cleveland Plain Dealer*. His professional career was launched! Later, Sahle moved to New York City and worked in the beginnings of the field in the 1940s for the comic book shops/packagers Harry A. Chesler and Funnies Inc. At MLJ Sahle drew the superheroes Red Rube and the Black Hood. At Timely/Marvel he drew the Blonde Phantom. His art of red-haired Archie, black-haired Veronica, and blonde Betty include some of the most unusual surreal Archie cover concepts. For the comic book publisher Quality and the *Chicago Times* newspaper syndicate, the cartoonist drew the comedic adventures of another teen named Candy. Sahle's pictured above with a painting he did of that sweet character.

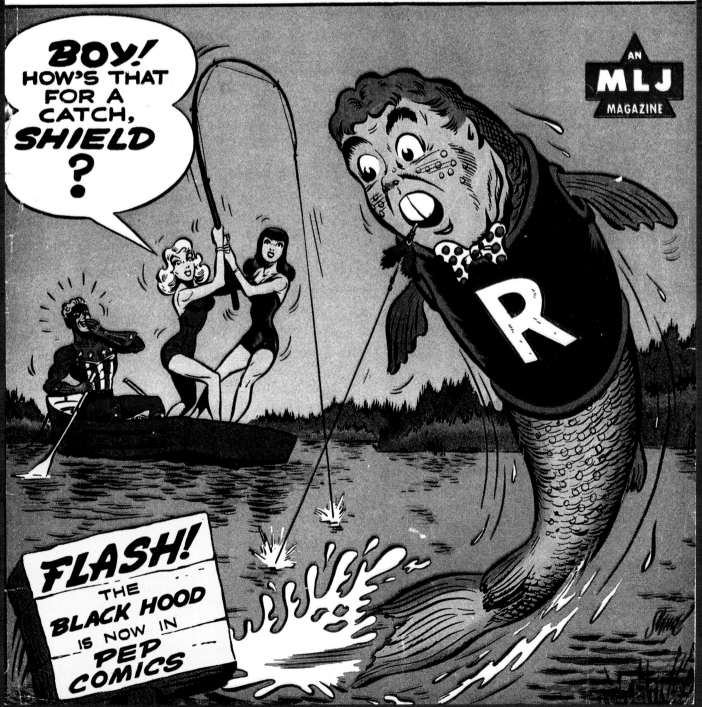

Harry Sahle, Pep Comics #48, May 1944

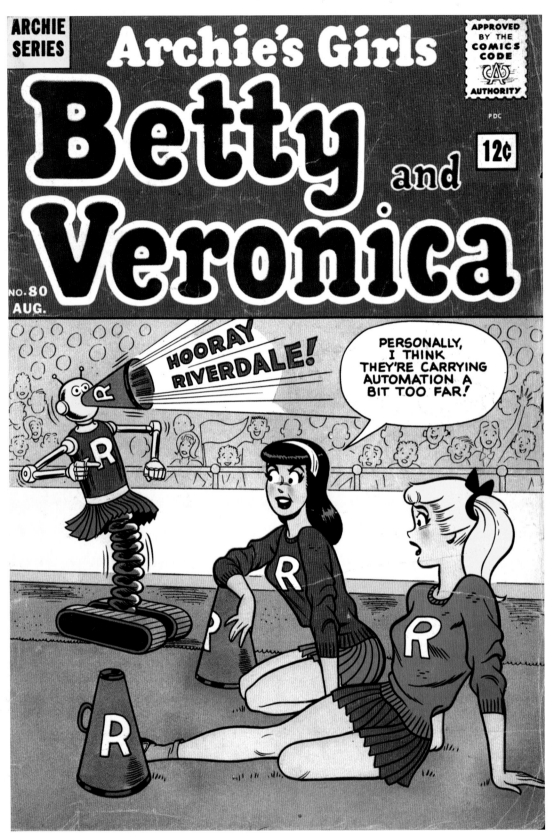

Bob White, Archie's Girls Betty and Veronica #80, August 1962

LET'S HEAR IT FOR THE BOY!

A-R-C-H-I-E-C-O-V-E-R-S! What's that spell? ARCHIE COVERS! And what do we like seeing on Archie covers? CHEERLEADERS! Let's hear it for Archie Comics with cheerleading squads on the covers! YAYYYY!!!! Betty, Veronica, and friends in their cute cheerleader outfits make us want to join them shouting, jumping, tumbling, and stunting! Bring it OOOONNNNN!!!

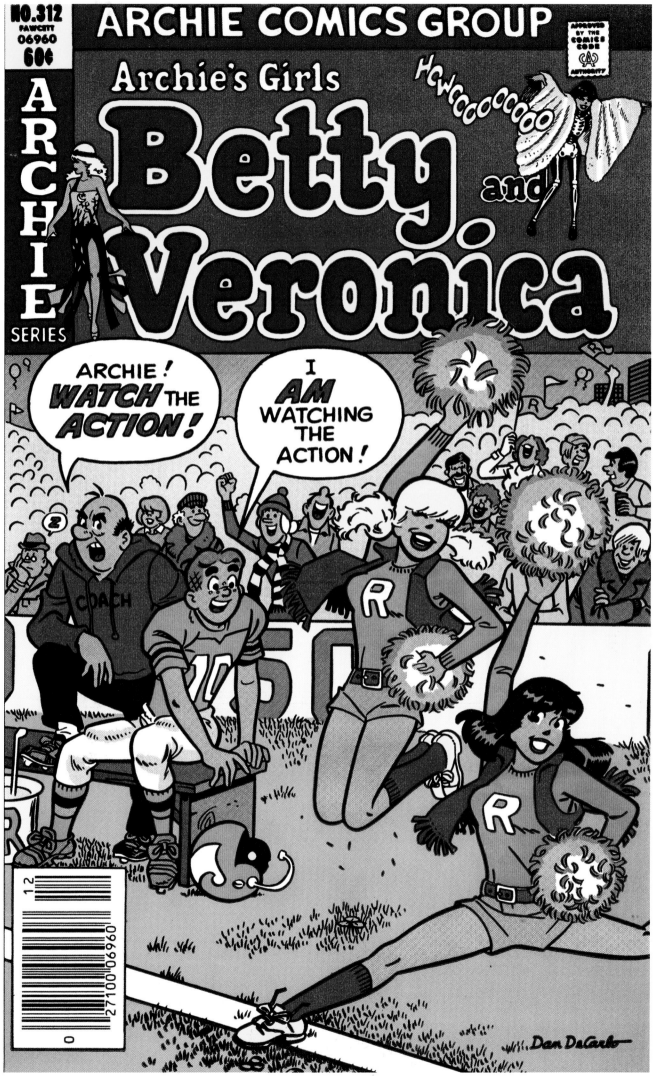

Dan DeCarlo, Archie's Girls Betty and Veronica *#312, December 1981*

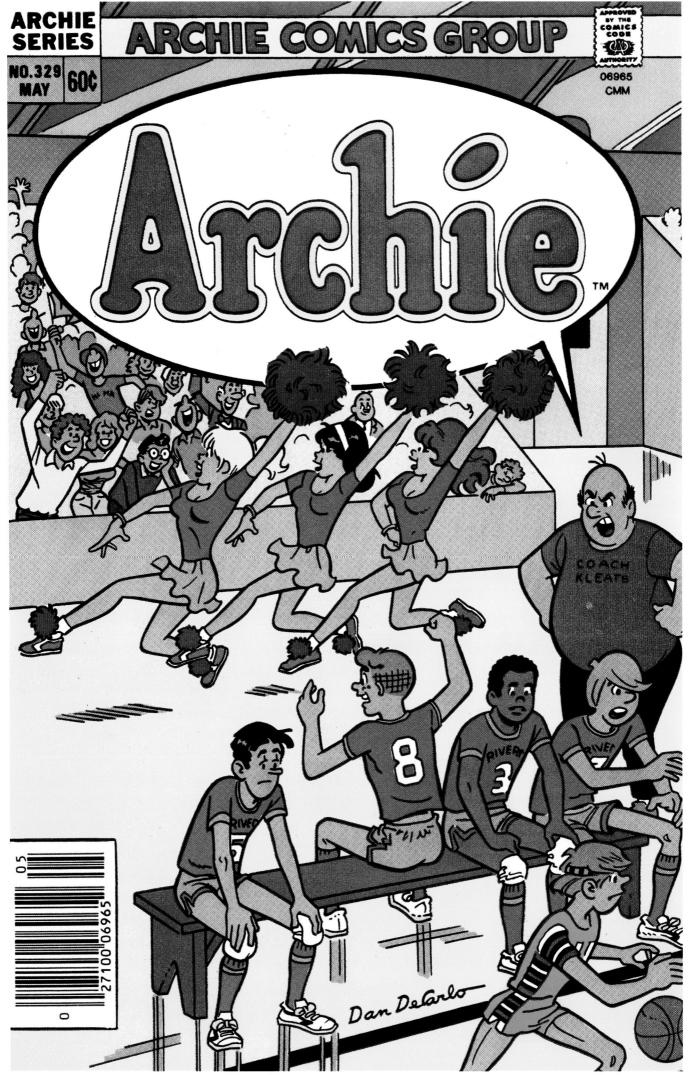

Dan DeCarlo, Archie #329, May 1984

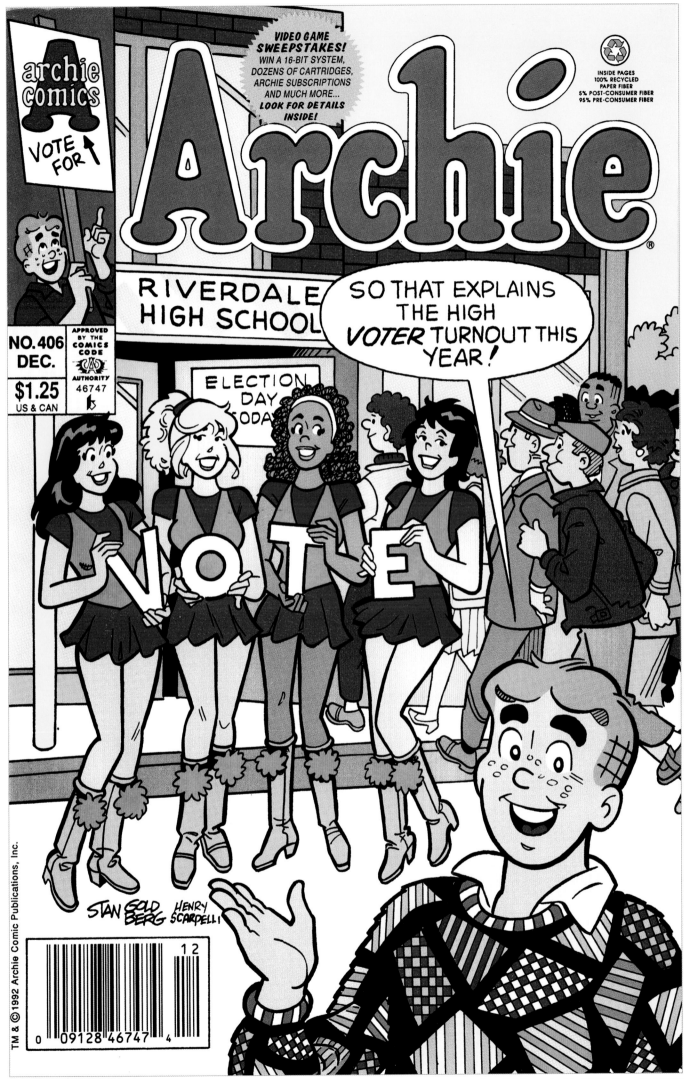

Stan Goldberg, Archie #406, December 1992

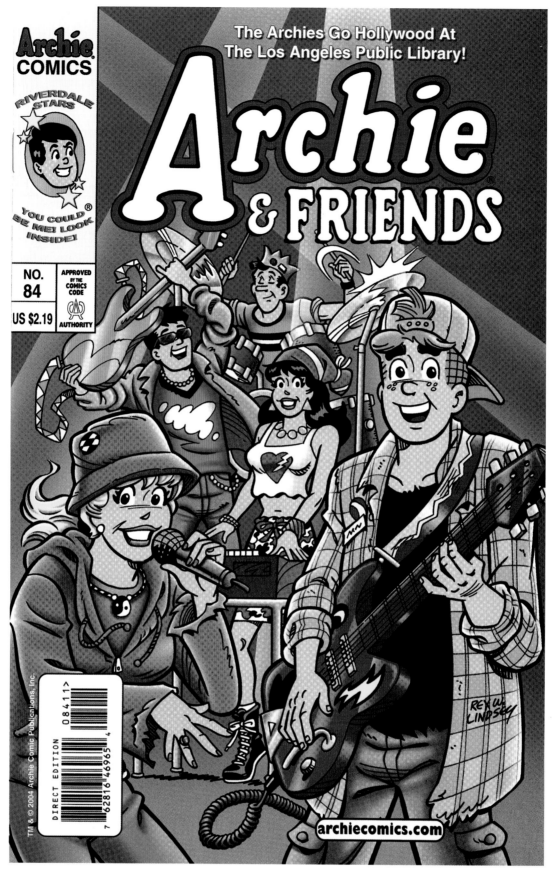

Rex Lindsey, Archie & Friends #84, October 2004

LADIES AND GENTLEMEN, THE ARCHIES!

The bubble gum music phenomenon, The Archies, had the #1 hit in 1969 with "Sugar Sugar"—SWEEET! This is when those wanna-be's, The Beatles, were still releasing new songs! The Archies scored six Top 100 hits altogether, four in the Top 40 and two in the Top 10. Famed producer Don Kirshner (formerly with the Monkees) and producer/songwriter Jeff Barry originally brought together the musicians for the Filmation animated cartoon show. A proto-version of The Archies, called Archie's Rock 'n' Rollers, appeared on *Archie's Pal Jughead* #49 (August 1958), but the group's own title and many covers followed the success of their original songs.

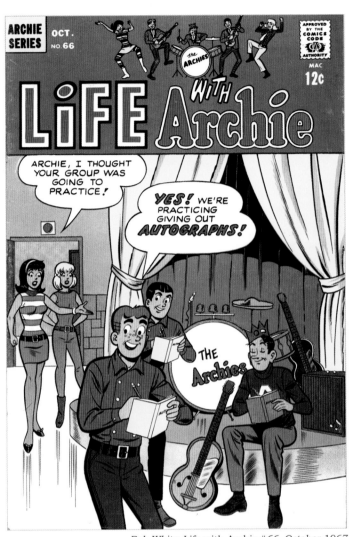

Bob White, Life with Archie #66, October 1967

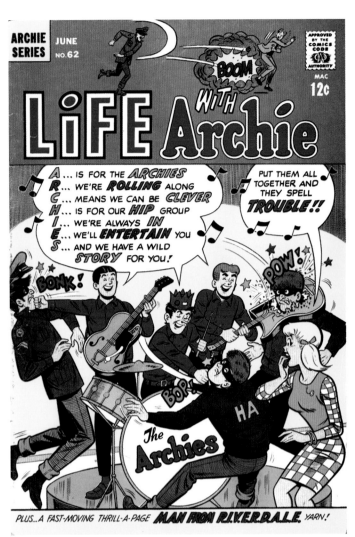

Bob White, Life with Archie #62, June 1967

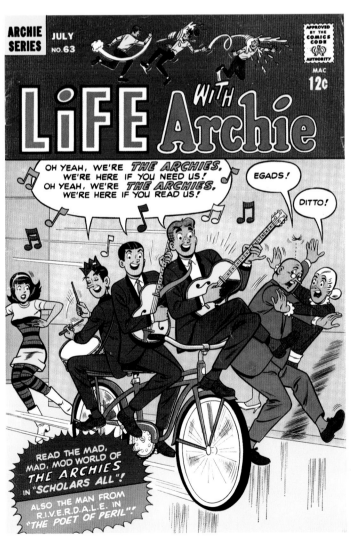

Bob White, Life with Archie #63, July 1967

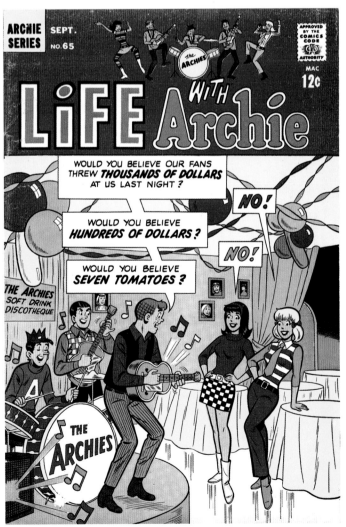

Bob White, Life with Archie #65, September 1967

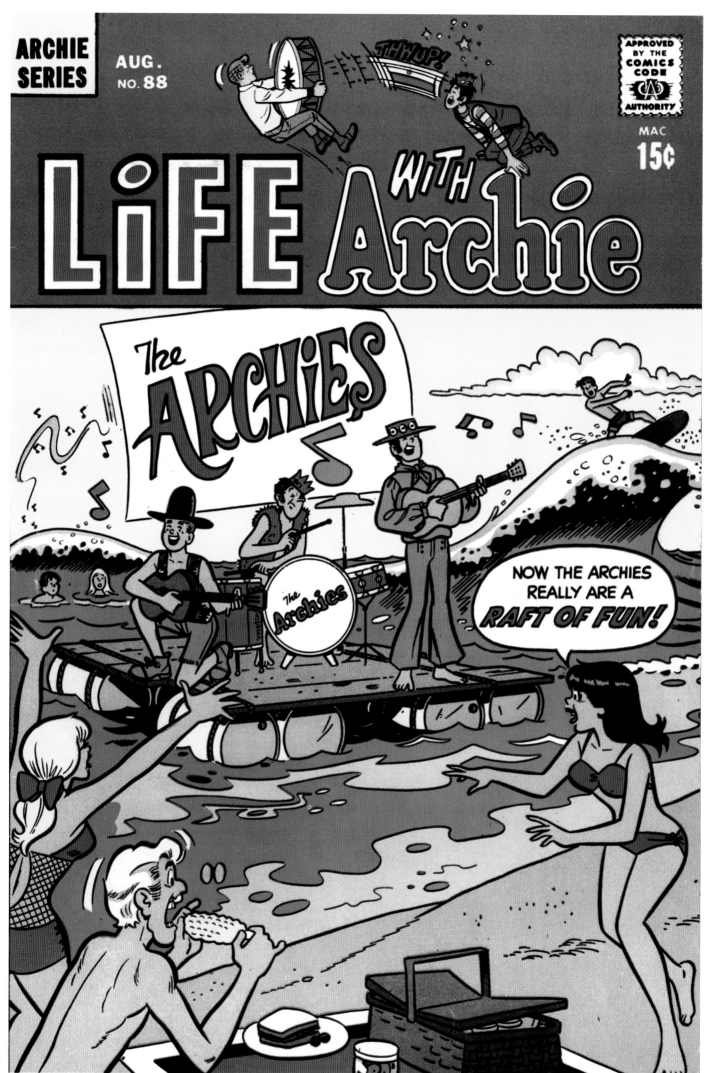

Dan DeCarlo, Life with Archie #88, August 1969

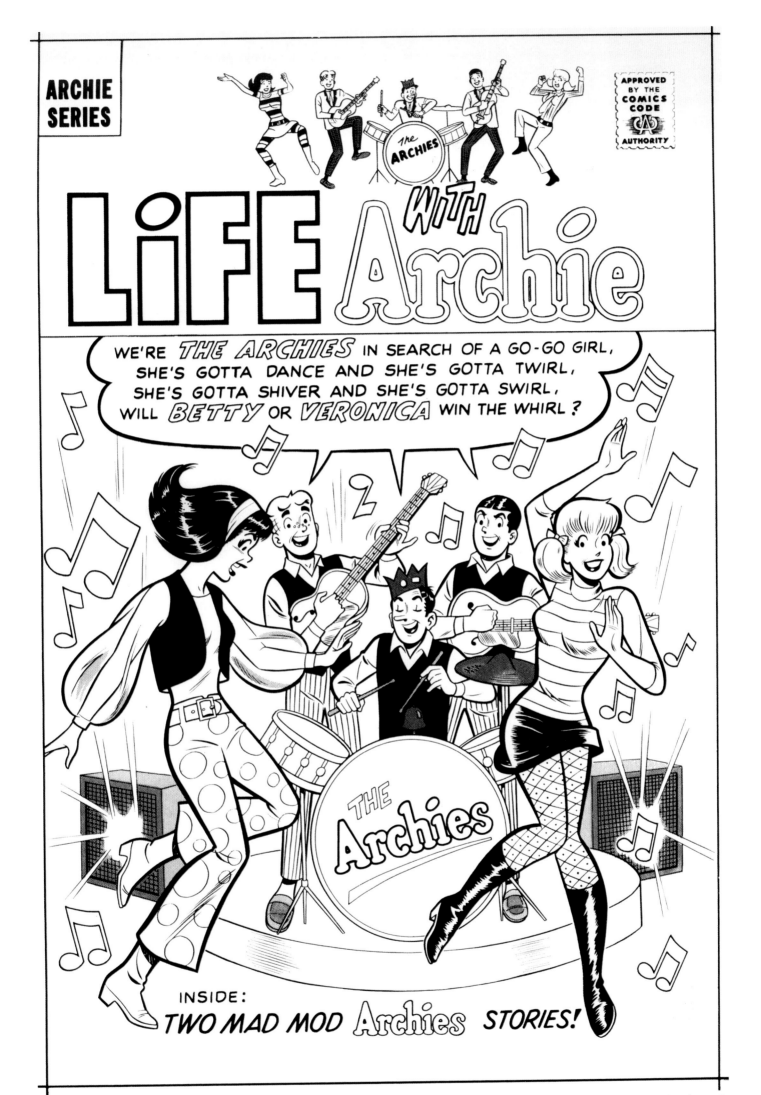

Bob White, Life with Archie #64, August 1967. Reproduced from the black plate of the printer's proofs.

Stan Goldberg, Archie & Friends #20, November 1996

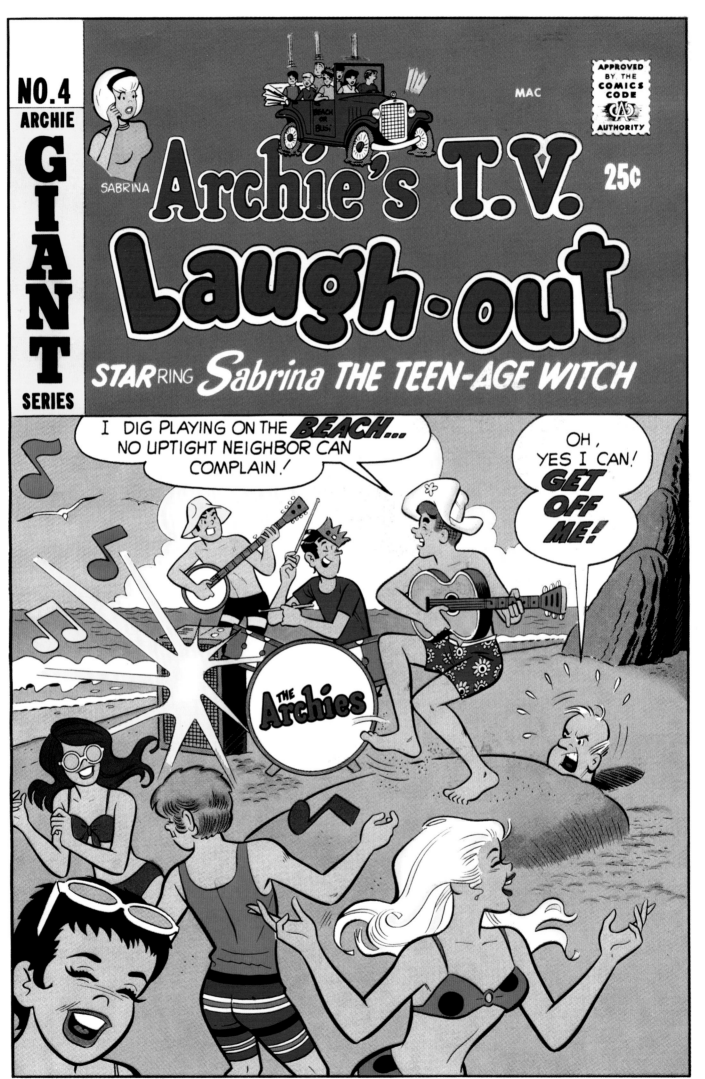

Dan DeCarlo, Archie's TV Laugh-Out #4, September 1970. Reproduced from the printer's proof.

ARCHIE COVER ARTIST
JOE EDWARDS

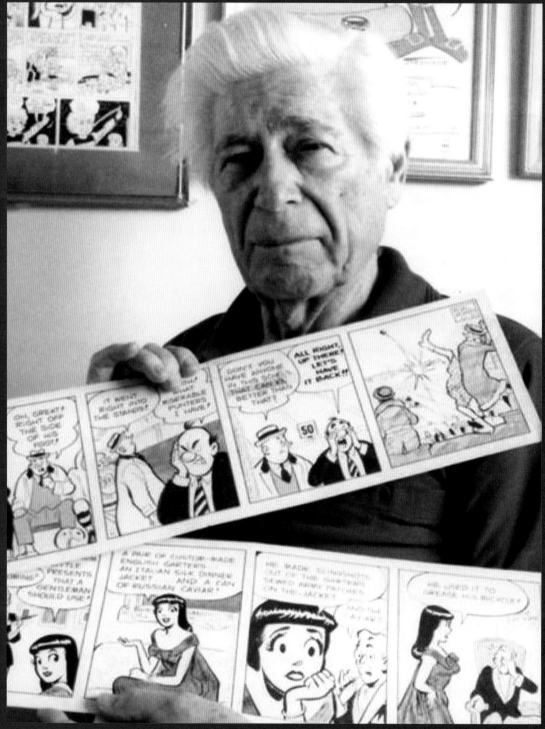

Joe Edwards (1921 – 2007). From the collection of Shaun Clancy.

Joe Edwards grew up on New York's Lower East Side. As a child, Edwards loved to read the Sunday newspaper comic strips and some of the first published comic books that he had received as a gift. Inspired by these, Joe knew that he wanted to become a cartoonist. When he was 18 years old, Edwards enrolled in the Hastings Animation School and later studied art at the Rome Academy. In 1942, he joined MLJ Comics working first on funny animal stories featuring Squoimy the Woim, Cubby the Bear, and Bumble the Bee-tective, some of which appeared in *Archie Comics* #1, Winter 1942. Joe also worked on *Super Duck Comics, Archie and Me,* and his own creation, Li'l Jinx. Joe said her name was inspired by her birth date, October 31, Halloween. Li'l Jinx appeared in *Pep* and *Laugh Comics* and as one-page filler in almost every Archie title.

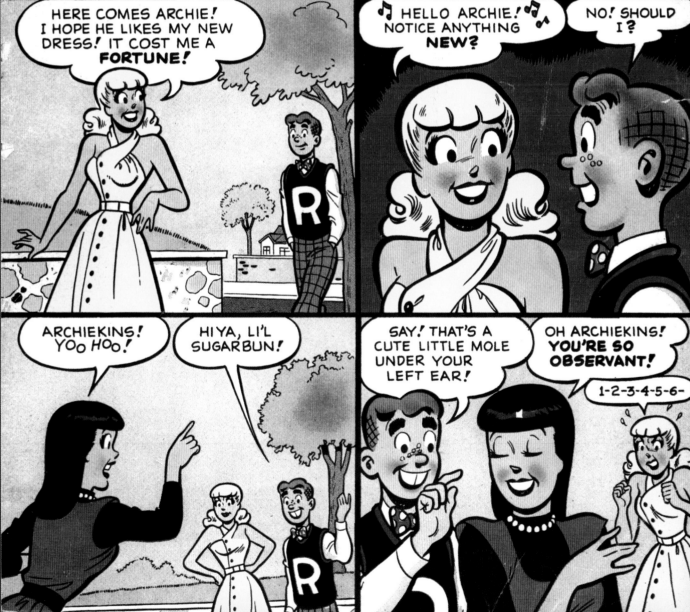

Joe Edwards, Archie's Joke Book Magazine, *1953*

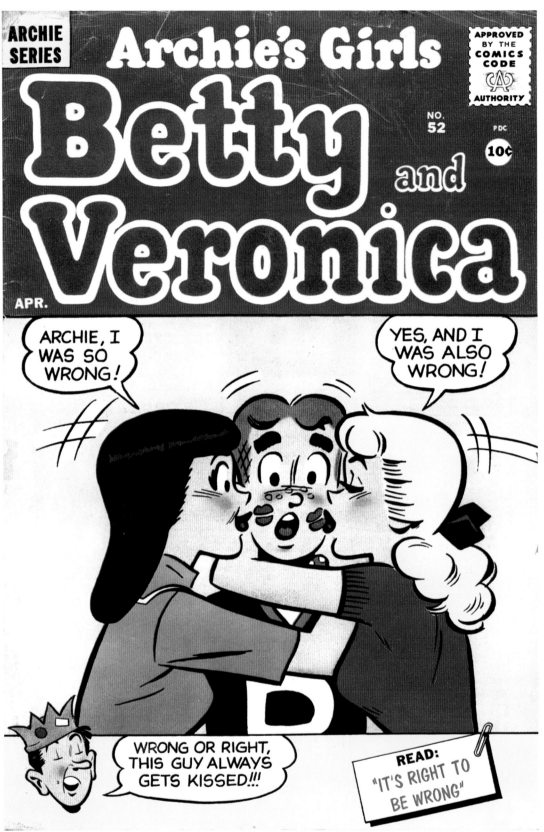

Dan DeCarlo, Archie's Girls Betty and Veronica #52, April 1960

XOXOXO!

Lots of PDAs (Public Displays of Affection) have been played out on the covers of Archie comics from the beginning of the line—and it always starts with a line—to the present day! Betty and Veronica have been in constant competition to place pecks on Archie's rosy cheeks, sometimes Betts winning and at times Ronnie being the victorious kisser. The girls often gave up the battle and just shared the moment together with the freckle-faced lad... with absolutely no complaints from The Arch!

Fernando Ruiz, Archie's Double Digest #288, April 24, 2012. Reproduced from the original art.

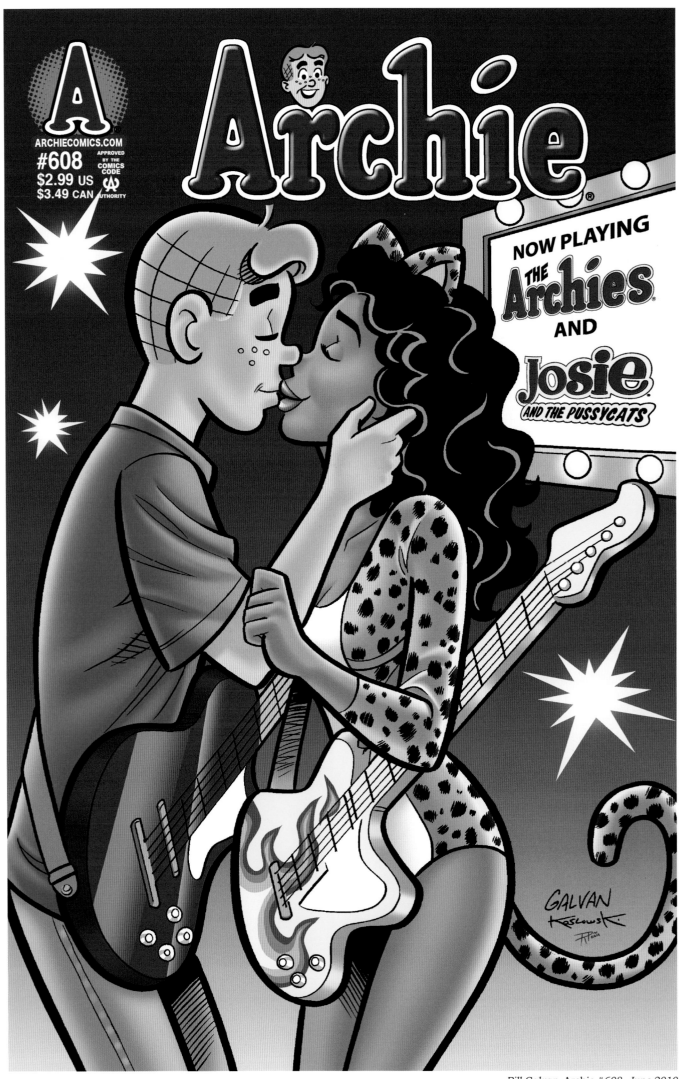

Bill Galvan, Archie #608, June 2010

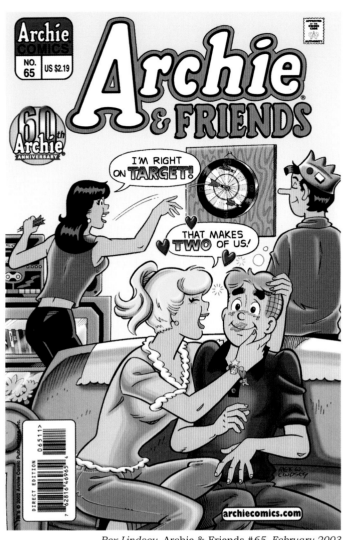

Rex Lindsey, Archie & Friends #65, February 2003

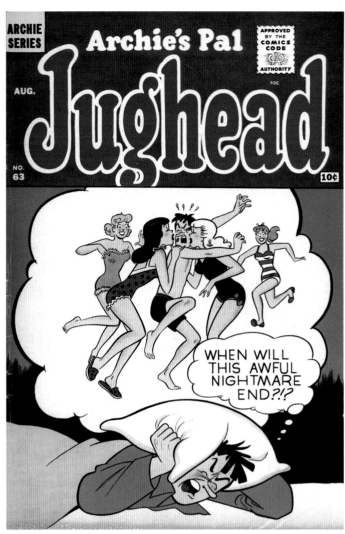

Samm Schwartz, Archie's Pal Jughead #61, August 1943

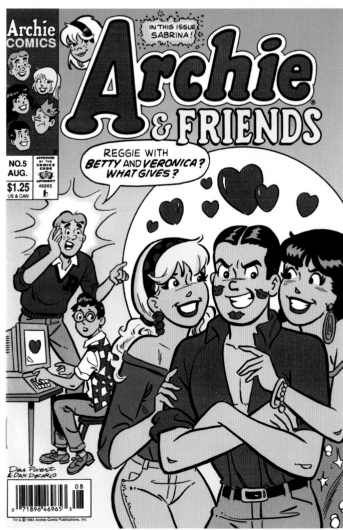

Dan Parent and Dan DeCarlo, Archie & Friends #5, August 1993

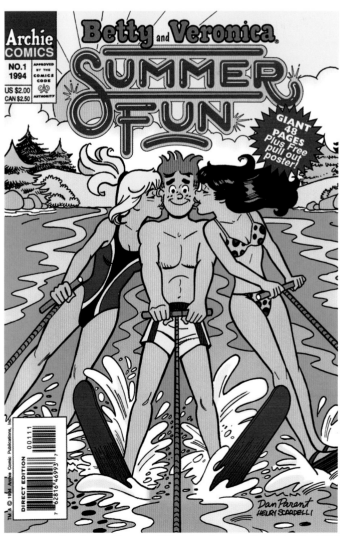

Dan Parent, Betty and Veronica Summer Fun #1, July 1994

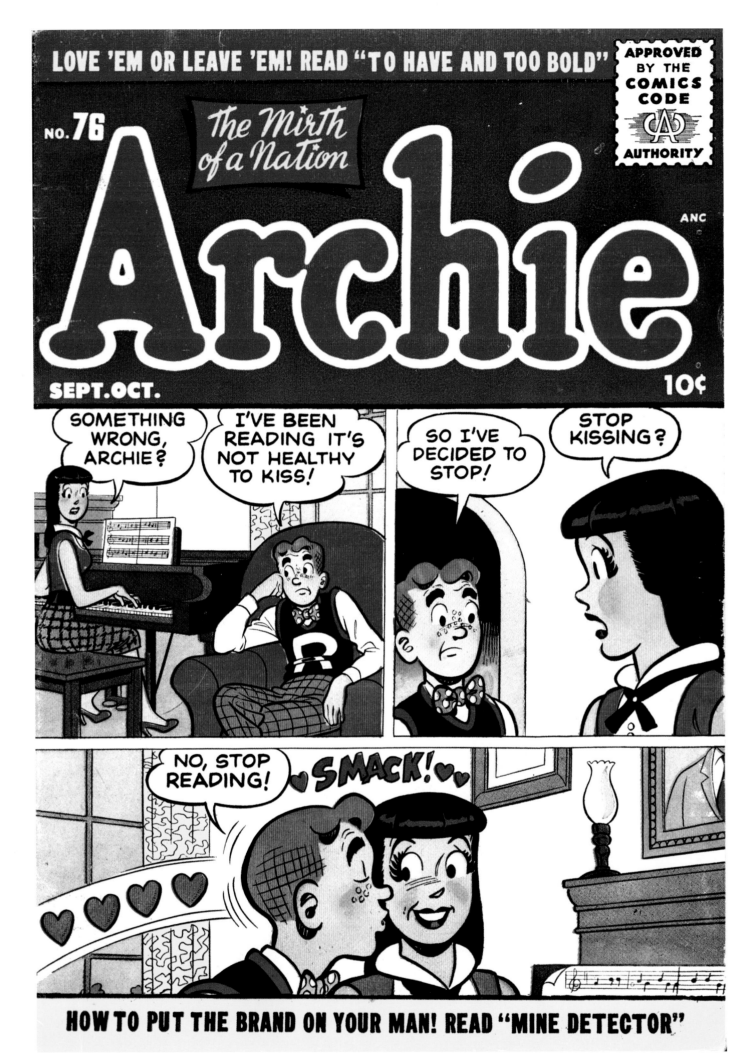

Samm Schwartz, Archie Comics #76, September-October 1955

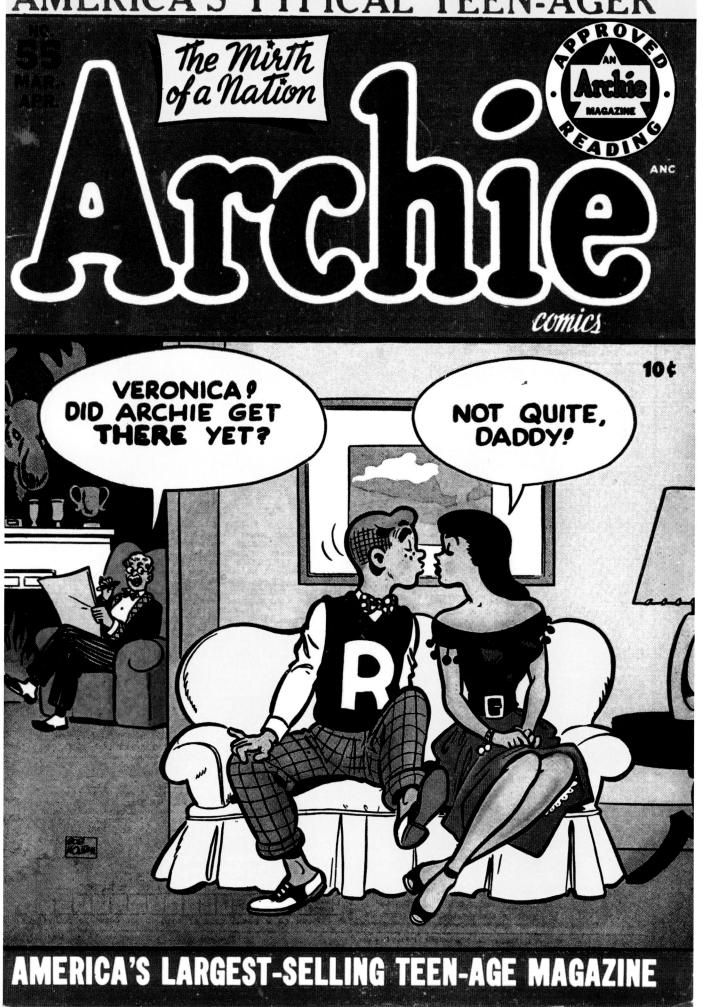

Bob Montana, Archie Comics #55, March-April 1952

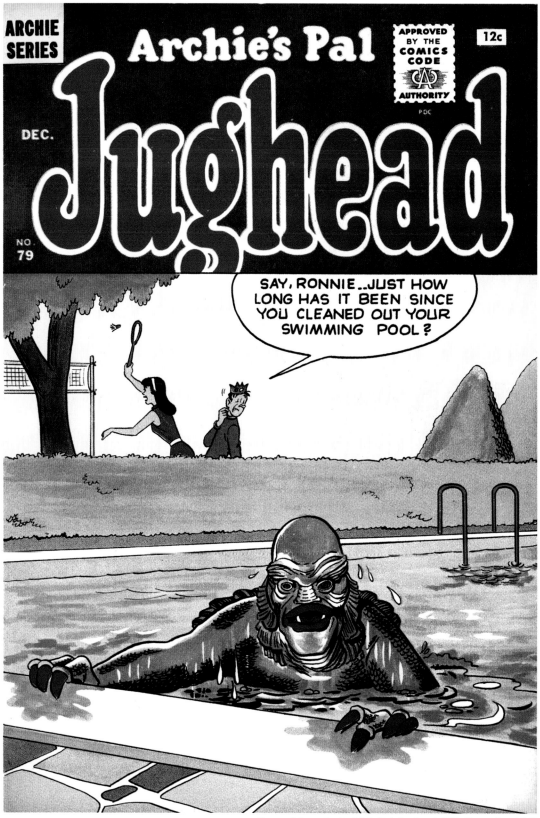

Samm Schwartz, Archie's Pal Jughead #79, December 1961

MONSTER BASH!

The many covers of Archie Comics that featured monsters were so good... they were scary! These spine chilling and funny bone tickling works of art remain some of the coolest—and kookiest—covers in Archie history! Reflecting the horror magazines and movies of the early 1960s, Frankenstein's Monster, werewolves, vampires, creatures from lagoons, mad scientists, witches, and outer space aliens haunted Archie comics. And the fans screamed with delight!

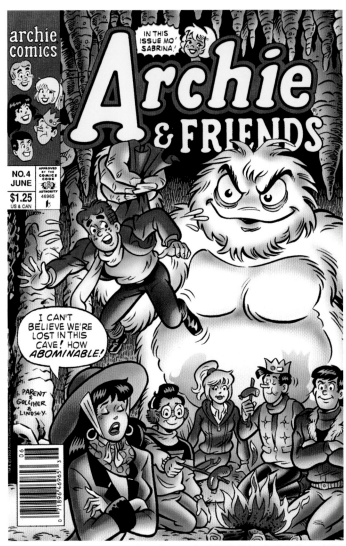

Dan Parent, Archie & Friends #4, June 1993

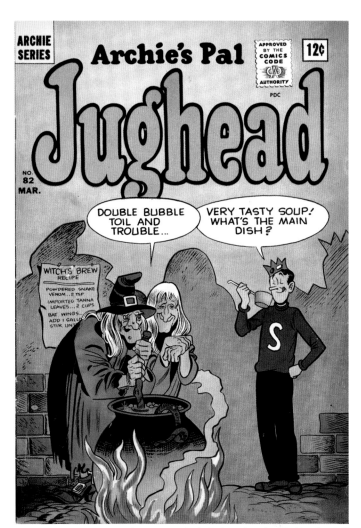

Samm Schwartz, Archie's Pal Jughead #82, March 1962

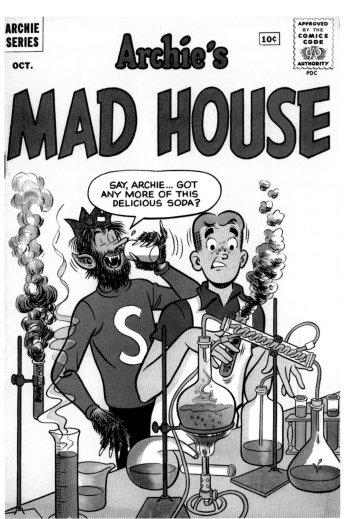

Samm Schwartz, Archie's Madhouse #15, October 1961

Samm Schwartz, Archie's Pal Jughead #81, February 1962

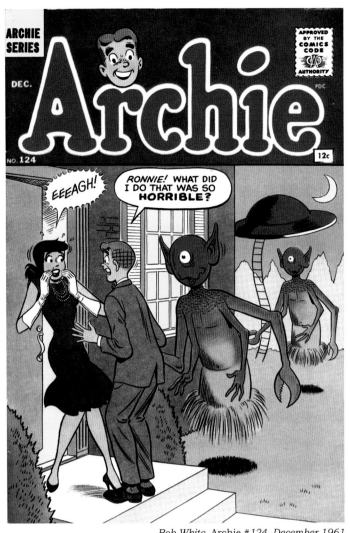

Bob White, Archie #124, December 1961

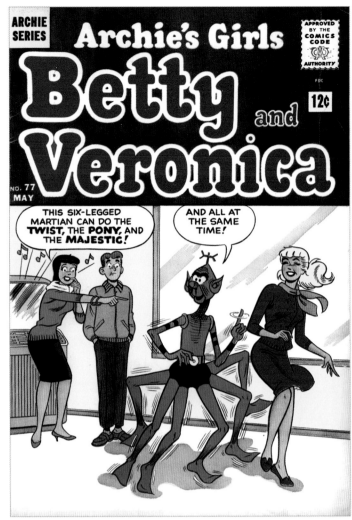

Bob White, Archie's Girls Betty and Veronica #77, May 1962

Bob White, Life with Archie #35, March 1965

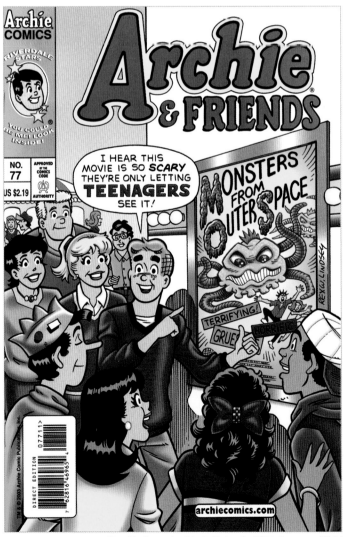

Rex Lindsey, Archie & Friends #77, January 2004

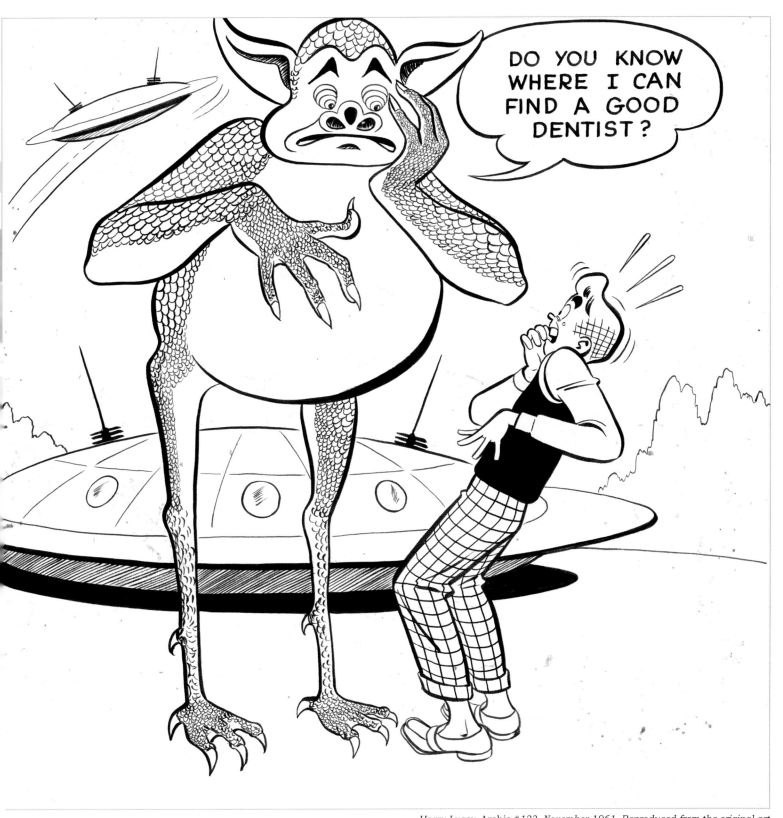

Harry Lucey, Archie #123, November 1961. Reproduced from the original art from the collection of R. Gary Land.

ARCHIE COVER ARTIST
DAN PARENT

Dan Parent (b. 1964)

Dan Parent is a lifelong comic book fan. Parent attended the Joe Kubert School of Cartoon and Graphic Art in Dover, New Jersey, and started his career at Archie Comics upon graduation in 1987. In the beginning, Dan worked on staff in the licensing department creating designs for various products featuring the Archie characters. He continued to hone his art skills with the help of his mentor, the great Dan DeCarlo. Soon, Dan Parent was given his first big assignment: to draw the first groundbreaking issue of Veronica's own self-title comic. Other important Archie projects Dan worked on were *Archie's Love Showdown, Cheryl Blossom, Archie Meets Kiss,* and *Archie Meets Glee* crossovers. Then, Dan created Kevin Keller, Archie's first gay character. Dan continues to freelance for Archie Comics from his home in Milford, Pennsylvania, where he lives with his wife and two children. He also frequently attends comic book conventions.

Dan Parent, a color proof of the artwork from Betty and Veronica #269, October 2013.
The pencilled and inked artwork has been colored digitally.

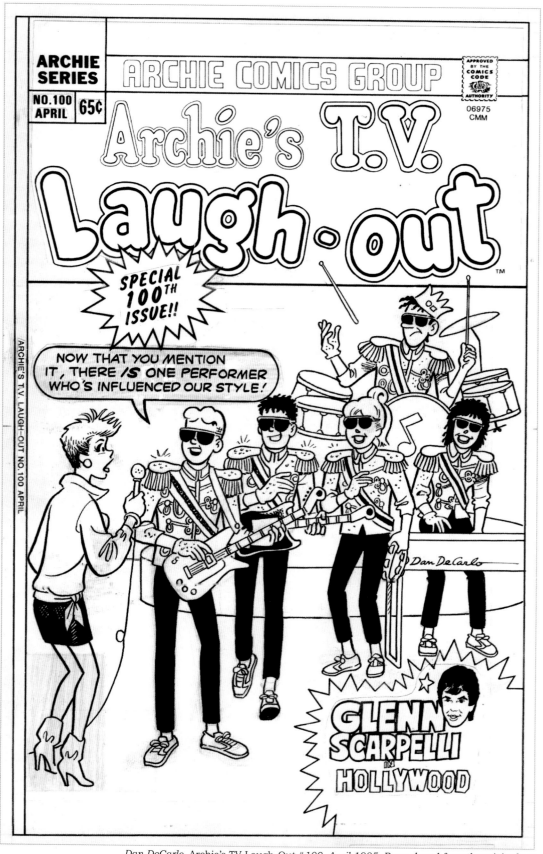

Dan DeCarlo, Archie's TV Laugh-Out #100, *April 1985. Reproduced from the original art from the collection of Nick Katradis.*

CELEBRITY SPOTTING!

Tweet THIS! The Archie gang are celebrities in their own right—at least in OUR book and not just here, but among the millions of fans through the years! Alongside Archie and his peeps, the covers have featured many celebs and celebrity look-a-likes. There's the King of Pop Michael Jackson, the Prez of U.S.A. Barack Obama, George Takei from *Star Trek,* JLo, the cast of *Glee,* and football great Michael Strahan. Plus the rock super-group Kiss got a gig on Archie covers— they look like real life walking, talking, singing comic book characters, after all! I want to rock 'n' roll all night and party all day all the time while I read my Archies!

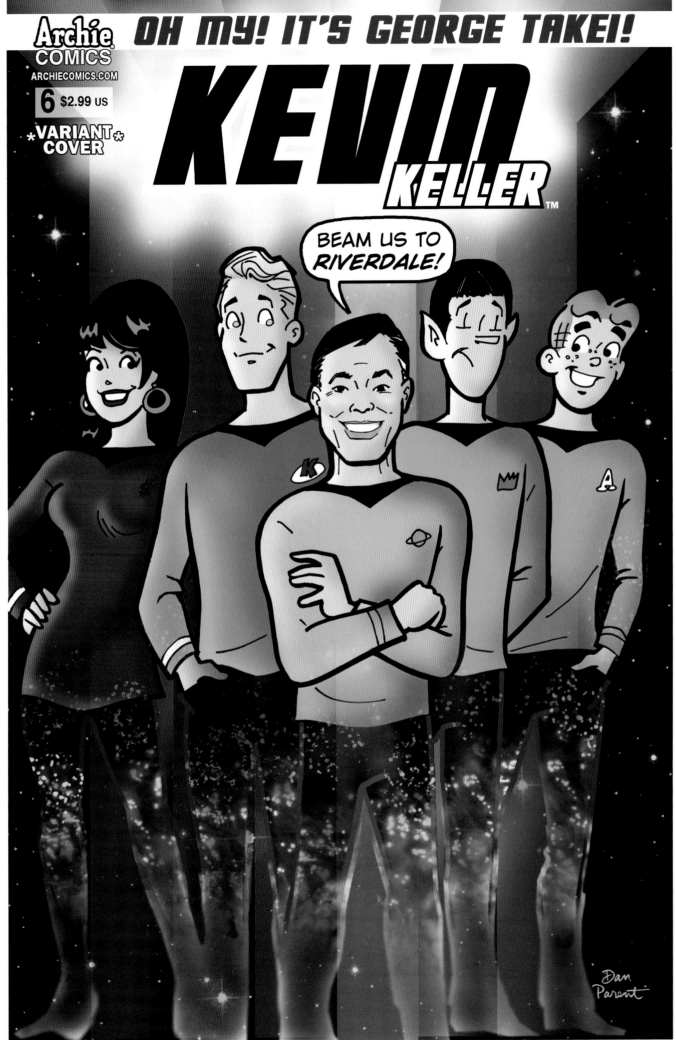

Dan Parent, variant cover for Kevin Keller #6, *January 2013*

Dan Parent, Veronica #199, May 2010. Reproduced from the original art from the collection of Arthur Chertowsky.

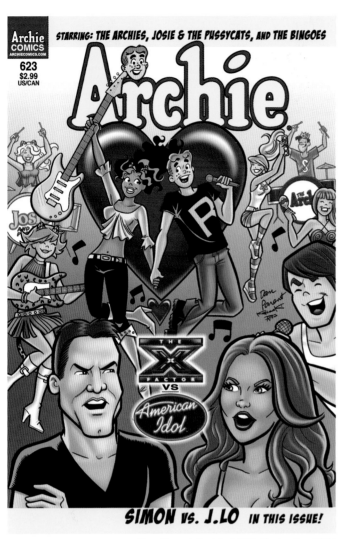

Dan Parent, Archie #623, September 2011

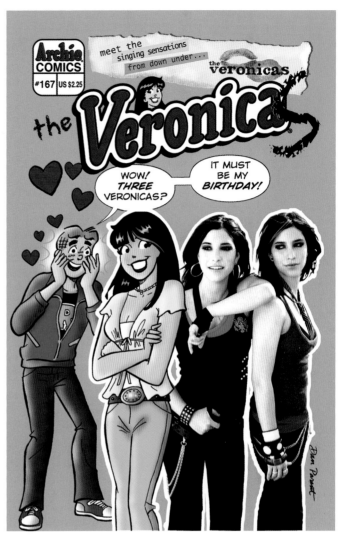

Dan Parent, Veronica #167, April 2006

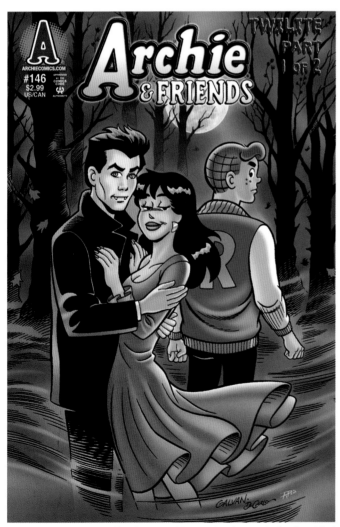

Bill Galvan, Archie & Friends #146, October 2010

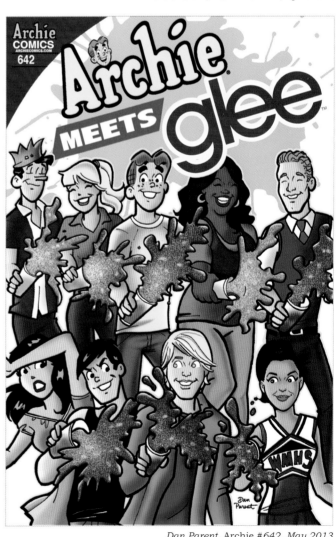

Dan Parent, Archie #642, May 2013

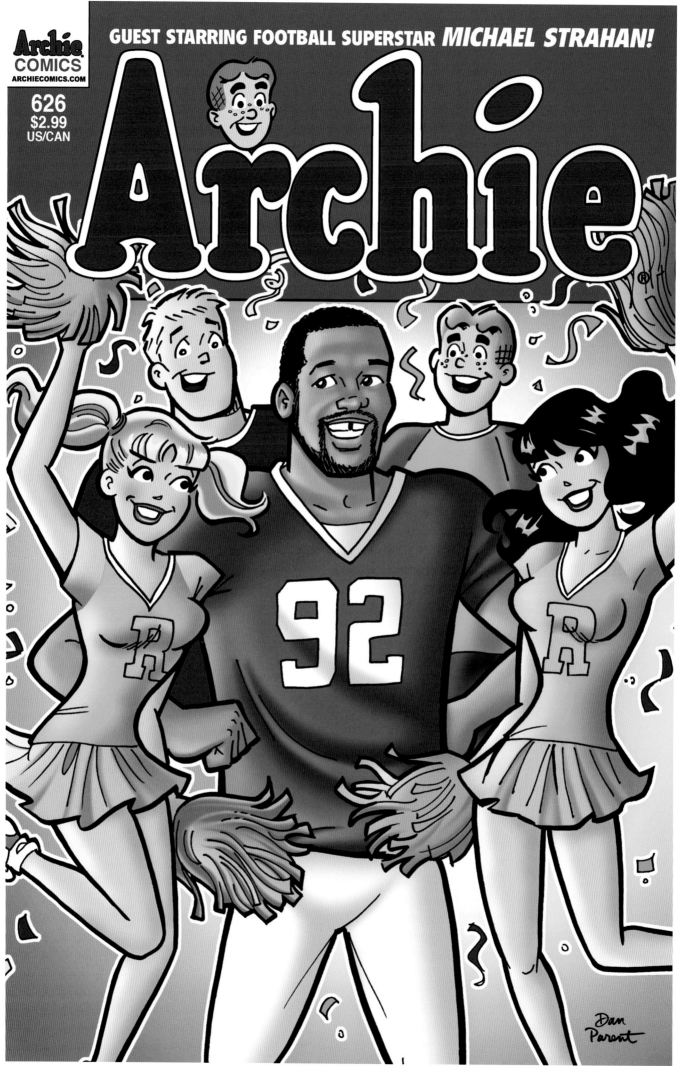

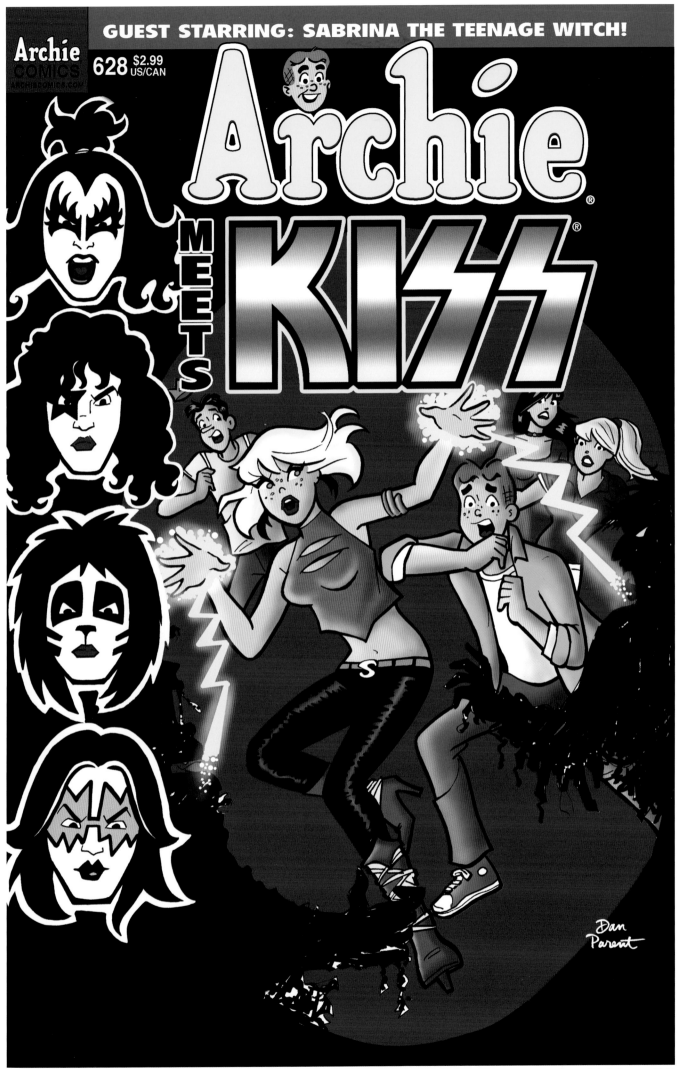

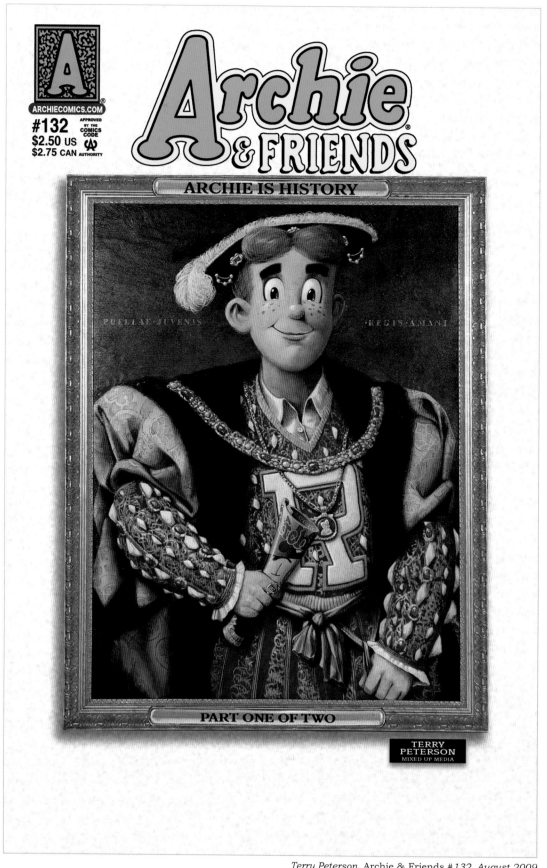

Terry Peterson, Archie & Friends #132, August 2009

ART FOR ARCHIE'S SAKE

Having gotten this far in the book, you can surely see that the work that the Archie artists do on the covers is great art! Comic book art is finally being recognized for its high quality and impact on culture. There are even institutions like the ToonSeum in Pittsburgh, the Museum of Comic and Cartoon Art (MoCCA) in New York City, and the Cartoon Art Museum in San Francisco that have shown Archie art on their walls to great acclaim. Archie covers have spoken about art and artists, of course, with their trademark humor not taking the subject TOO seriously. Veronica or Mona Lisa... don't make us choose!

Al Fagaly, Pep Comics #60, March 1947

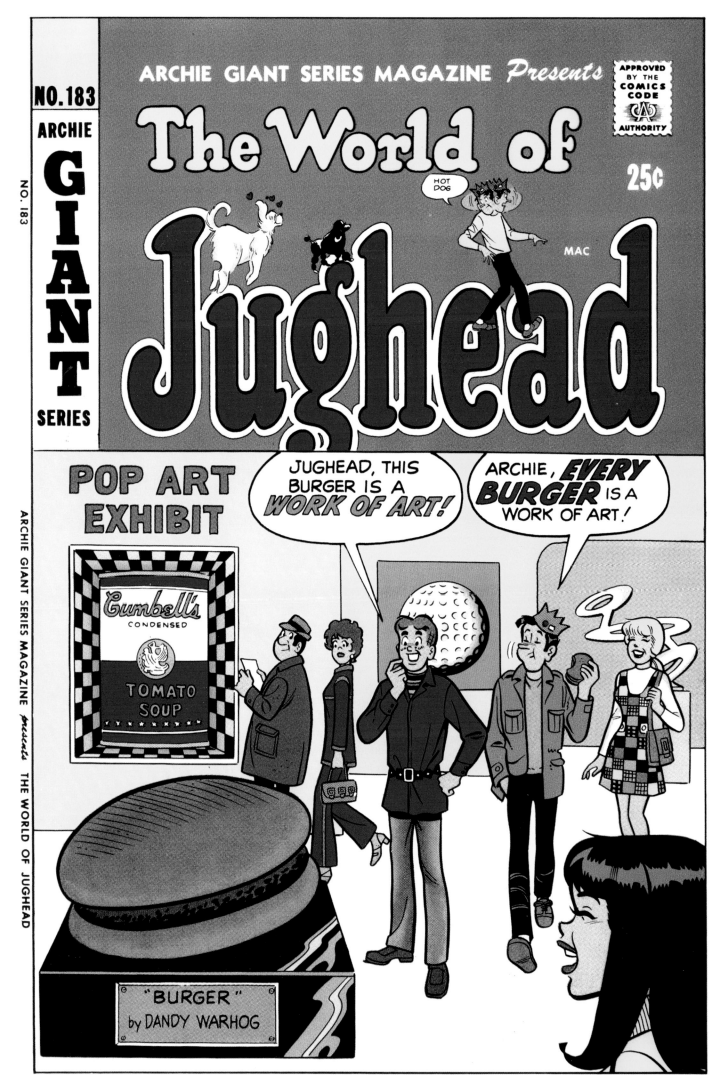

Dan DeCarlo, Archie Giant Series Magazine #183, February 1971. Reproduced from the printer's proof.

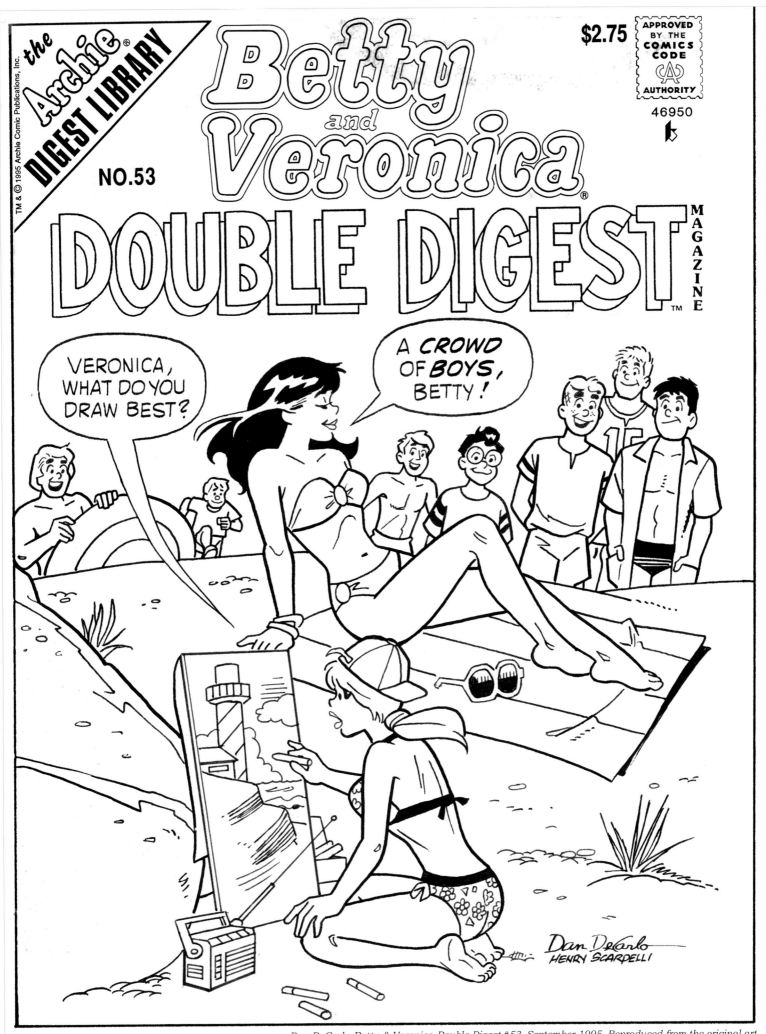

Dan DeCarlo, Betty & Veronica Double Digest #53, September 1995. Reproduced from the original art from the collection of Arthur Chertowsky.

ARCHIE COVER ARTIST
HARRY LUCEY

Harry Lucey (1913 – 1984)

Harry Lucey will always be remembered as a versatile artist who worked on both adventure and humor titles at MLJ and Archie Comics. He was the primary artist on the *Archie* title from the late 1950s to the mid-'70s. But Harry's talents went beyond just drawing. He could write as well and, in the late '30s-early '40s, Lucey co-created Madam Satan and The Hangman. In the '50s, obviously influenced by film noir and Will Eisner's *The Spirit*, Harry wrote, penciled, inked, and lettered seven issues of a comic called *Sam Hill, Private Eye*. He also, possibly on spec for a future series, wrote and drew a story titled, "The Iron Curtain Caper," featuring for the first time Archie's cousin Andy Andrews. It had never been published until 2010 in *Archie The Man From R.I.V.E.R.D.A.L.E* trade paperback.

Harry Lucey, Pep Comics #132, April 1959. Reproduced from the original art from the collection of R. Gary Land.

Samm Schwartz, Archie #111, July 1960

THE TIME ARCHIE WAS PINKED OUT!

Each cover of an Archie comic book is designed to look familiar to the readers looking for their favorites, yet different from the last issue to signal a new offering. Back in the day, one of the ways that was accomplished was to alternate the colors of the mastheads. One month there would be blue lettering on a red background and the next month that would be switched. At the last second, it was discovered at the printer that the color switch for the cover of *Archie* #115 hadn't been made. The CEO at the time, John L. Goldwater, was upset by this news and wanted things rectified as best as possible. An inexpensive solution was to make some quick, easy changes on the printing plates resulting in our hero Archie, or his logo anyway, being "pretty in pink"!

Dan DeCarlo, Archie #112, August 1960

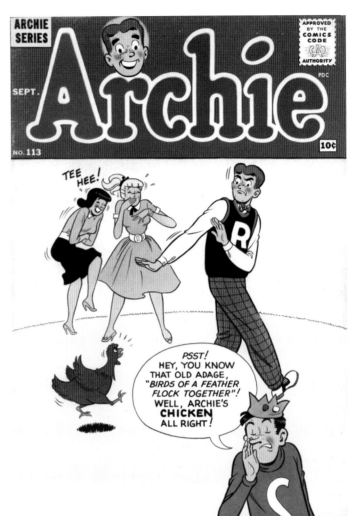

Bob White, Archie #113, September 1960

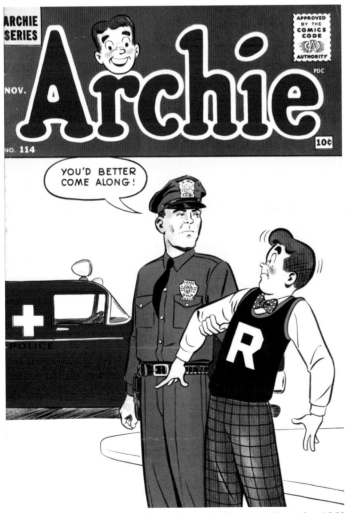

Harry Lucey, Archie #114, November 1960

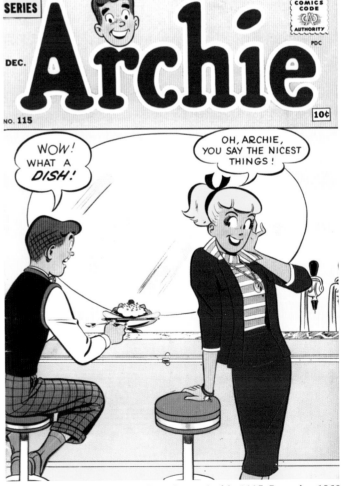

Harry Lucey, Archie #115, December 1960

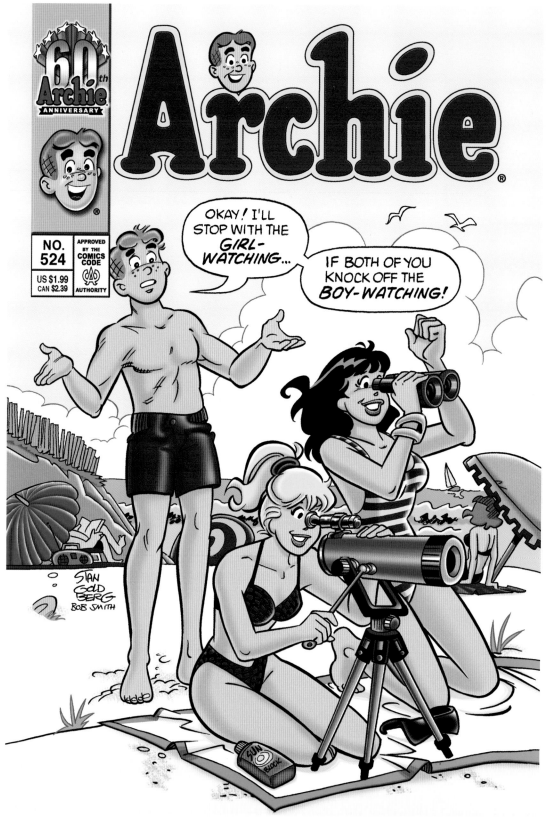

Stan Goldberg, Archie #524, *August 2004*

LIFE WITH ARCHIE'S A BEACH!

Frankie Avalon and Annette Funicello and Beach Blanket Bingo had nothing on Archie's pals and gals! The Riverdale gang flock to the sand every summer, doff their cover-ups on the covers, and strut their stuff! America's favorite tanned teens are immersed in surfing, sunbathing, and swimming, for sure, but mostly are passionately involved in the time-honored beach activity of girl and boy watching! Shore enough!

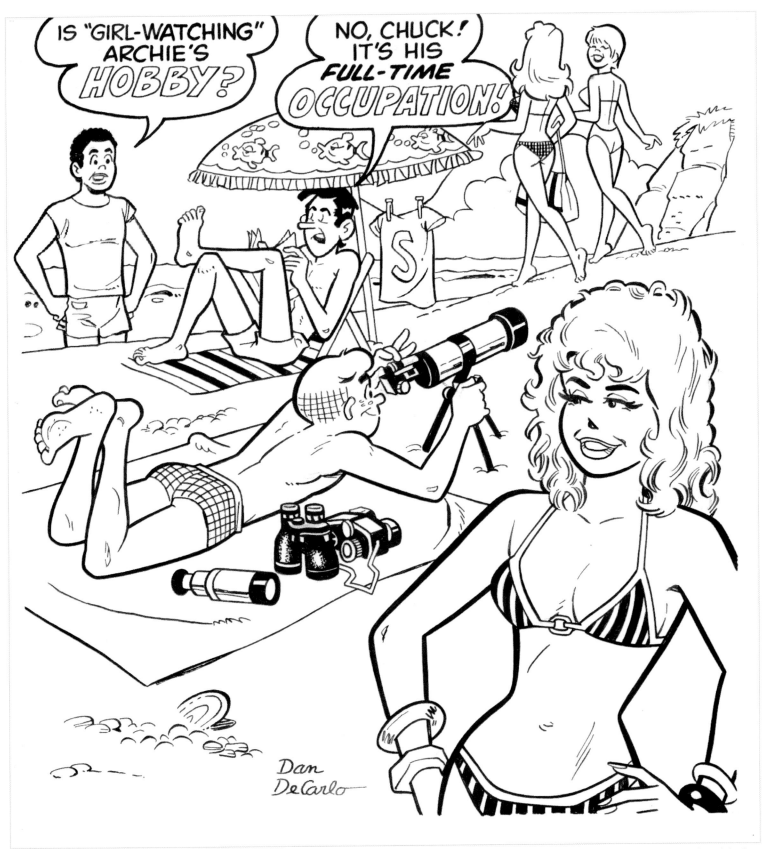

Dan DeCarlo, Archie Giant Series Magazine #521, *September 1982. Reproduced from the original art from the collection of Nick Katradis.*

Dan DeCarlo, Archie Giant Series Magazine #23, September 1963.
Reproduced from the printer's proof.

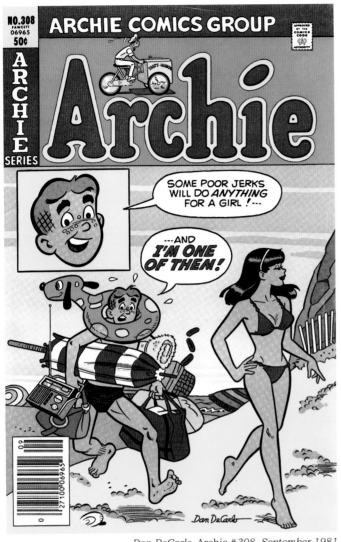

Dan DeCarlo, Archie #308, *September 1981*

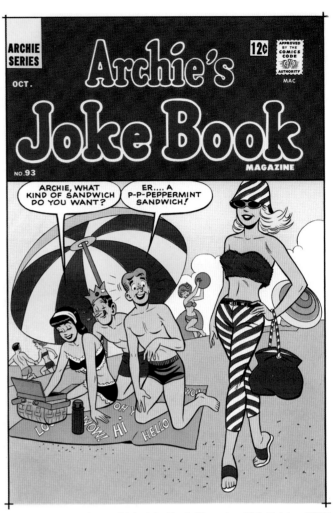

Bob White, Archie's Joke Book Magazine #93, *October 1965. Reproduced from the printer's proof.*

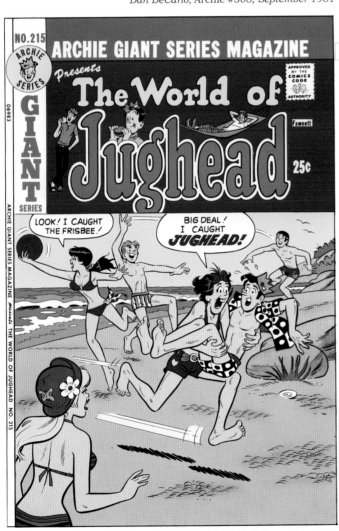

Dan DeCarlo, Archie Giant Series Magazine #215, *November 1973. Reproduced from the printer's proof.*

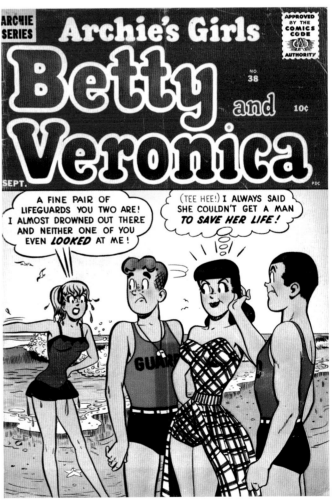

Harry Lucey, Archie's Girls Betty and Veronica #38, *September 1958*

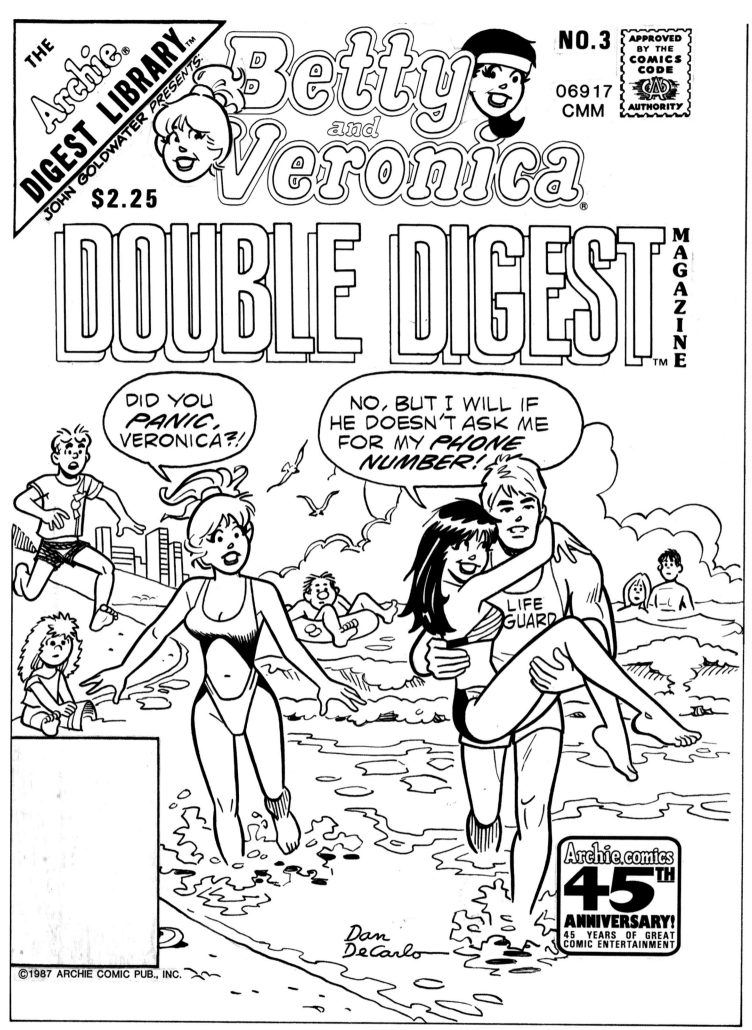

Dan DeCarlo, Betty and Veronica Double Digest #3, October 1987. Reproduced from the original art from the collection of Arthur Chertowsky.

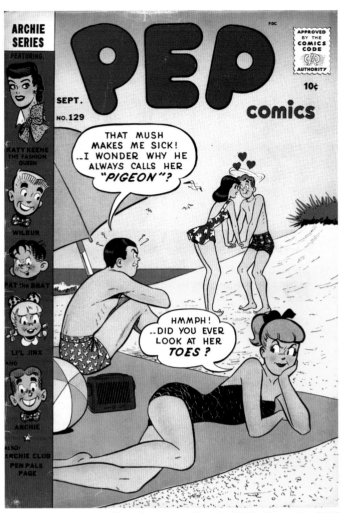

Harry Lucey, Pep Comics #129, September 1958

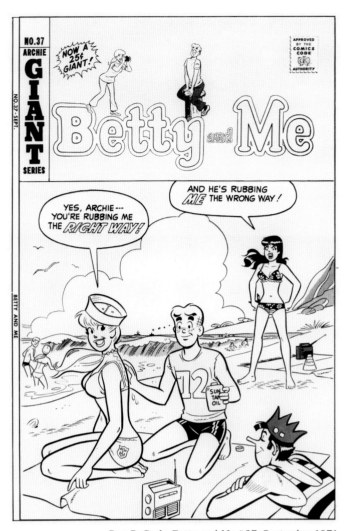

Dan DeCarlo, Betty and Me #37, September 1971.
Reproduced from the black plate of the printer's proofs.

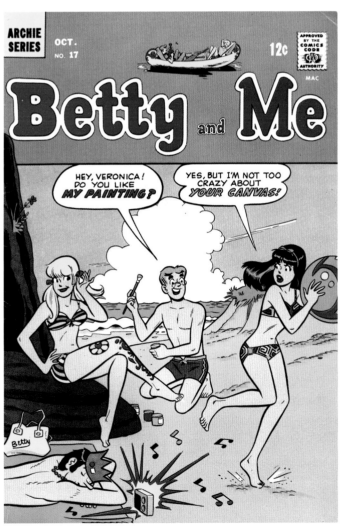

Dan DeCarlo, Betty and Me #17, October 1968

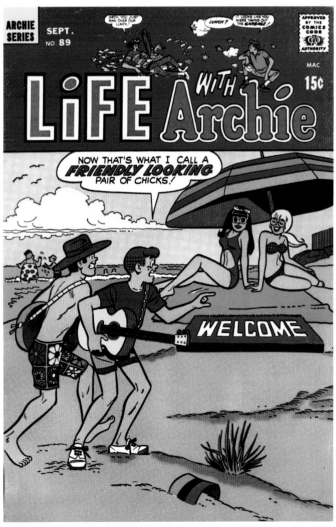

Dan DeCarlo, Life with Archie #89, September 1969

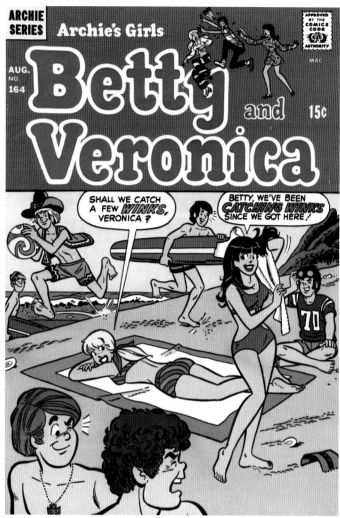

Dan DeCarlo, Archie's Girls Betty and Veronica #164, August 1969

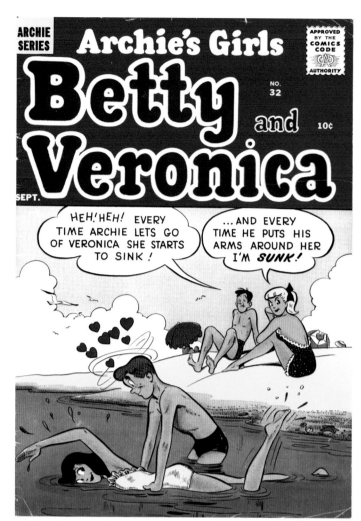

Harry Lucey, Archie's Girls Betty and Veronica #32, September 1957

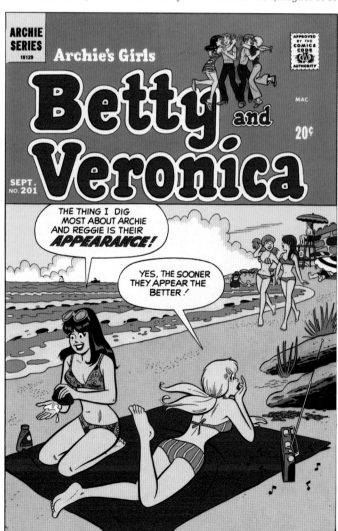

Dan DeCarlo, Archie's Girls Betty and Veronica #201, September 1969.
Reproduced from the printer's proof.

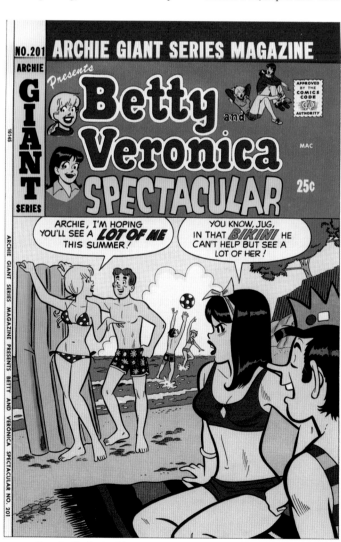

Dan DeCarlo, Archie Giant Series Magazine #201, October 1972.
Reproduced from the printer's proof.

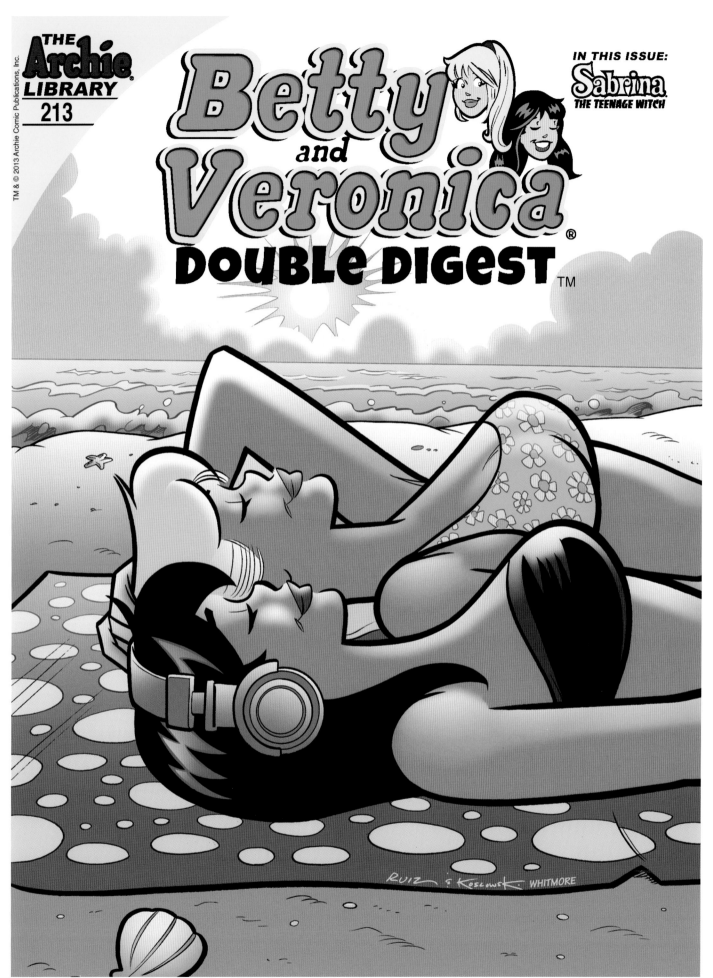

TM & © 2013 Archie Comic Publications, Inc.

THE
Archie
LIBRARY
213

Betty
and
Veronica
DOUBLE DIGEST ™

IN THIS ISSUE:
Sabrina
THE TEENAGE WITCH

RUIZ & KOSLOWSKI WHITMORE

Fernando Ruiz, Betty and Veronica Double Digest #213, June 2013

ARCHIE COVER ARTIST
FERNANDO RUIZ

Fernando Ruiz (b. 1969)

Fernando Ruiz was born and raised in New Jersey. Ruiz has loved comic books and cartoons from the time he was a child, enjoying drawing from them. Fernando graduated with a BFA from Caldwell College in 1991, where he studied Fine Art. But comic books were still a big attraction for him, so Ruiz enrolled in the prestigious Joe Kubert School of Cartoon and Graphic Art. It was there that Victor Gorelick, Archie Comics' editor-in-chief, discovered Ruiz. Immediately upon graduation, Fernando began writing and drawing for Archie Comics. His work has appeared in *Archie, Betty & Veronica Spectacular*, and many of Archie's popular digest books, trade paperbacks, and, most recently, the critically acclaimed, Eisner-nominated magazine, *Life With Archie*.

Fernando Ruiz, Jughead's Double Digest #178, April 2012. Reproduced from the original art.

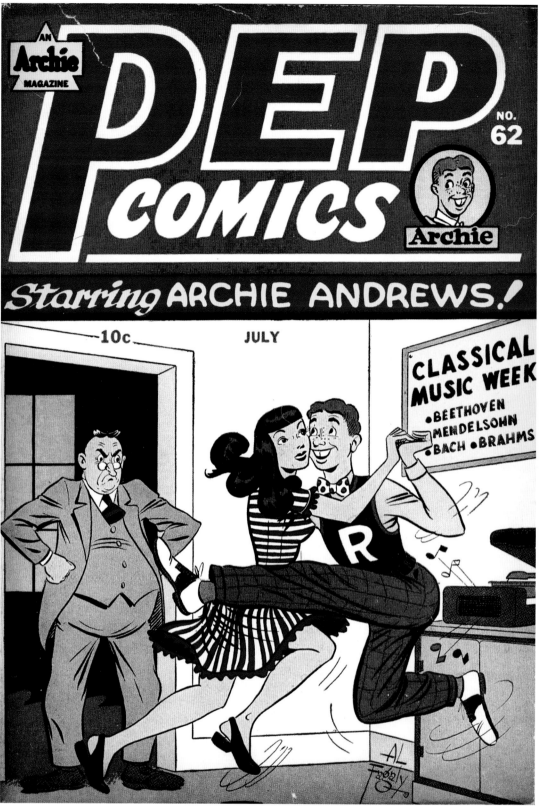

Al Fagaly, Pep Comics #62, July 1947

DANCE! DANCE! DANCE!

If there's anything that teenagers do especially well it's keeping up with the latest, greatest dance moves! The Riverdale gang had lots of fun dancing their heads off doing the jitterbug to the twist and beyond—so we say they can sure dance! The cover artists had a blast dancing with the Archie stars as did, in turn, the faithful readers!

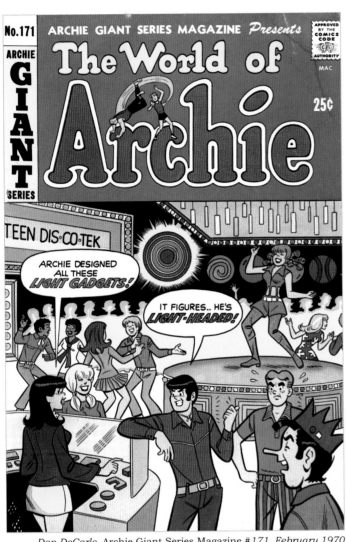

Dan DeCarlo, Archie Giant Series Magazine #171, February 1970

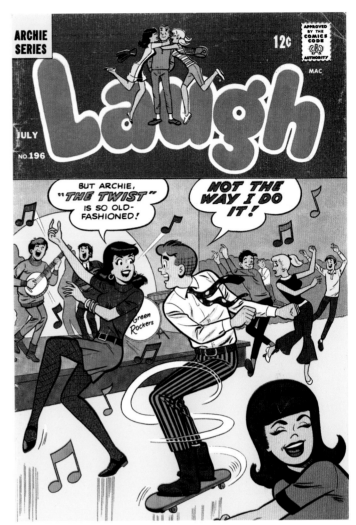

Bill Vigoda, Laugh #196, July 1967

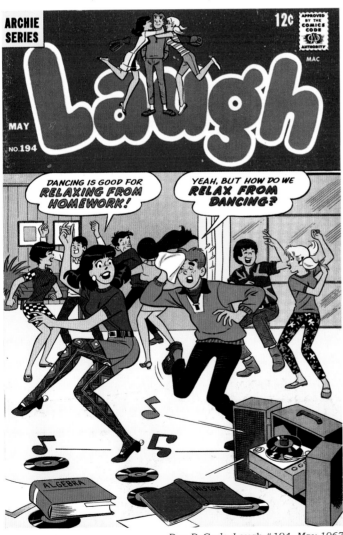

Dan DeCarlo, Laugh #194, May 1967

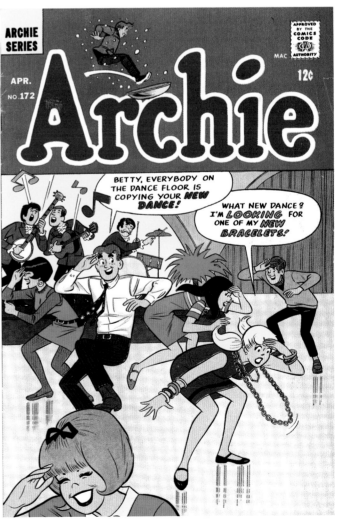

Dan DeCarlo, Archie #172, April 1967

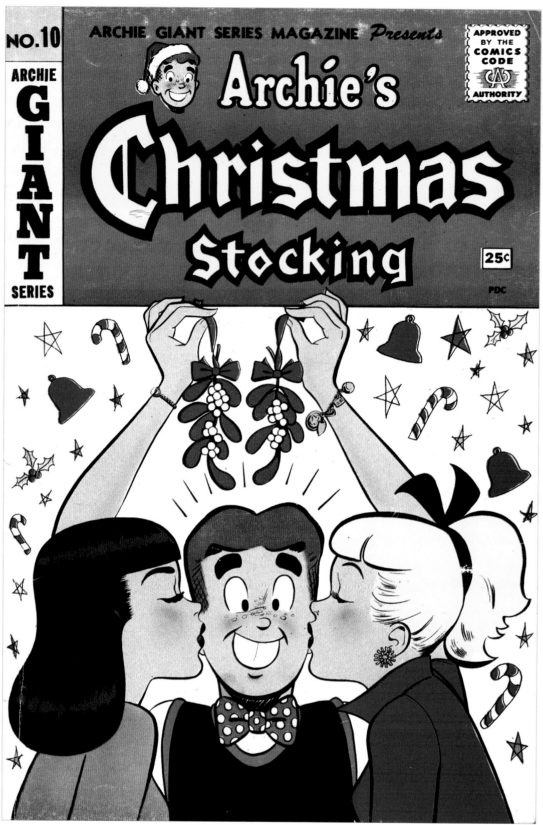

Harry Lucey, Archie Giant Series Magazine #10, February 1961

THE HAPPIEST OF HOLIDAYS!

On Christmas Eve, many wide-eyed kids hung their stockings with care in hopes that the annual Archie Christmas comic would soon be rolled-up in there. Naughty or nice, the millions of kids who asked the red-hatted elf to bring the adventures of the red-headed boy were not disappointed. The Christmas covers are festive, sometimes a little nicely sentimental and always funny. Way after the energized batteries in the toys had ground to a halt, the holiday comics keep on going!

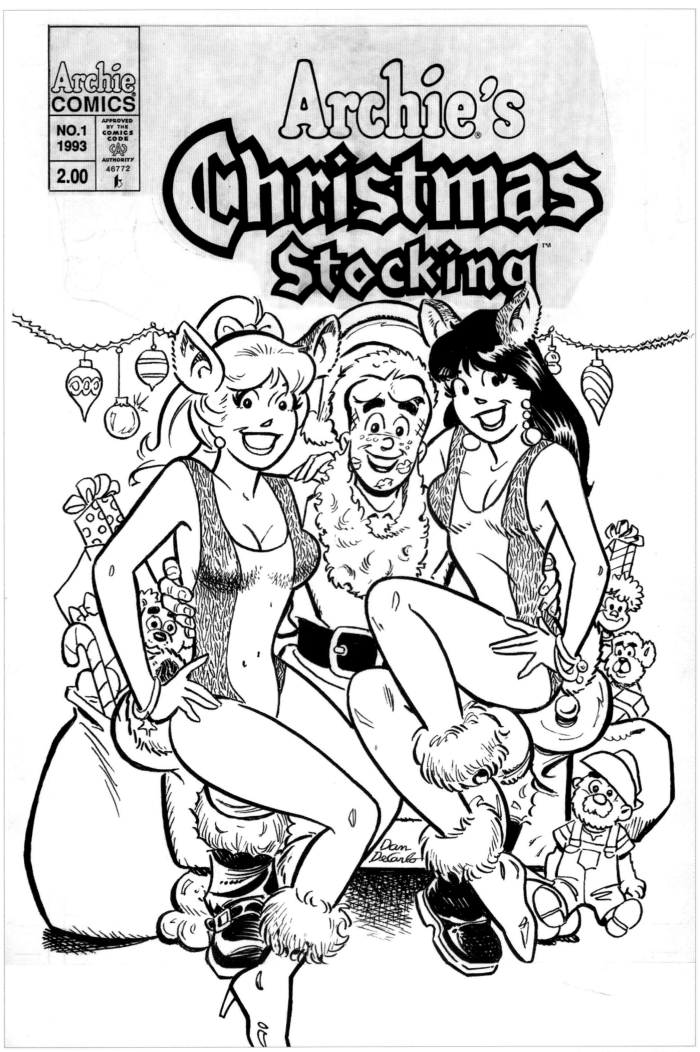

Dan DeCarlo, Archie's Christmas Stocking #1, *January 1994. Reproduced from the original art from the collection of R. Gary Land.*

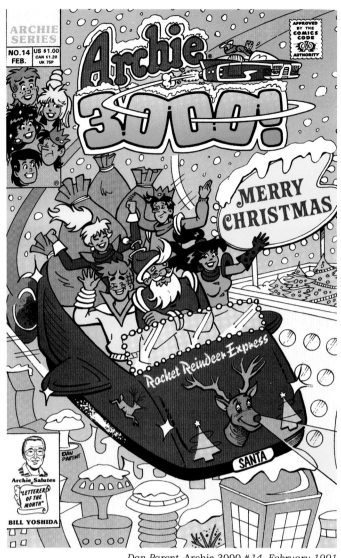

Dan Parent, Archie 3000 #14, February 1991

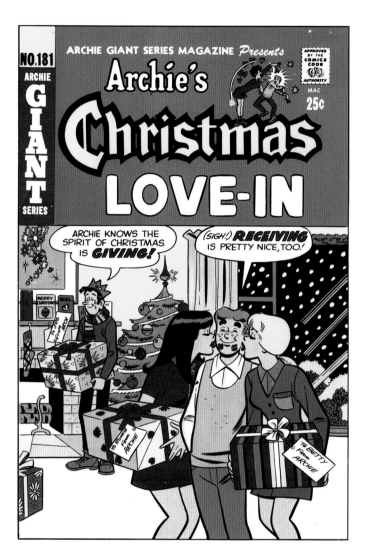

Dan DeCarlo, Archie Giant Series Magazine #181, January 1971.
Reproduced from the printer's proof.

Dan DeCarlo, Archie Giant Series Magazine #169, January 1970.
Reproduced from the black plate of the printer's proofs.

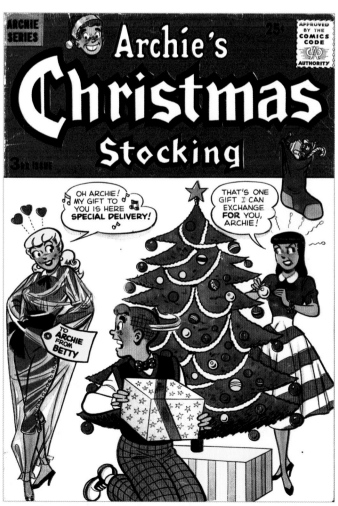

George Frese, Archie Giant Series Magazine #3, December 1956

THE
Archie
LIBRARY
$3.99 US
22

IN THIS ISSUE:
The New Archies

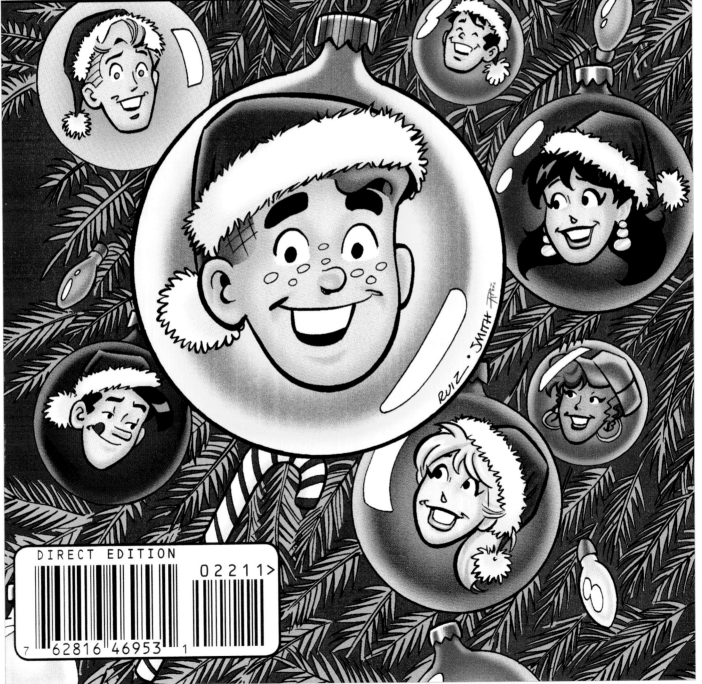

DIRECT EDITION

02211>

7 62816 46953 1

Fernando Ruiz, Archie & Friends Double Digest #22, January 2013

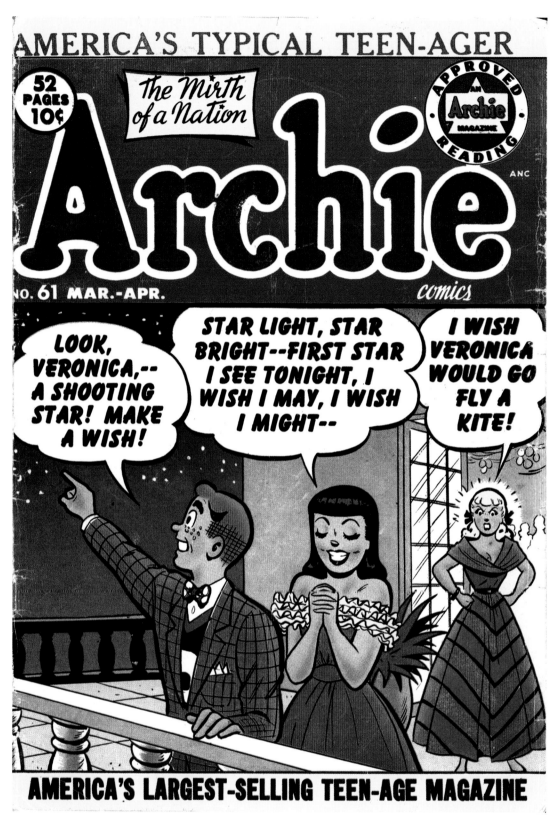

Bill Vigoda, Archie Comics #61, March-April 1953

RHYME TIME

On Archie covers some of the time
The characters would eloquently speak in rhyme.
Betty and Veronica before you would know it
Would spout a choice witticism worthy of a poet!

George Frese, Archie's Girls Betty and Veronica *#2, June 1950*

Harry Lucey, Archie's Girls Betty and Veronica *Annual #6, 1958*

Bob White, Archie's Girls Betty and Veronica Annual #5, 1957

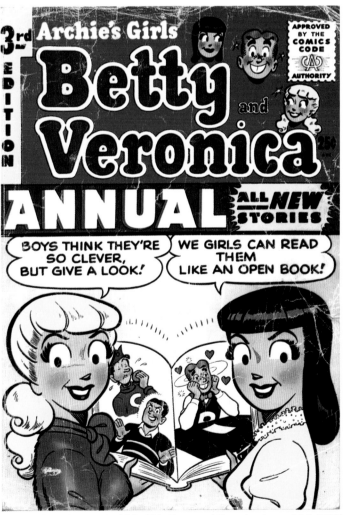

Artist unknown, Archie's Girls Betty and Veronica Annual #3, 1955

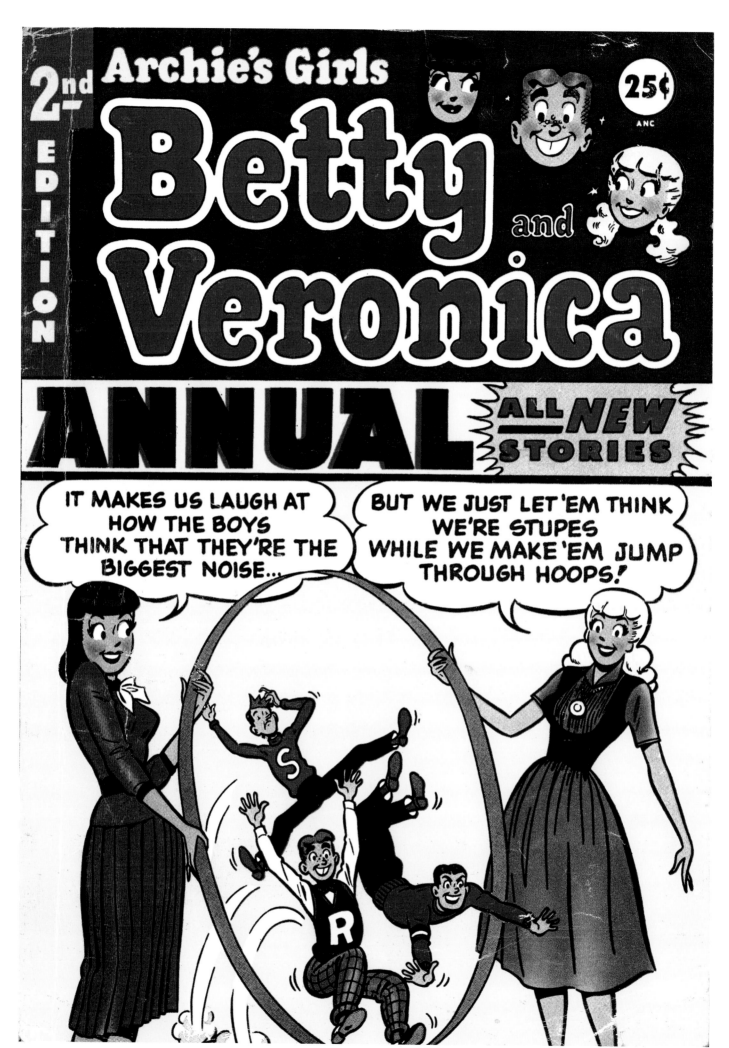

Bill Vigoda, Archie's Girls Betty and Veronica Annual #2, 1954

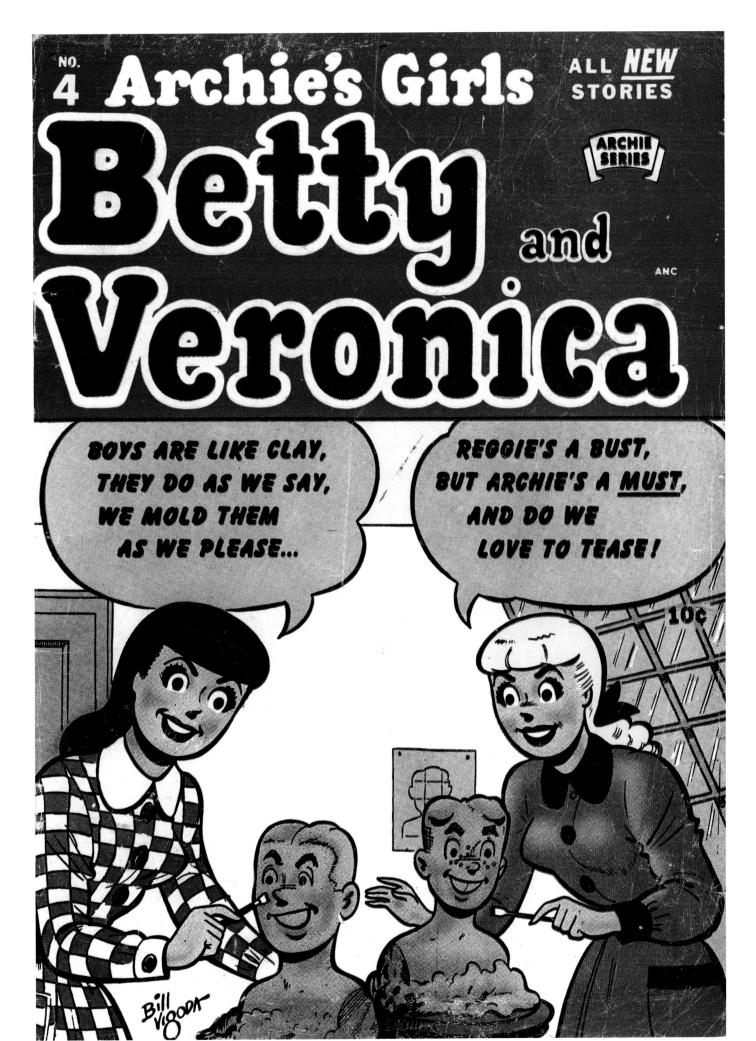

Bill Vigoda, Archie's Girls Betty and Veronica #4, 1951

ARCHIE COVER ARTIST
SAMM SCHWARTZ

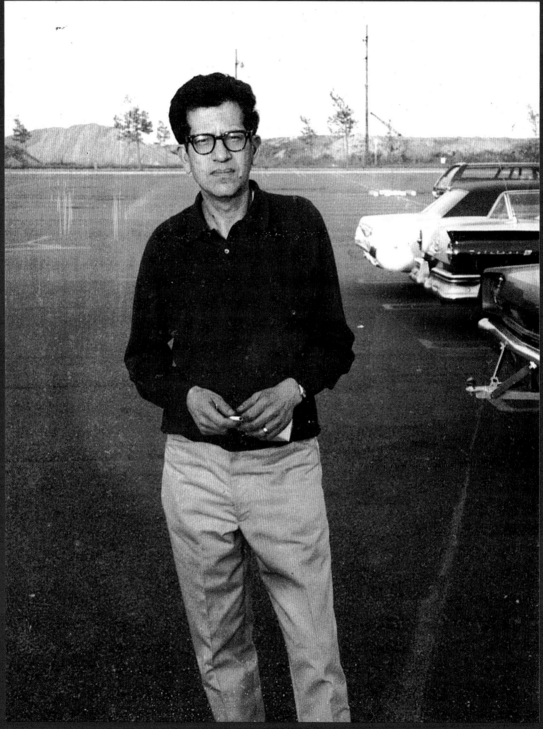

Samm Schwartz (1920 – 1997)

Samm Schwartz' first job was as an apprentice in a New York fashion studio drawing illustrations for department stores. Just before he was drafted into the Army, Schwartz landed a job at MLJ. One of his first assignments was working on a superhero character, Black Jack. While serving in the Army, Samm created a comic strip featuring Pvt. Oswald and Sgt. Gus appearing in the Army Air Force newspaper. Starting in the 1950s, Samm Schwartz and the *Jughead* comic became synonymous. He usually penciled, lettered, and inked the title. Samm had a great sense of humor that came through in every story. In 1965, Samm left Archie to become an editor at Tower Comics. When Tower went out of business, Schwartz worked at DC Comics for about a year and then came back to Archie and, of course, *Jughead*. Samm was truly a great cartoonist and storyteller, although some writers wouldn't recognize the story they wrote from the story Samm drew: Samm Schwartz was always editing!

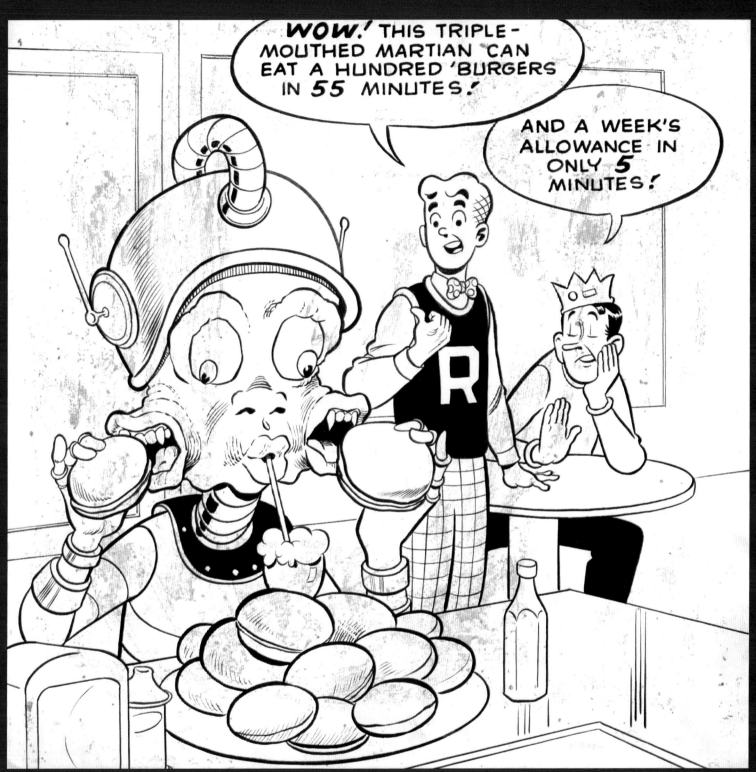

Samm Schwartz, Archie's Pal Jughead #80, January 1962. Reproduced from the original art from the collection of Nick Katradis.

Samm Schwartz, Archie Giant Series Magazine #22, 1963. Reproduced from the printer's proof.

READIN', WRITIN', AN' ARCHIE

On many covers, Archie is billed as "America's Typical Teenager" but the school days at Riverdale High are anything but. The faculty, the principal Mr. Weatherbee ("The Bee"), teachers Ms. Grundy and Benjamin Flutesnoot, the cafeteria lady Ms. Beazly, the janitor Mr. Svenson, and Coach Kleats have their hands quite full with the antics of THESE typical teenagers. There's really not a bad kid in the bunch, but the zaniness they find themselves in every single school day makes for some pretty colorful and crazy classrooms—and covers!

Dan DeCarlo, Archie and Me #53, *December 1972*

Dan DeCarlo, Archie #218, *June 1972.*
Reproduced from the black plate of the printer's proofs.

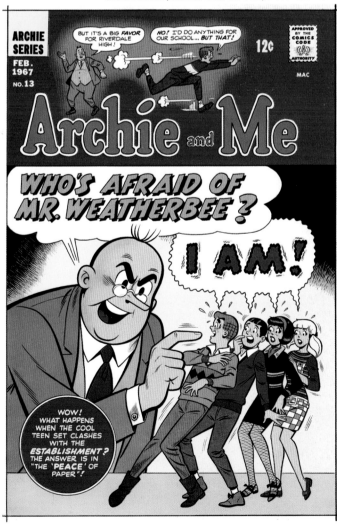

Joe Edwards, Archie and Me #13, *February 1967.*
Reproduced from the printer's proof.

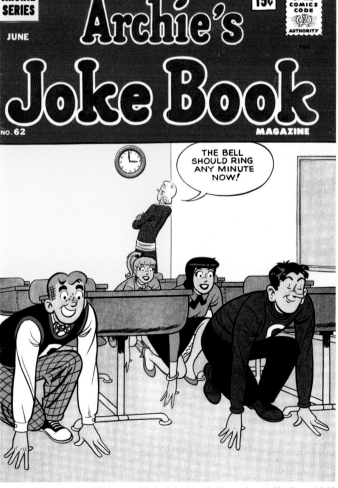

Bob White, Archie's Joke Book Magazine #62, *June 1962*

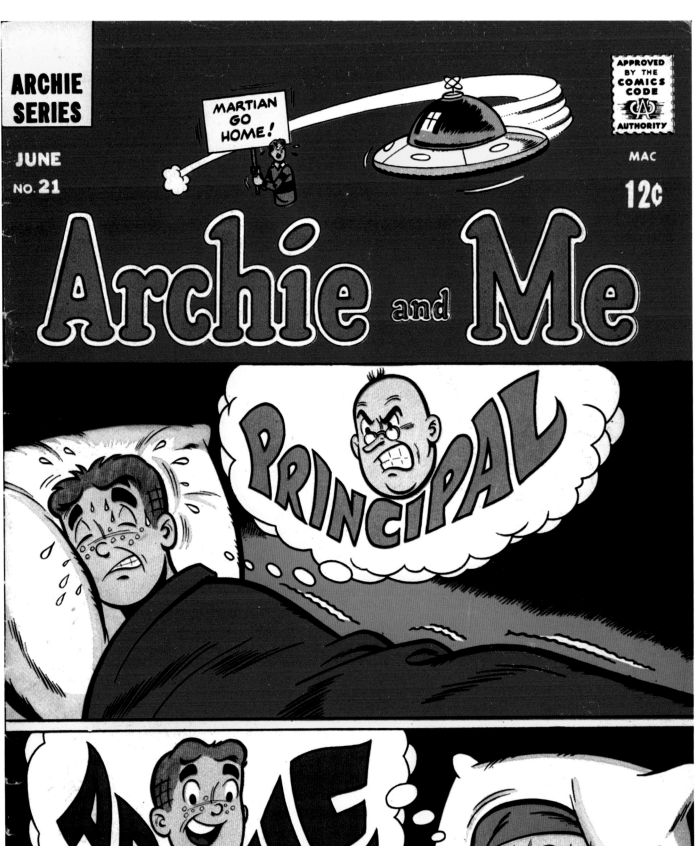

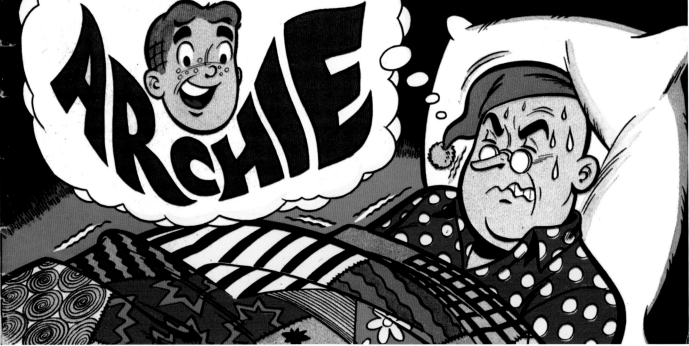

Joe Edwards, Archie and Me *#21, June 1968*

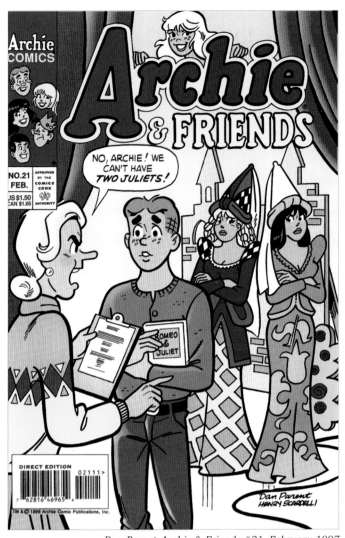

Dan Parent, Archie & Friends #21, February 1997

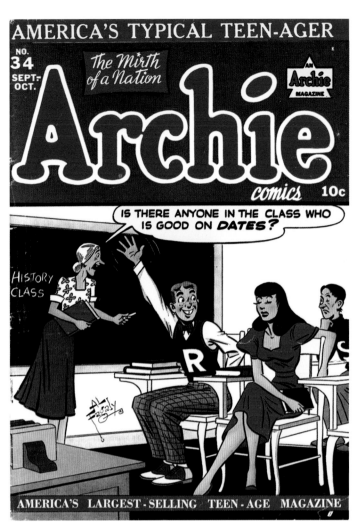

Al Fagaly, Archie Comics #34, September-October 1948

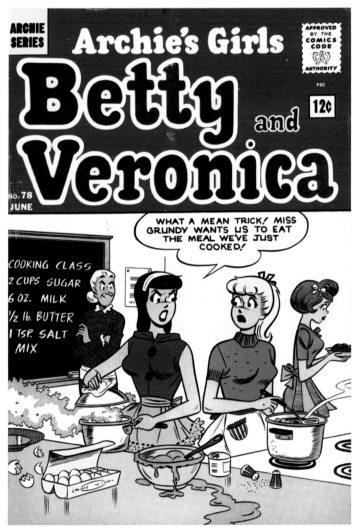

Dan DeCarlo, Archie's Girls Betty and Veronica #78, June 1962

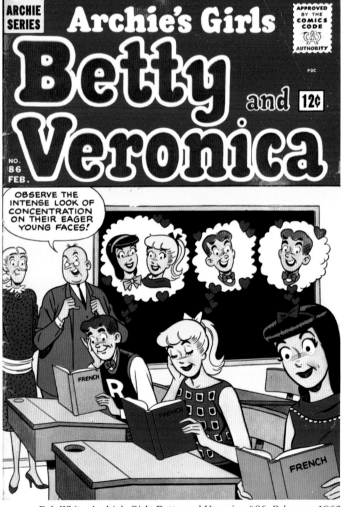

Bob White, Archie's Girls Betty and Veronica #86, February 1963

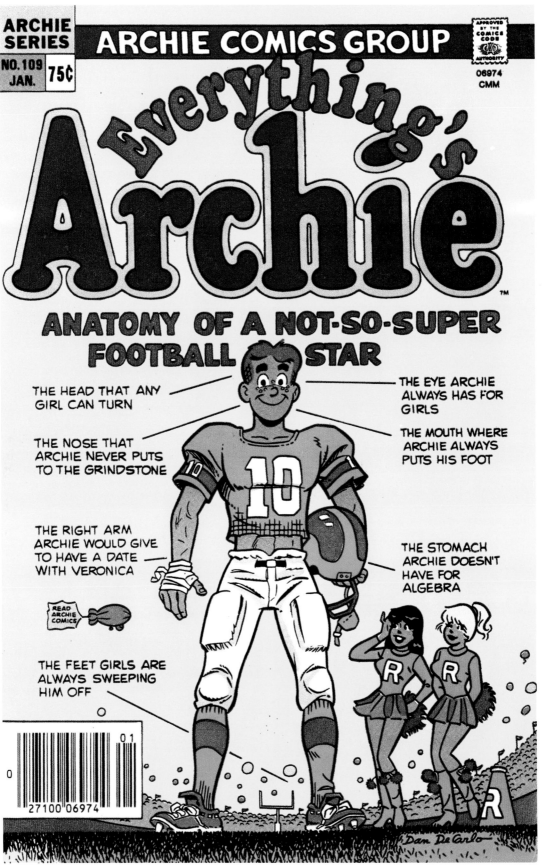

Dan DeCarlo, Everything Archie #109, *January 1984*

GOOD SPORTS!

The Archie characters have never been lazy slugs. Instead, the lively bunch has always been extremely physically active. The teens have fun and keep fit engaging in everything from America's Favorite Pastime to sports imported to the States like karate. Betty is probably the biggest jock of the Archie team but all the characters from Moose to Midge have been depicted playing hard. On the comic book covers football, hockey, tennis, skiing, golf, all these and more, have had their sports illustrated.

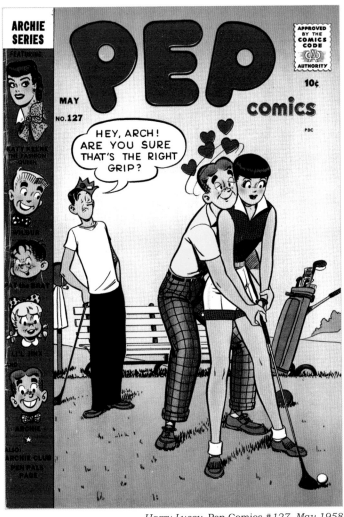

Harry Lucey, Pep Comics #127, May 1958

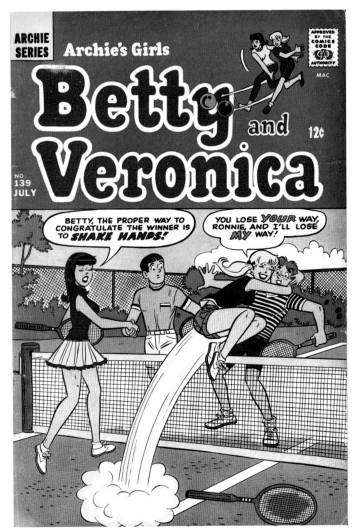

Dan DeCarlo, Archie's Girls Betty and Veronica #139, July 1967

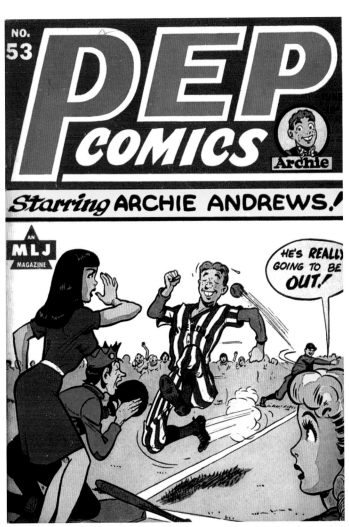

Harry Sahle, Pep Comics #53, June 1945

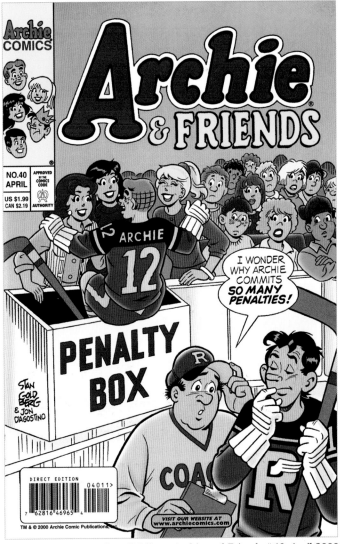

Stan Goldberg, Archie and Friends #40, April 2000

Dan DeCarlo, Archie's Girls Betty and Veronica #124, April 1966.
Reproduced from the printer's proof.

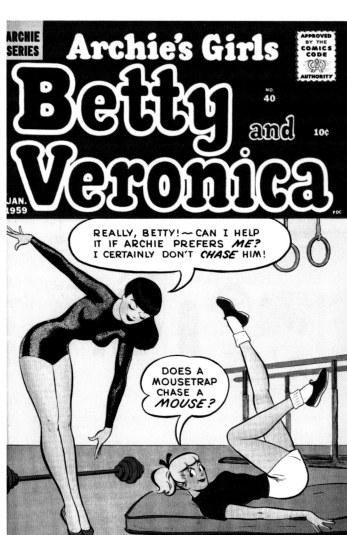

Harry Lucey, Archie's Girls Betty and Veronica #40, January 1959

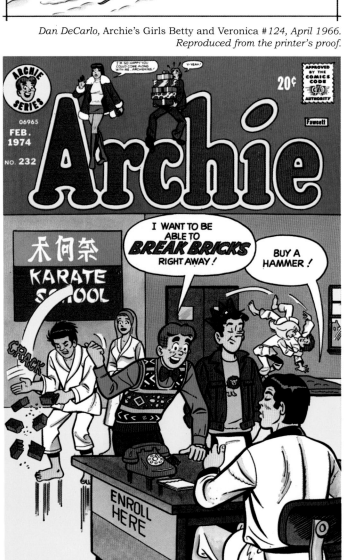

Dan DeCarlo, Archie #232, February 1974

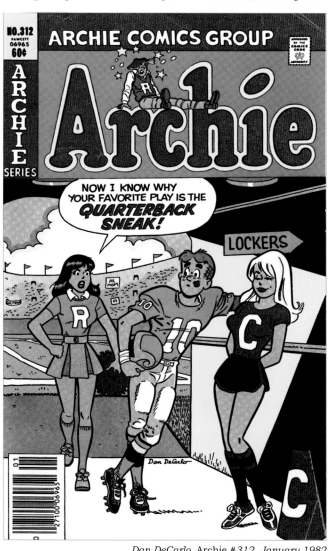

Dan DeCarlo, Archie #312, January 1982

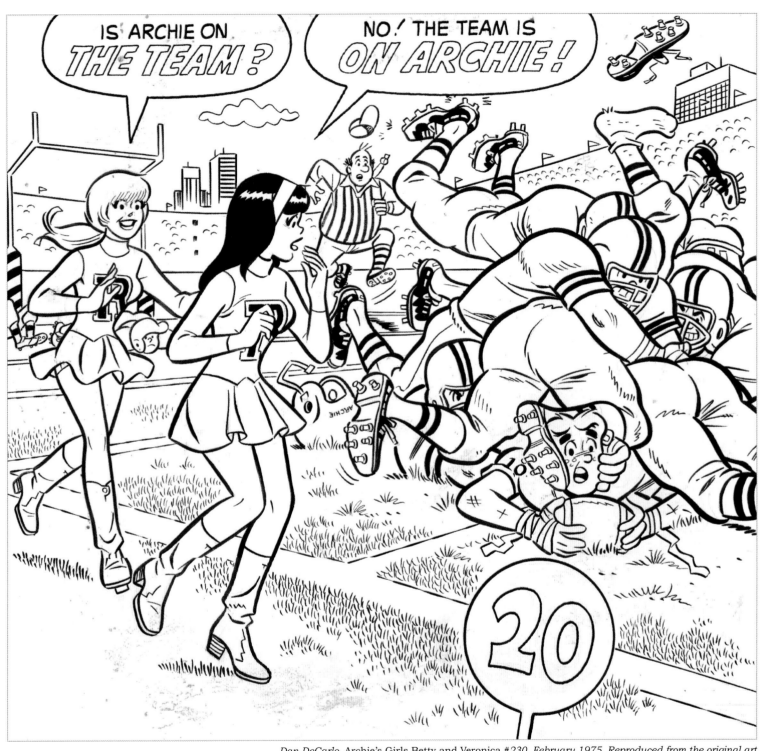

Dan DeCarlo, Archie's Girls Betty and Veronica #230, *February 1975. Reproduced from the original art from the collection of Nick Katradis.*

ARCHIE COVER ARTIST
DAN DeCARLO

Dan DeCarlo (1919 – 2001)

Dan DeCarlo's career in comics started in 1947 working for Timely Comics, which eventually became Marvel. DeCarlo worked at Timely for ten years while freelancing for other publishers, including Archie Comics. Archie's editor Harry Shorten was very impressed with Dan's artwork and guaranteed him steady work if he would focus on the company's characters. DeCarlo really enjoyed drawing the Archie teens, especially Betty and Veronica. He drew their eponymous title for almost 50 years, in addition to which he also became the main Archie cover artist. DeCarlo was Archie Comics' premier cartoonist who was willing to share his talent with any new talent aspiring to work in the industry.

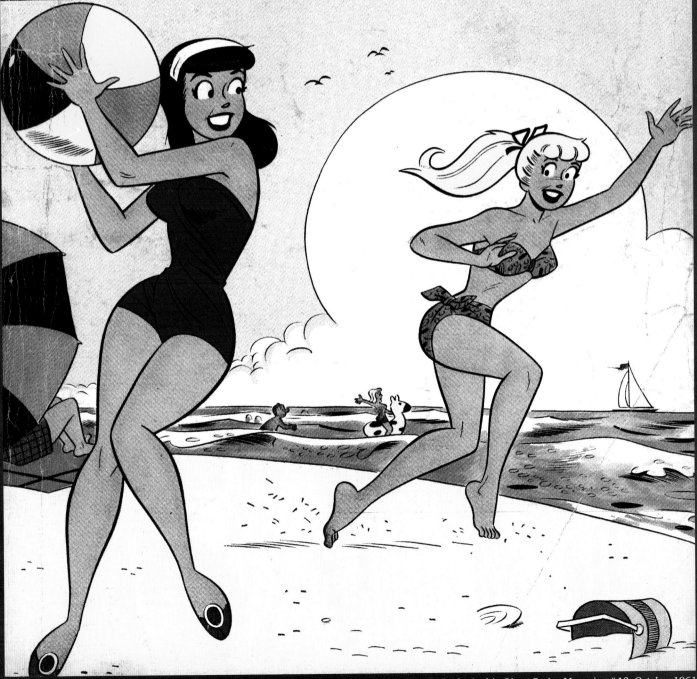

Dan DeCarlo, Archie Giant Series Magazine #13, October 1961

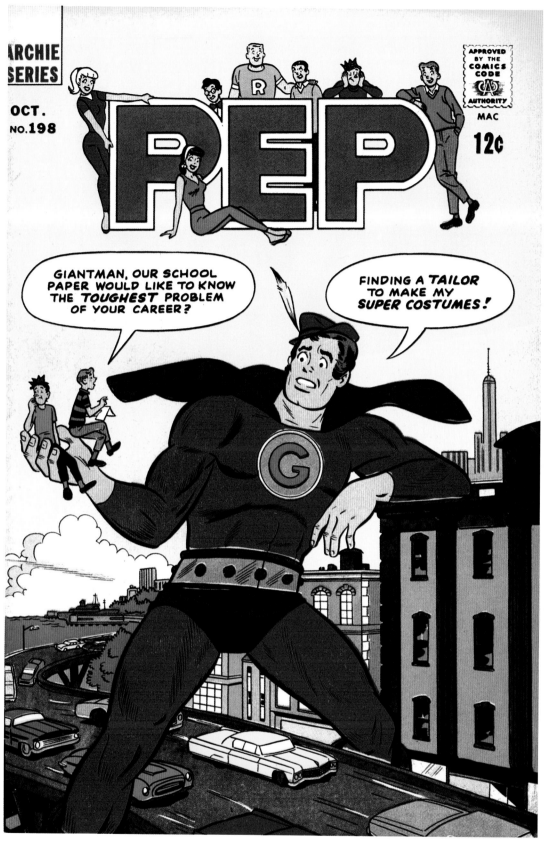

Dan DeCarlo, Pep #198, *October 1966*

THAT'S JUST SUPER!

Before changing their name and focus to Archie, in the early 1940s, the MLJ publishing company concentrated on superhero fare including the first star-spangled patriotic action hero, The Shield. When Archie first came into the scene, the teenager appeared on covers with the long-john guys before they flew away, their capes flapping behind them. The *Pep Comics* #36 cover shows how Archie was being ushered in, hoisted on the shoulders of The Shield and The Hangman. When the *Batman* TV show took the world with a BIFF-POW-BAM! in 1966, not only did the superheroes return to the comics, but Archie and his pals and gals themselves donned colorful crime fighting costumes to make the world safe for both action and laughs!

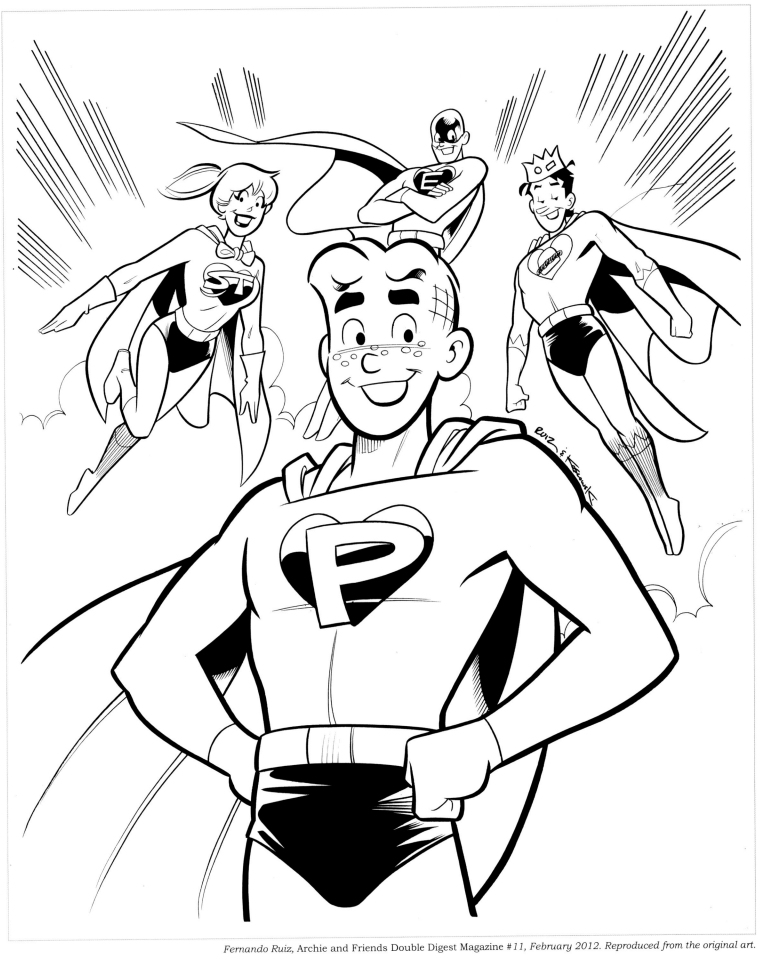

Fernando Ruiz, Archie and Friends Double Digest Magazine #11, February 2012. Reproduced from the original art.

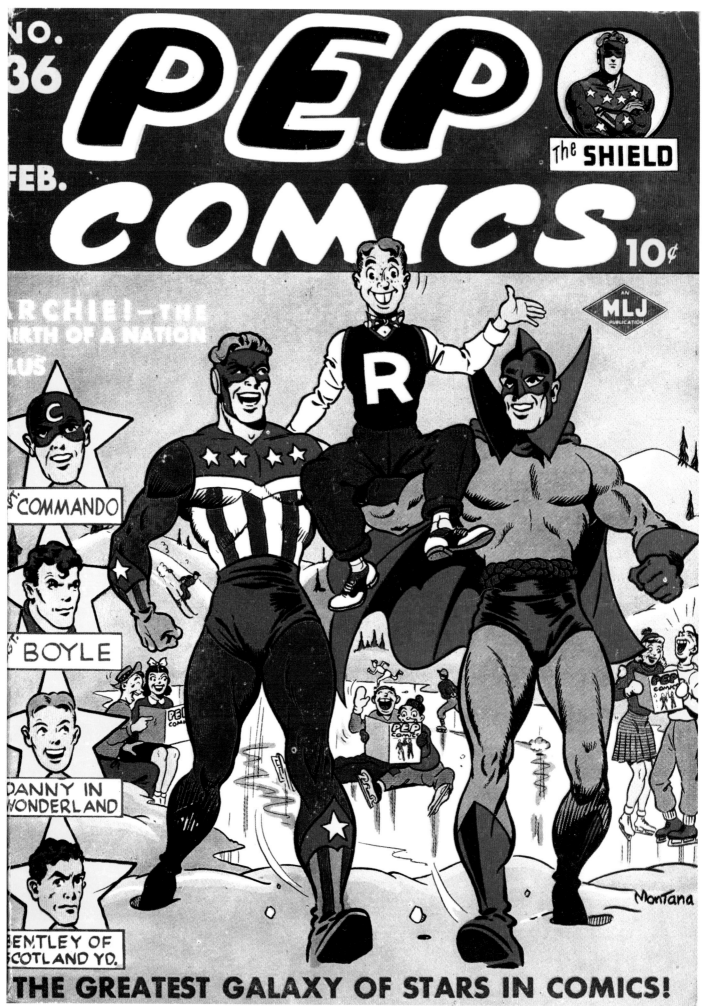

Bob Montana, Pep Comics #36, February 1943

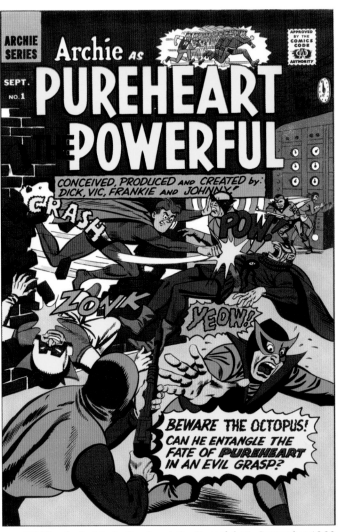

Bill Vigoda, Archie As Pureheart the Powerful #1, September 1966.
Reproduced from the printer's proof.

Dan DeCarlo, Betty and Me #3, August 1966

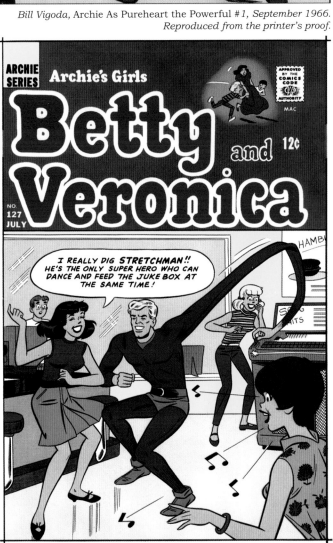

Dan DeCarlo, Archie's Girls Betty and Veronica #127, July 1966.
Reproduced from the printer's proof.

Bill Golliher, Archie & Friends #10, August 1994

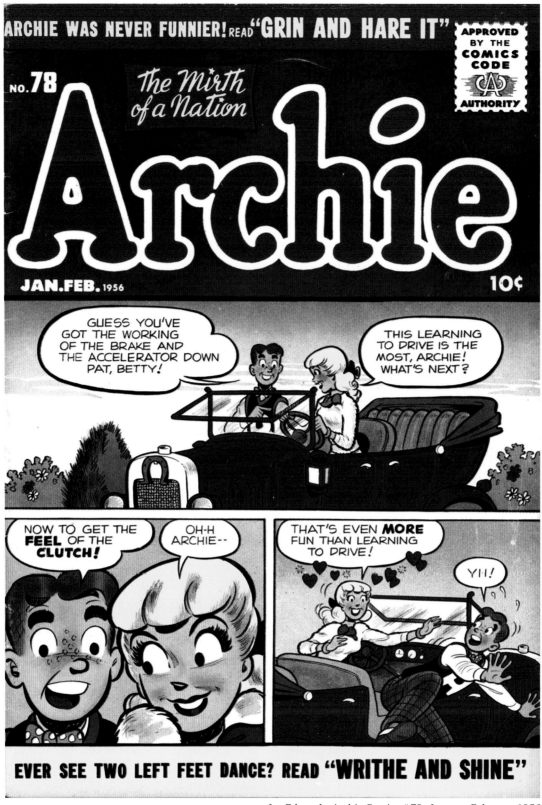

Joe Edwards, Archie Comics #78, *January-February 1956*

LET'S GET THIS PARTY STARTED!

Archie had an inventive and intriguing period when many of the covers reflected the idea of "let's not wait until the insides to get going with the comics!" The editors thought it was a good idea to start the action right smack on the front cover. In two, three, or four panels, the writers and artists pulled the readers at the newsstand or candy shop right in with this tactic and the fans were hooked. The eager readers joyfully plunked down their dimes for the rest of the fun in the comic book interiors. Party on, Archie!

Dan DeCarlo, Archie and Me #55, *April 1973*

Dan DeCarlo, Archie's Girls Betty and Veronica #298, *October 1980*

Samm Schwartz, Archie Comics #77, *December 1955*

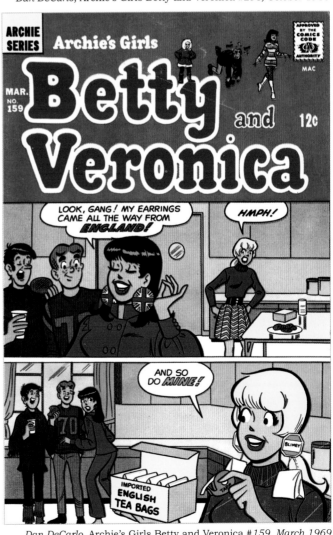

Dan DeCarlo, Archie's Girls Betty and Veronica #159, *March 1969*

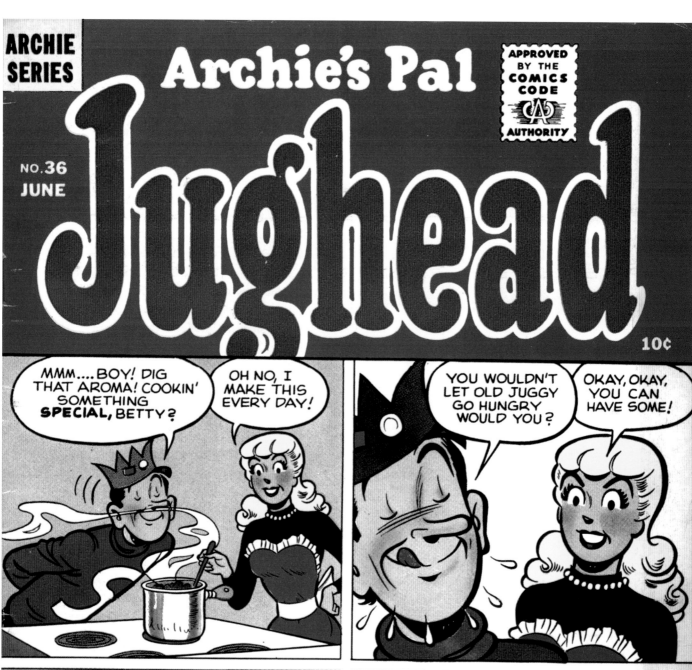

Samm Schwartz, Archie's Pal Jughead #36, *June 1956*

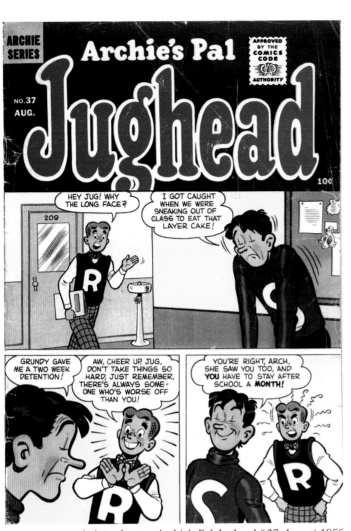

Artist unknown, Archie's Pal Jughead #37, August 1956

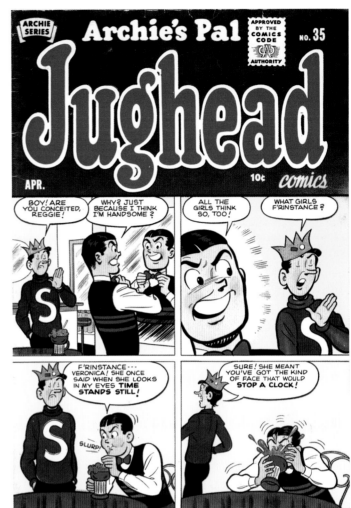

George Frese, Archie's Pal Jughead #35, April 1956

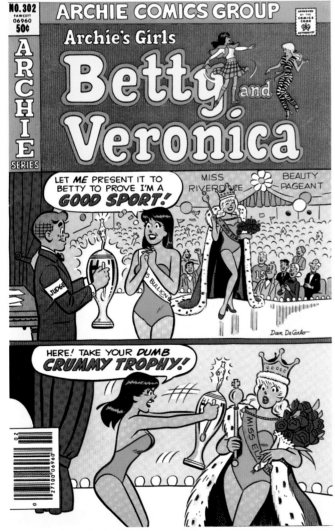

Dan DeCarlo, Archie's Girls Betty and Veronica #302, February 1981

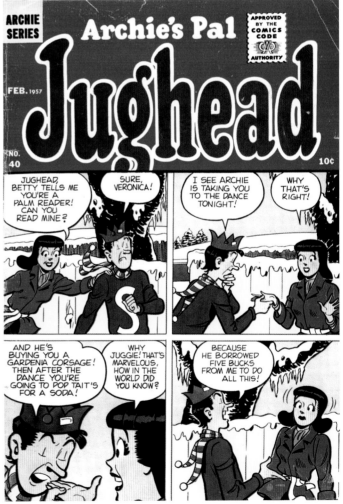

Samm Schwartz, Archie's Pal Jughead #40, February 1957

ARCHIE COVER ARTIST
BOB BOLLING

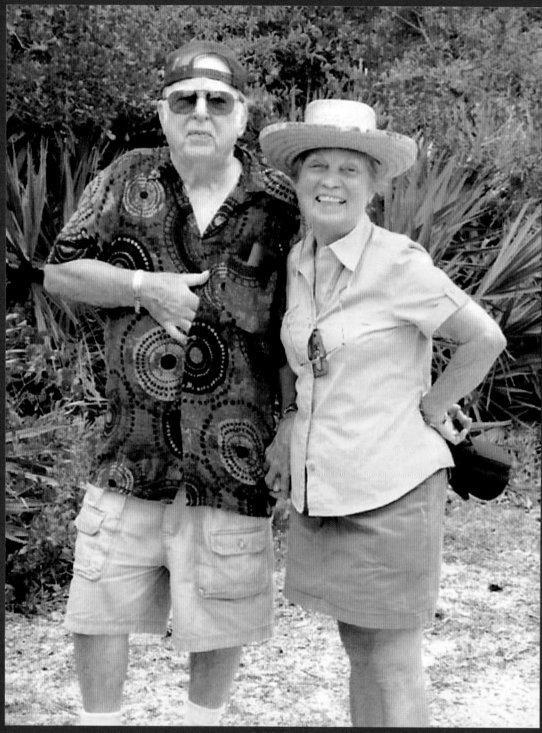

Bob Bolling (b. 1928) and his wife Mary Ann in a recent photo.

Bob Bolling was born in Brockton, Massachusetts, and attended the Vesper George Art School in Boston. Bob's first job was as an assistant to George Shedd on the adventure comic strip *Marlin Keel*. Bob came to New York and in 1954 became a freelance artist for Archie Comics, writing and drawing joke pages. Archie editor Harry Shorten noticed Bolling's talent for drawing children and assigned him to the comic book *Pat the Brat*. In 1956, John L. Goldwater wanted to publish a comic featuring Archie and all his friends as little kids. Bolling came up with designs for a diminutive Archie and pint-sized pals and gals. He was assigned to write and draw the first issue of *Little Archie* and worked exclusively on this title from 1957 to 1965. Bob lives in Florida with his wife, Mary Ann. He enjoys painting and drawing an occasional story for Archie. His paintings are on display at a local gallery. Bolling received the Inkpot Award in 2005.

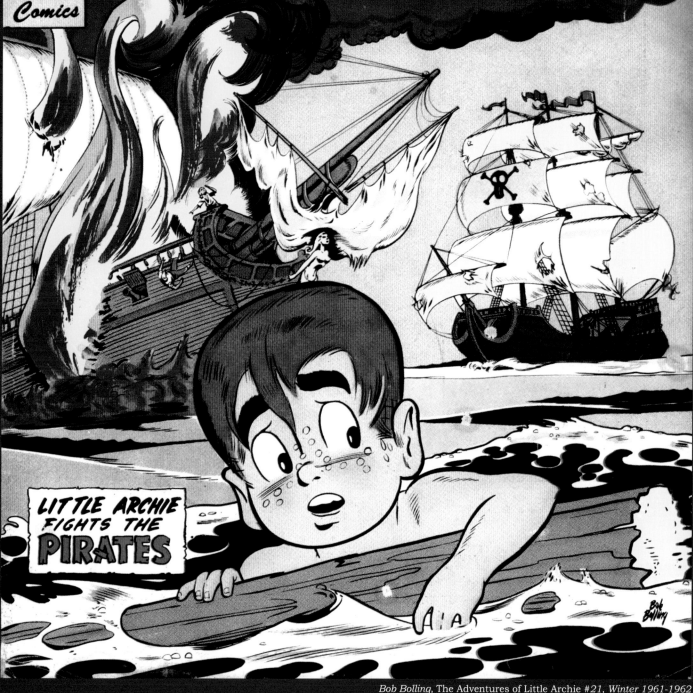

LITTLE ARCHIE

GIANT Comics

21ST ISSUE

THE ADVENTURES OF...

Little Archie

APPROVED BY THE COMICS CODE AUTHORITY

25¢

LITTLE ARCHIE FIGHTS THE PIRATES

Bob Bolling, The Adventures of Little Archie #21, Winter 1961-1962

Dexter Taylor, The Adventures of Little Archie #43, *Summer 1967. Reproduced from the original art from the collection of Arthur Chertowsky.*

A LITTLE GOES A LONG WAY!

The teenage world of Archie is a sweet spot—but what could be sweeter than the Riverdale gang as little kids?! With Little Archie artist Bob Bolling got in touch with his inner child, whimsically writing, drawing, and even lettering the comic book stories. The cartoonist made the Archie kid stuff, in his words, "lovable and laughable." Along with the love and laughs, many of these comics were lengthy, spirited, adventure-type tales wonderfully crafted by Bolling and cartoonist Dexter Taylor.

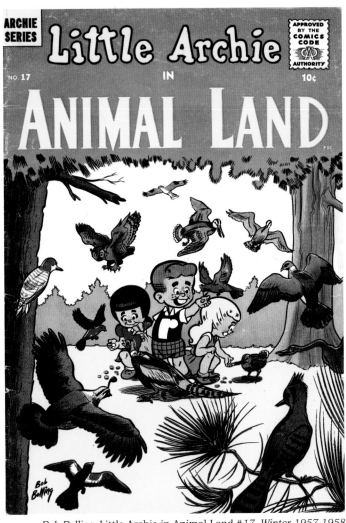

Bob Bolling, Little Archie in Animal Land #17, Winter 1957-1958

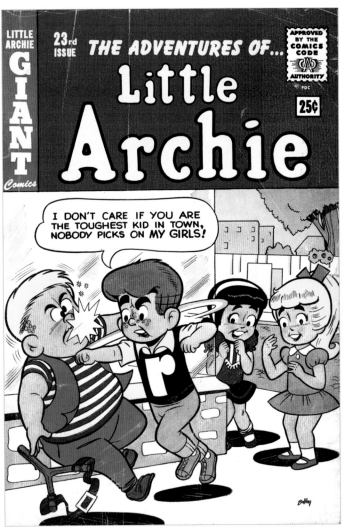

Bob Bolling, The Adventures of Little Archie #23, Summer 1962

Frank Rocco, Little Archie Digest Magazine #1, July 1991

Bob Bolling, Little Archie #2, Winter 1956-1957

Dan DeCarlo, Betty #12, February 1994. Reproduced from the original art from the collection of James Meeley.

A PASSION FOR FASHION!

The Archie artists and writers have done a fabulous job of keeping up on teenage fashion and even inspiring a few trends. Cover gags have often capitalized on the more outlandish or sexy teenage fashion fads, foibles, or faux pas. Betty and Veronica have rocked their clothes, from kooky sweaters to hot pants and even to the "sack" dress!

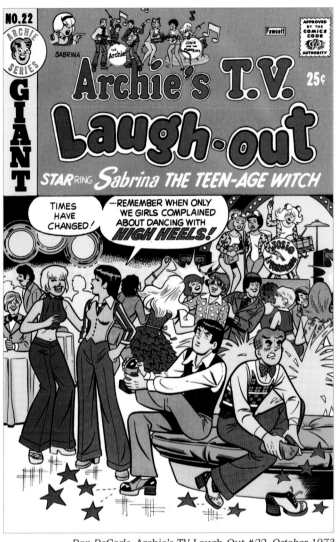

Dan DeCarlo, Archie's TV Laugh-Out #22, October 1973

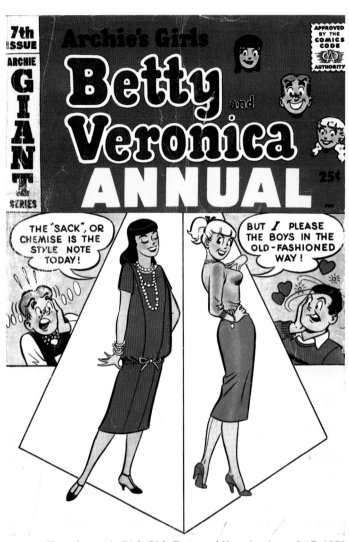

Harry Lucey, Archie's Girls Betty and Veronica Annual #7, 1959

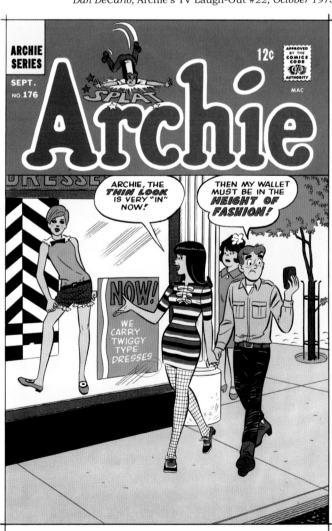

Dan DeCarlo, Archie #176, September 1967.
Reproduced from the printer's proof.

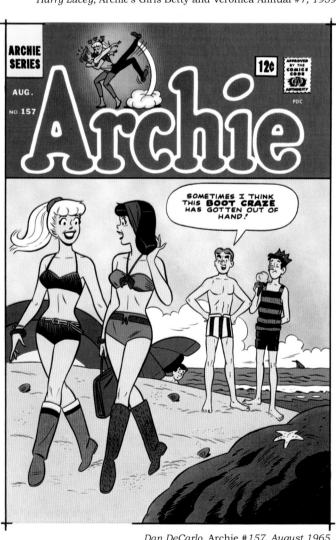

Dan DeCarlo, Archie #157, August 1965
Reproduced from the printer's proof.

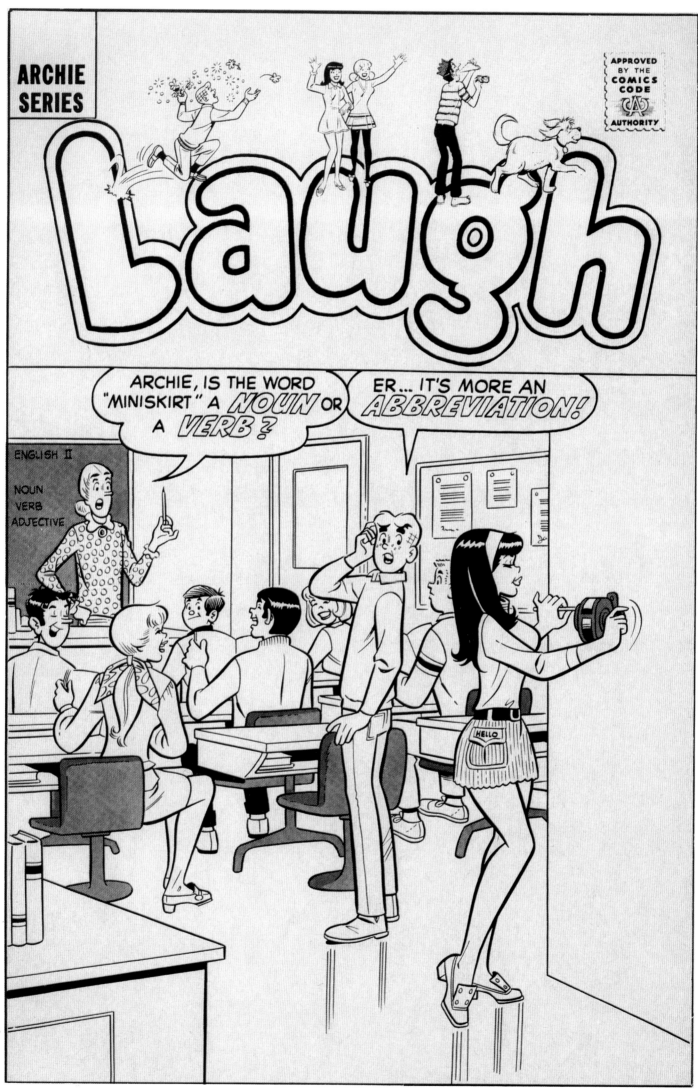

Dan DeCarlo, Laugh Comics #227, February 1970. Reproduced from the black plate of the printer's proofs.

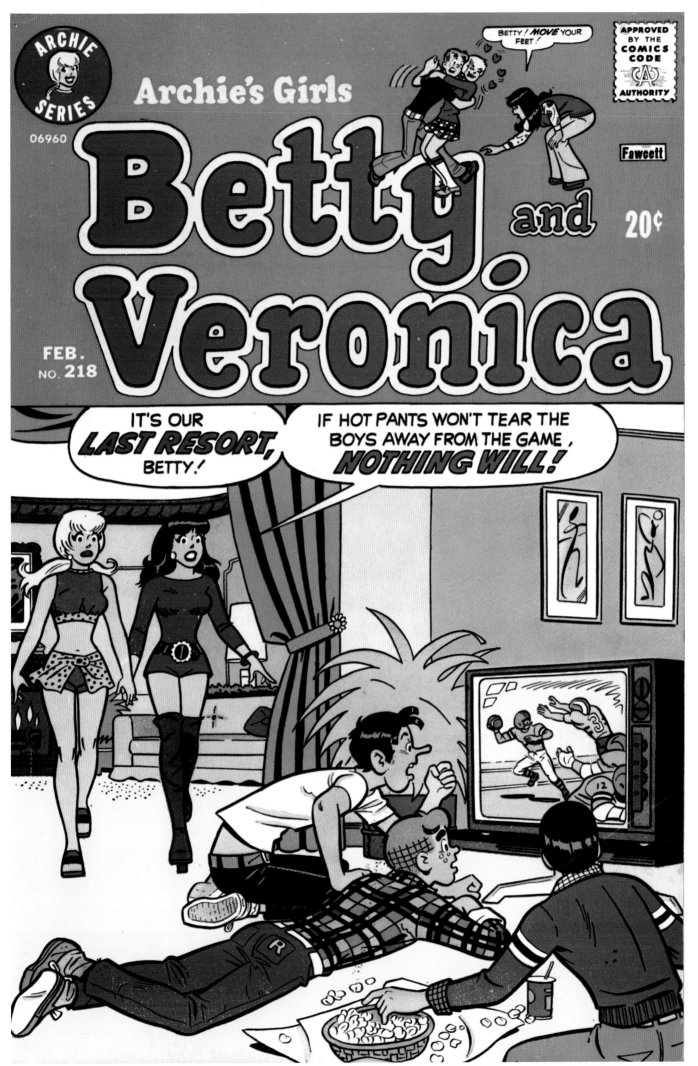

Dan DeCarlo, Archie's Girls Betty and Veronica *#218, February 1974*

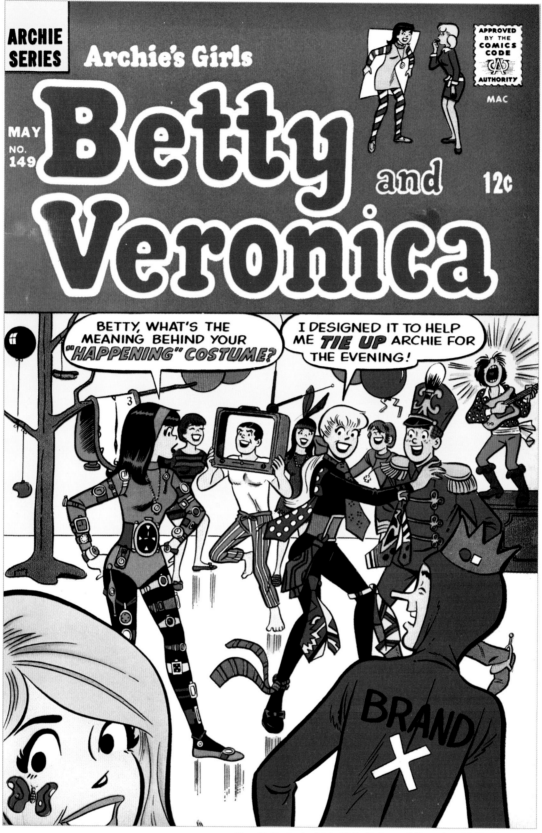

Dan DeCarlo, Archie's Girls Betty and Veronica #149, May 1968

COME AS YOU AREN'T!

The Merriam-Webster dictionary defines a masquerade as "a social gathering of persons wearing masks and often fantastic costumes." The Archie gang had many masquerade social gatherings on their covers and their costumes were ALWAYS fantastic! They were fantastic in imagination and when Betty and Veronica dressed up fantastic in sexiness! Some of the costume parties in the '60s covers even became downright surreal, reflecting the "happenings" of the times. It's obvious that the artists had lots of fun delineating these affairs!

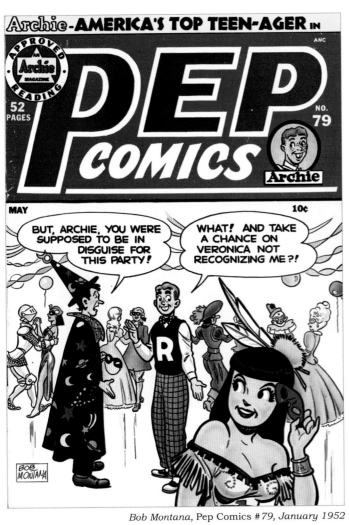

Bob Montana, Pep Comics #79, January 1952

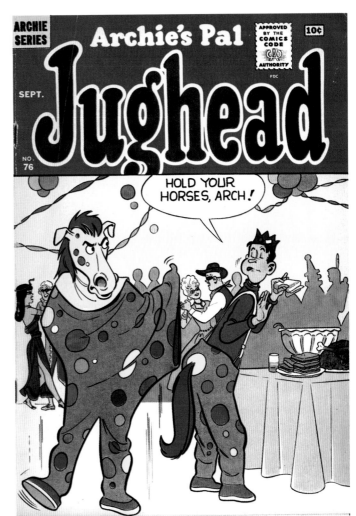

Samm Schwartz, Archie's Pal Jughead #76, September 1961

Stan Goldberg, Archie & Friends #83, August 2004

Dan DeCarlo, Archie and Me #49, June 1972.
Reproduced from the printer's proof.

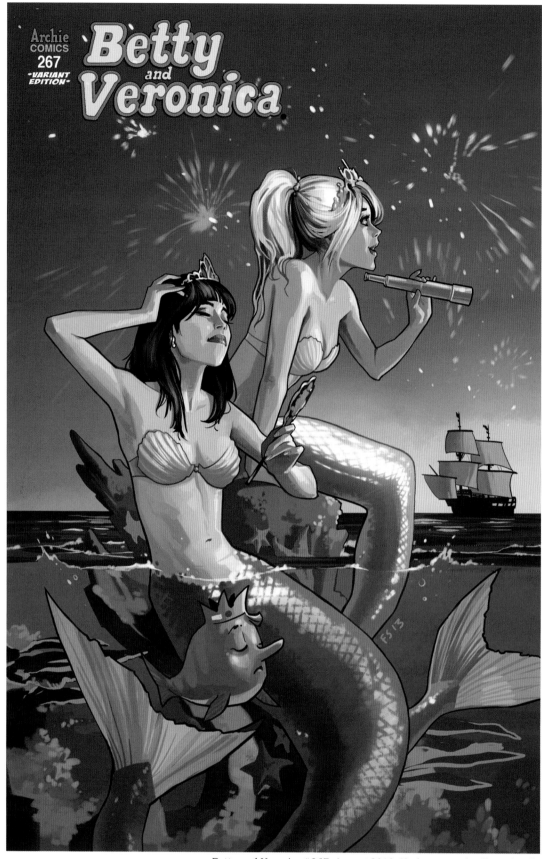

Betty and Veronica #267, August 2013. Variant cover by Fiona Staple.

ALTERNATE REALITIES

A popular fascinating trend in the world of comic books is to offer a variant cover to the regular editions. These covers are the most effective when artists who have styles different than the normal approach to the characters are commissioned. Some incredibly talented people have done some striking variants for Archie covers, a handful of which are presented here. Variants are the spice of life!

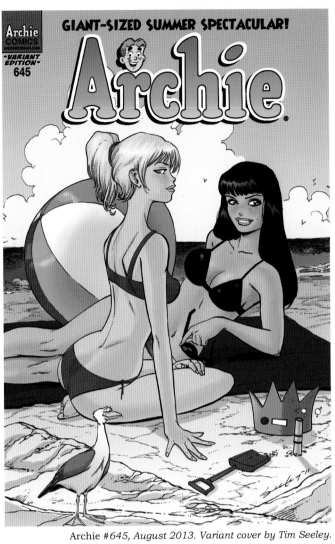

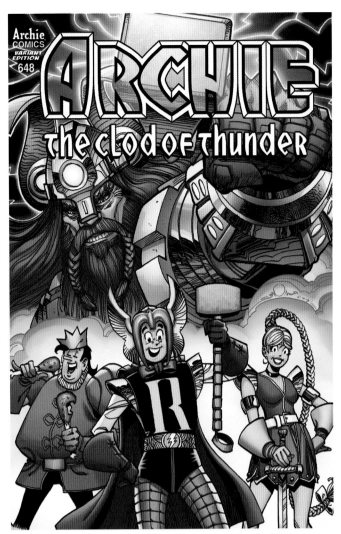

Archie #645, August 2013. Variant cover by Tim Seeley.

Archie #648, November 2013. Variant cover by Walter Simonson.

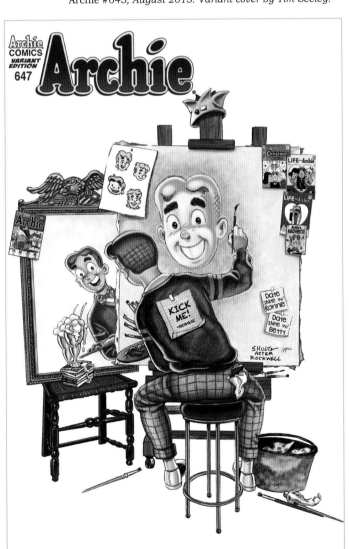

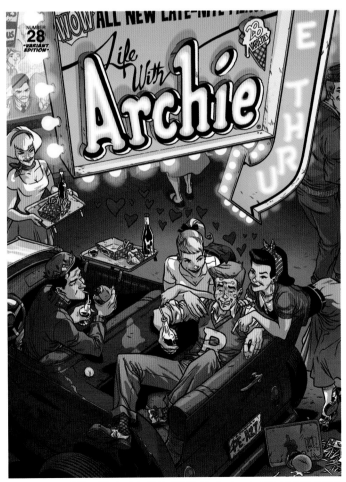

Life with Archie #28, 2013. Variant cover by Ramon Perez.

Archie #647, September 2013. Variant cover by Jeff Shultz.

ARCHIE COVER ARTIST
BOB WHITE

Left to right: Bob White (1928 – 2005) with the other Archie artists Bill Vigoda, Samm Schwartz, and Sy Reit in 1954.

Born in Portland, Maine, Bob White was always drawing pictures as a child. After serving in the Navy, Bob attended art school. Through his friend Bob Bolling, White got a job in the Archie production department, but an editor recognized White's artistic talent. Soon Bob was drawing stories for *Archie, Pat the Brat, Betty and Veronica,* and covers. White is also known for writing and drawing a fan favorite comic book, *Cosmo the Merry Martian.* In the early 1960s, Archie Comics set up a small studio across the street from the main office for Bob White and Samm Schwartz. There was always artwork needed in a hurry—a cover or major art correction—and Bob and Samm were there to save the day! Bob continued to draw and even write. His work appeared in *Archie's Madhouse, Pureheart the Powerful,* and a special issue of *Life with Archie* that featured the 1964 New York World's Fair.

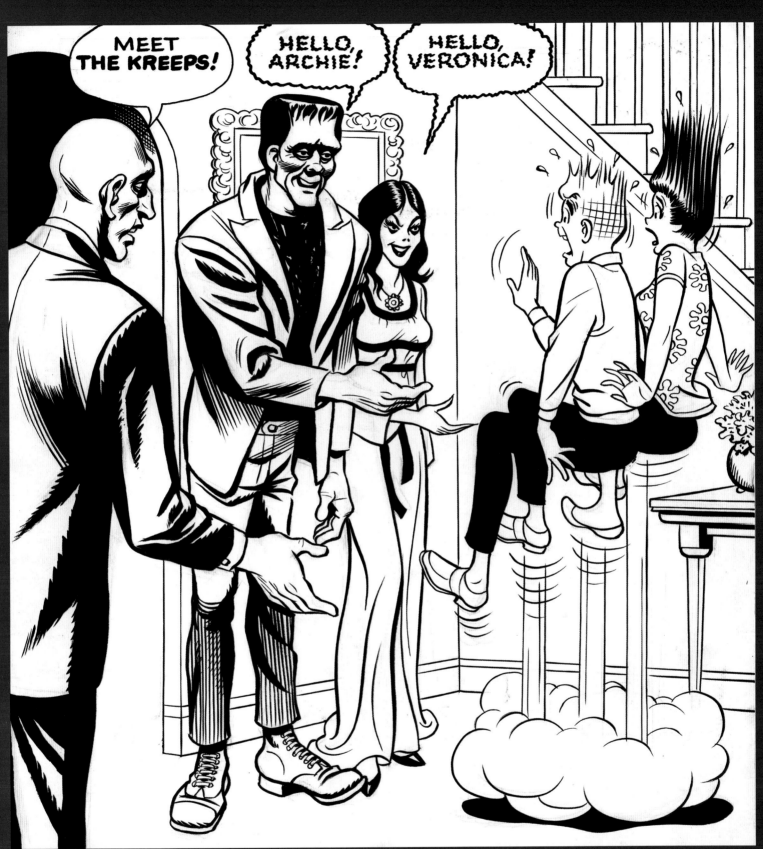

Bob White, Life with Archie *#39, July 1965. Reproduced from the original art from the collection of Linda Marsico.*

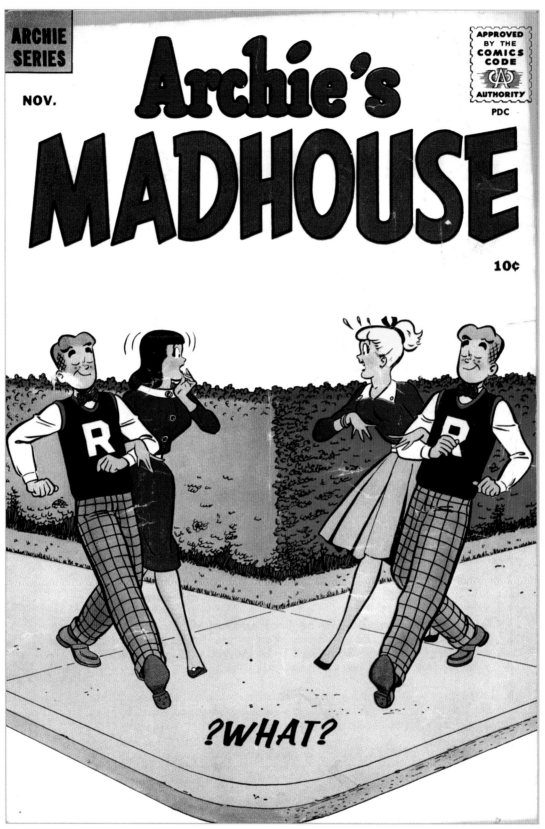

Harry Lucey, Archie's Madhouse #2, October 1959

AND NOW FOR SOMETHING COMPLETELY DIFFERENT...

All the many thousands of Archie covers through over 70 decades are stupendous fun! This book has endeavored to showcase the very best of the best for your immense entertainment. There are some covers that are every bit in the grand Archie comics humorous vein, but, at the same time, deviate from the norm for a splashy conceptual surprise! This section shows those covers where the artists were at their most creative, playful, and even surreal. The Archie covers here, in the best comic book tradition, will make you exclaim: "What th'!?"

Bob White, Archie's Girls Betty and Veronica #70, October 1961

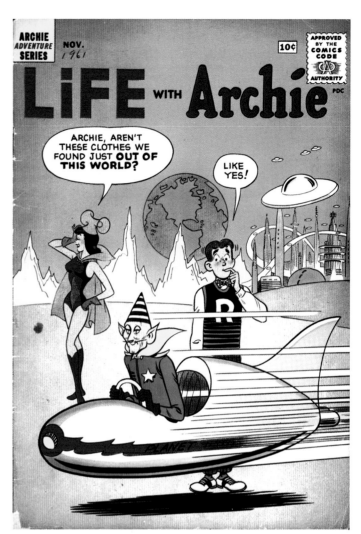

Bob White, Life with Archie #11, November 1961

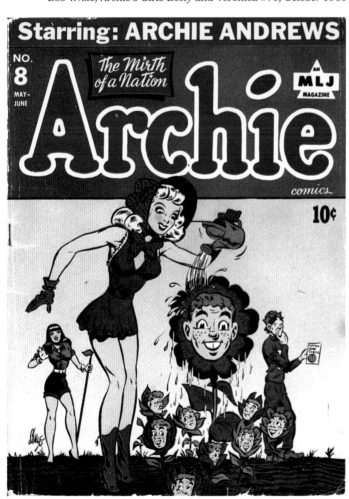

Harry Sahle, Archie Comics #8, May-June 1944

Dan DeCarlo, Archie's Joke Book Magazine #171, April 1972.
Reproduced from the printer's proof.

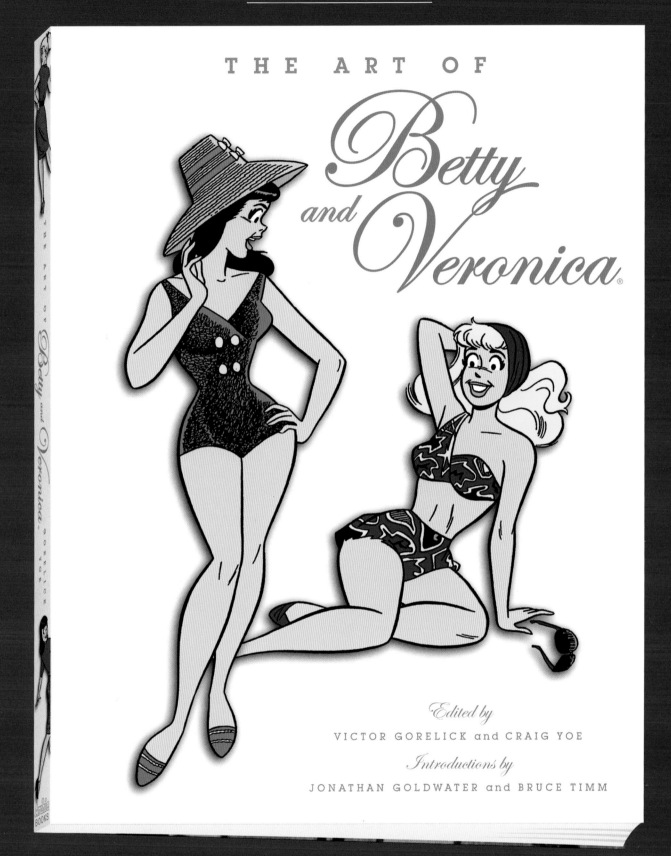

THE ART OF

Betty

and

Veronica

Edited by

VICTOR GORELICK and CRAIG YOE

Introductions by

JONATHAN GOLDWATER and BRUCE TIMM

ISBN: 978-1-936975-03-7

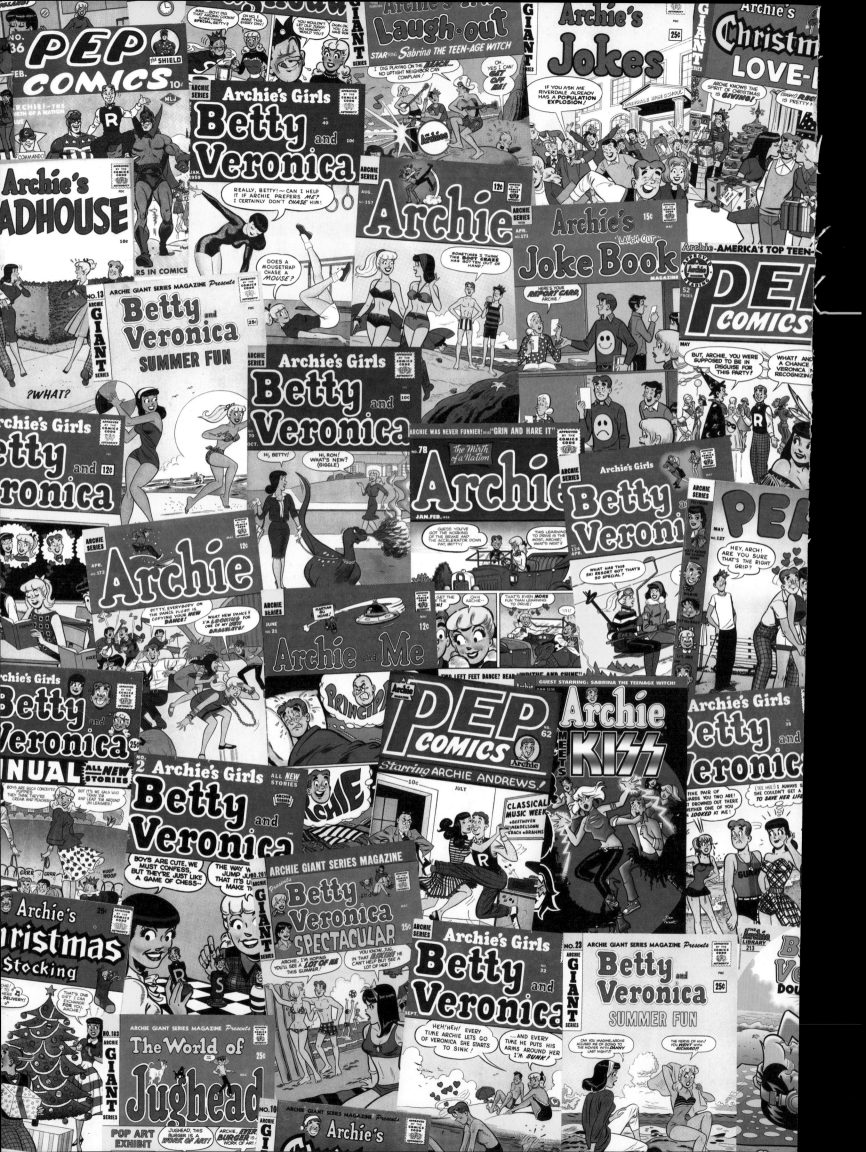